FISHING

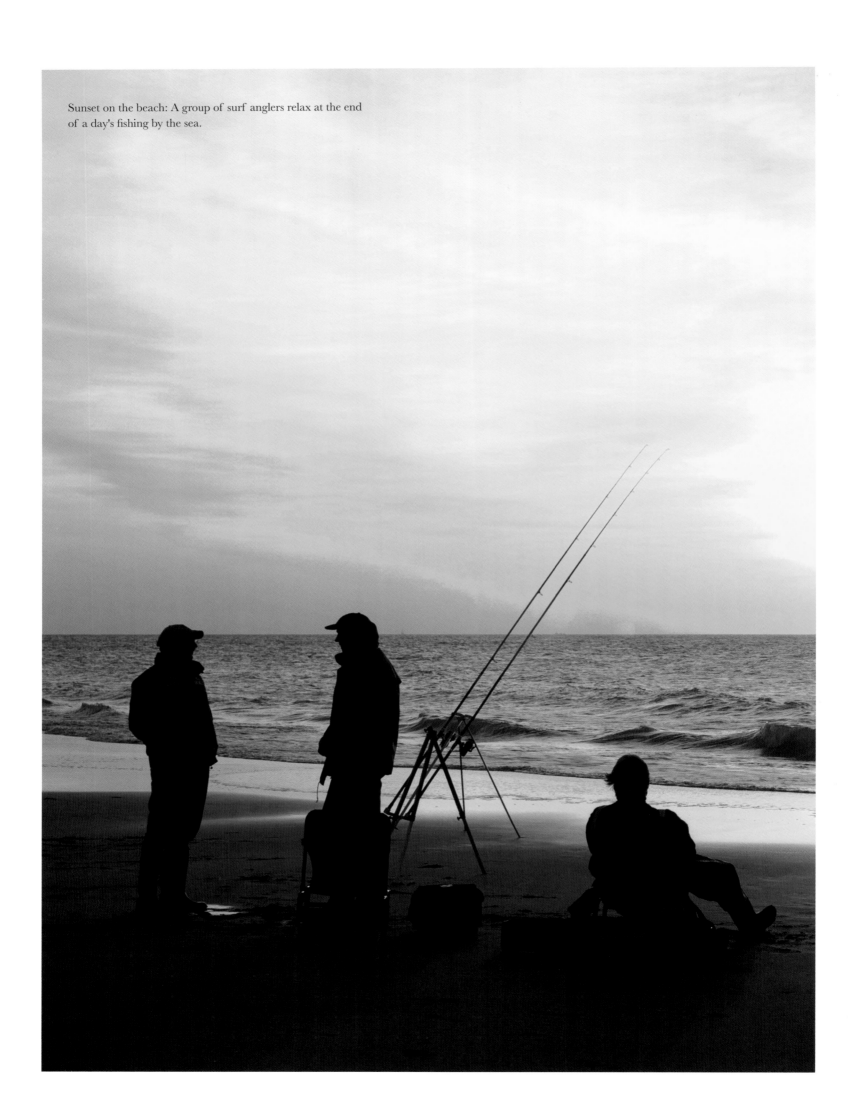

Sunset on the beach: A group of surf anglers relax at the end of a day's fishing by the sea.

Moritz Rott

FISHING
THE ULTIMATE BOOK

teNeues

CONTENT

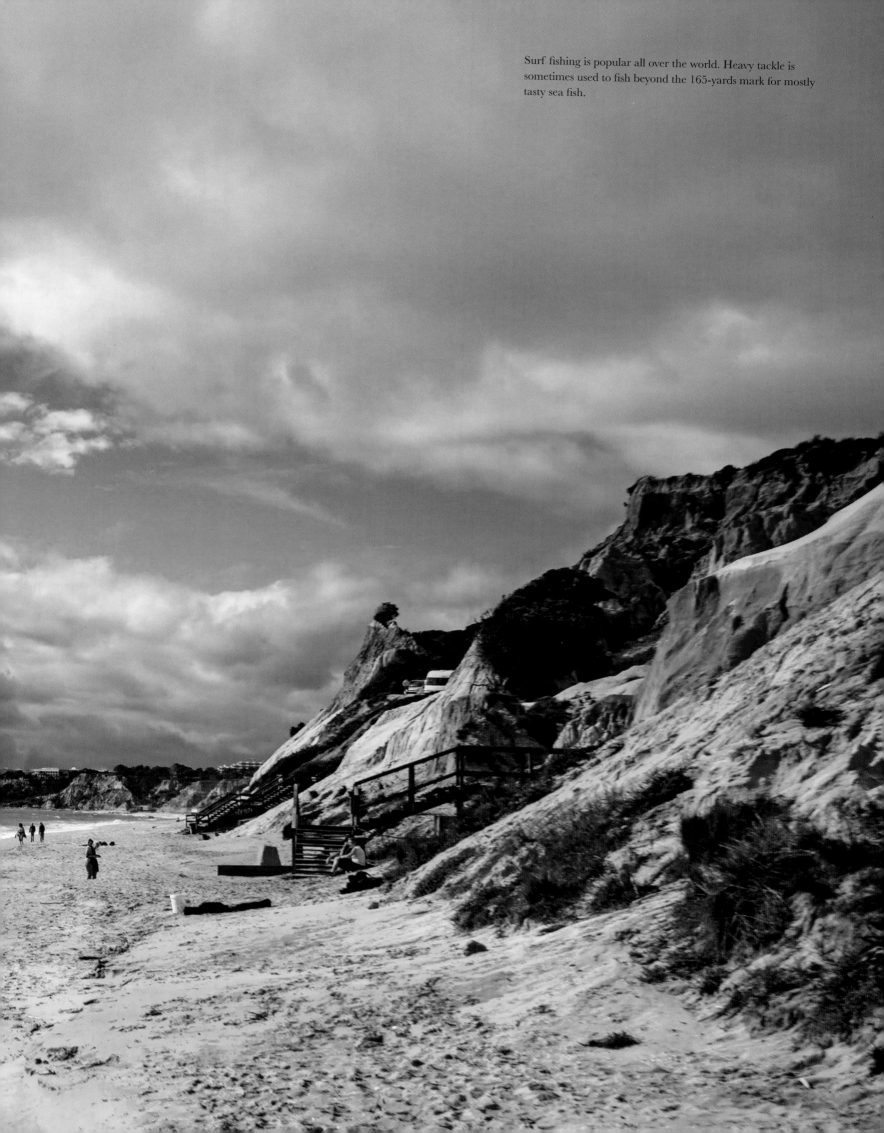

Surf fishing is popular all over the world. Heavy tackle is sometimes used to fish beyond the 165-yards mark for mostly tasty sea fish.

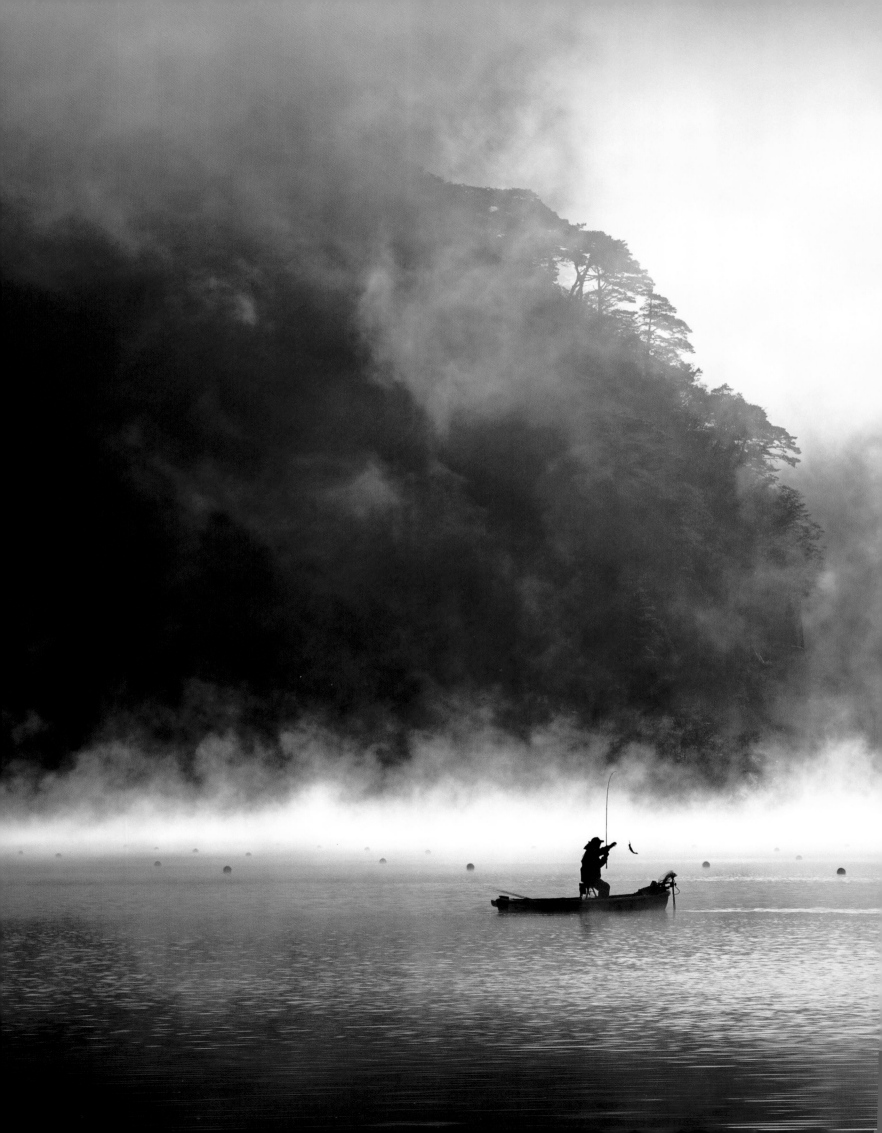

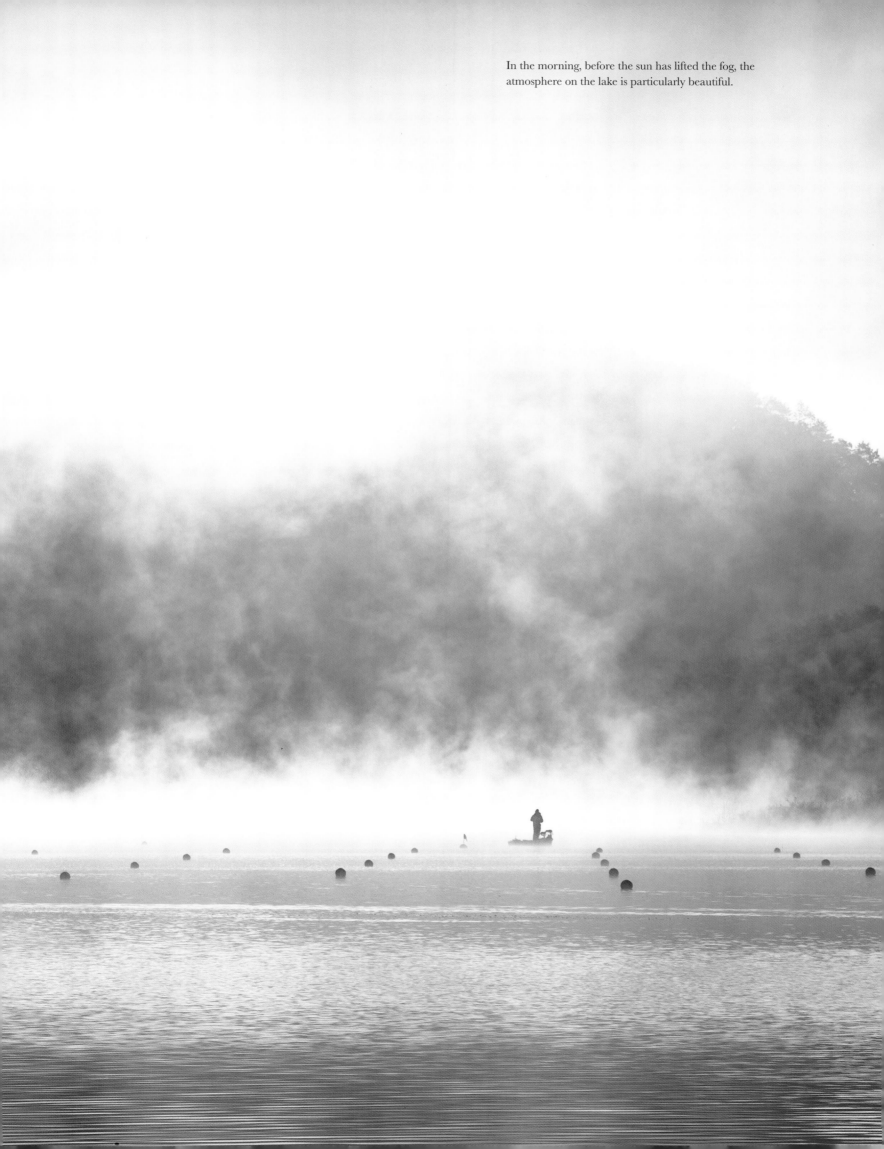

In the morning, before the sun has lifted the fog, the atmosphere on the lake is particularly beautiful.

About Fishing

»It is called Fishing not Catching« –
Fishing is much more than just catching fish.

Relaxation and Slowing Down
In an increasingly hectic and overstimulated world, fishing offers many people an opportunity to escape everyday life and relax. The peaceful environment of nature, the rhythmic movements and sounds of the water, and the patience required while waiting for a bite can help reduce stress and calm the mind.

Connection with Nature
At a time when people and nature are drifting further apart, fishing offers a way to establish a deeper connection with nature. Observing the surroundings, studying the waters, and learning about the life of fish and other aquatic creatures can foster a sense of connectedness and respect for the natural world.

Self-Reflection and Meditation
The quiet and patient waiting while fishing can provide an opportunity to reflect on life, organize personal thoughts, and meditate. For many anglers fishing is a form of meditation, where they can get to know themselves better and find inner peace.

Challenge and Fulfillment
Fishing can also be seen as a challenge requiring skills like patience, dexterity, perseverance, and strategy. Successfully catching a fish can bring a sense of accomplishment and pride, achieved through overcoming obstacles and applying knowledge and skill.

Social Bonds
Fishing can also be a social activity that allows people to spend time with family and friends and share common interests. The shared experience of fishing can help strengthen relationships and create lasting memories.

→ Forgetting everyday life: An angler, completely absorbed in tying his rig.

→→ On the trail of the fish: The fishing kayak makes it easy to navigate large stretches of fishing waters. The fish are easier to find thanks to the fishfinder and the pedal drive leaves the angler's hands free for fishing.

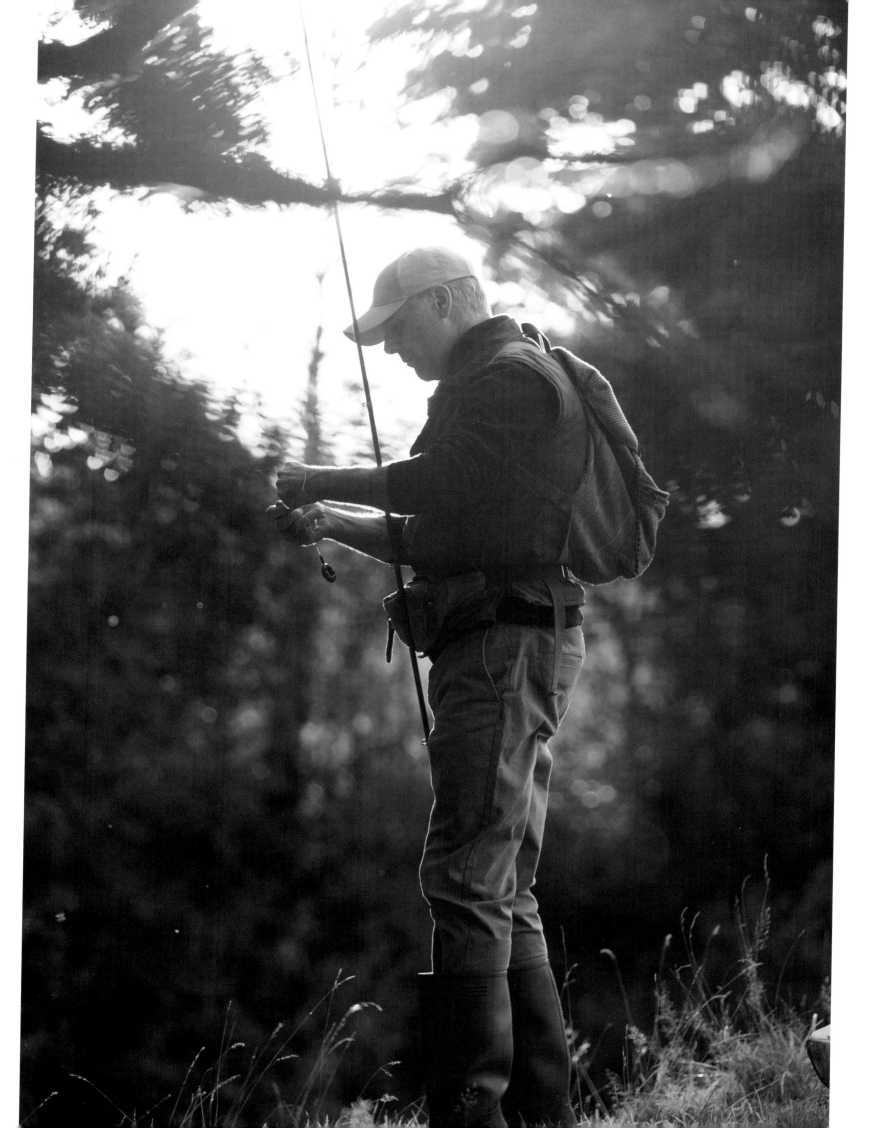

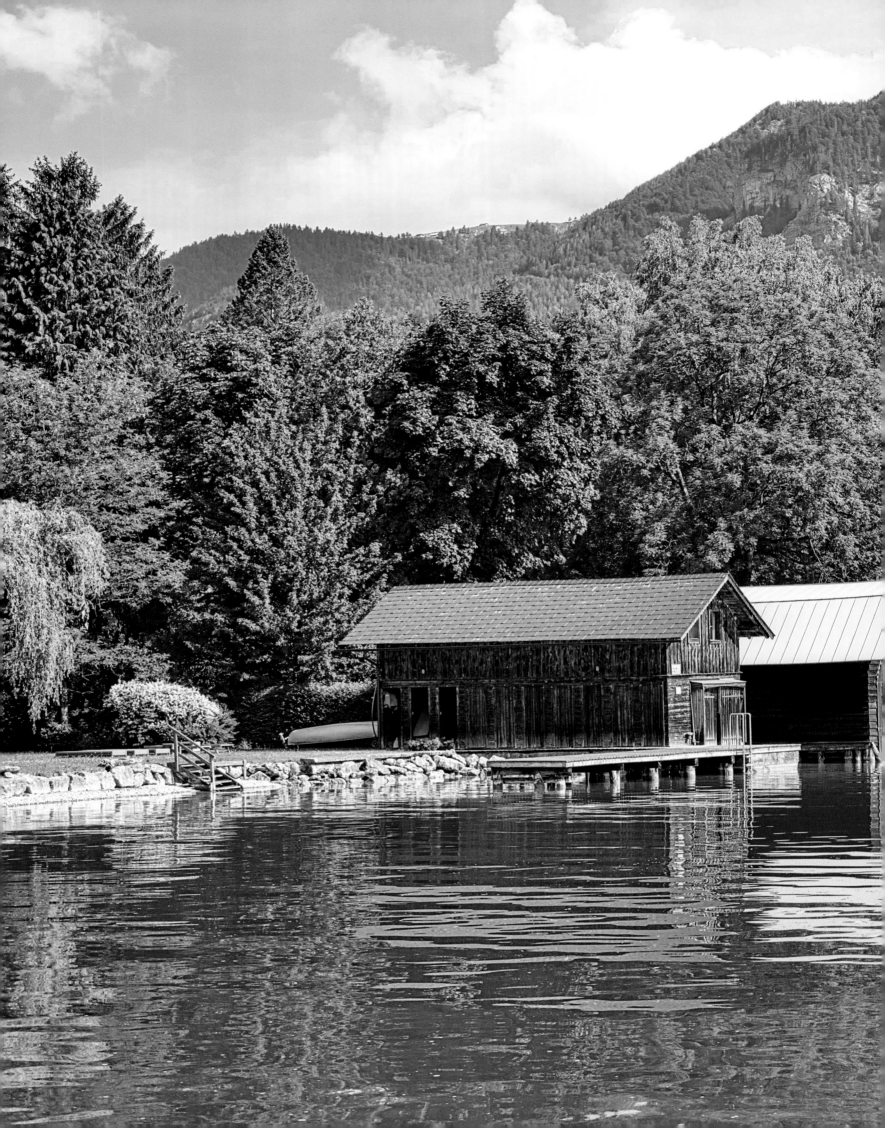

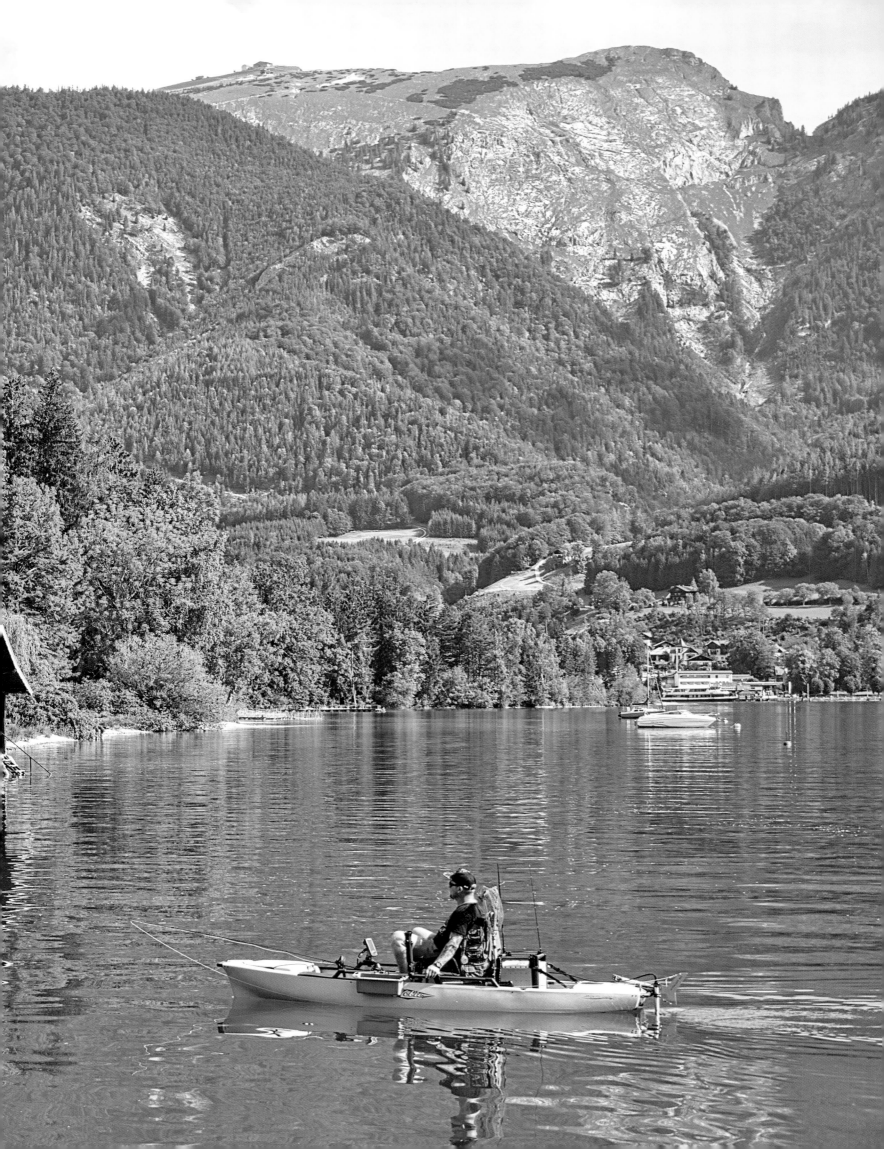

Methods

There are various methods for fishing, some differing greatly, others only in nuances. Concerning the presentation of the bait, there are roughly three main types:

Float Fishing

In float fishing, the bait is presented using a float that drifts on the water's surface; this also serves as a bite indicator. The depth at which the bait is offered can be freely adjusted. Float fishing is probably the most classic of all fishing methods—it is suitable for almost all fish species and can be practiced in both still and flowing waters.

→ Lucky is the person who has caught such a magnificent specimen.

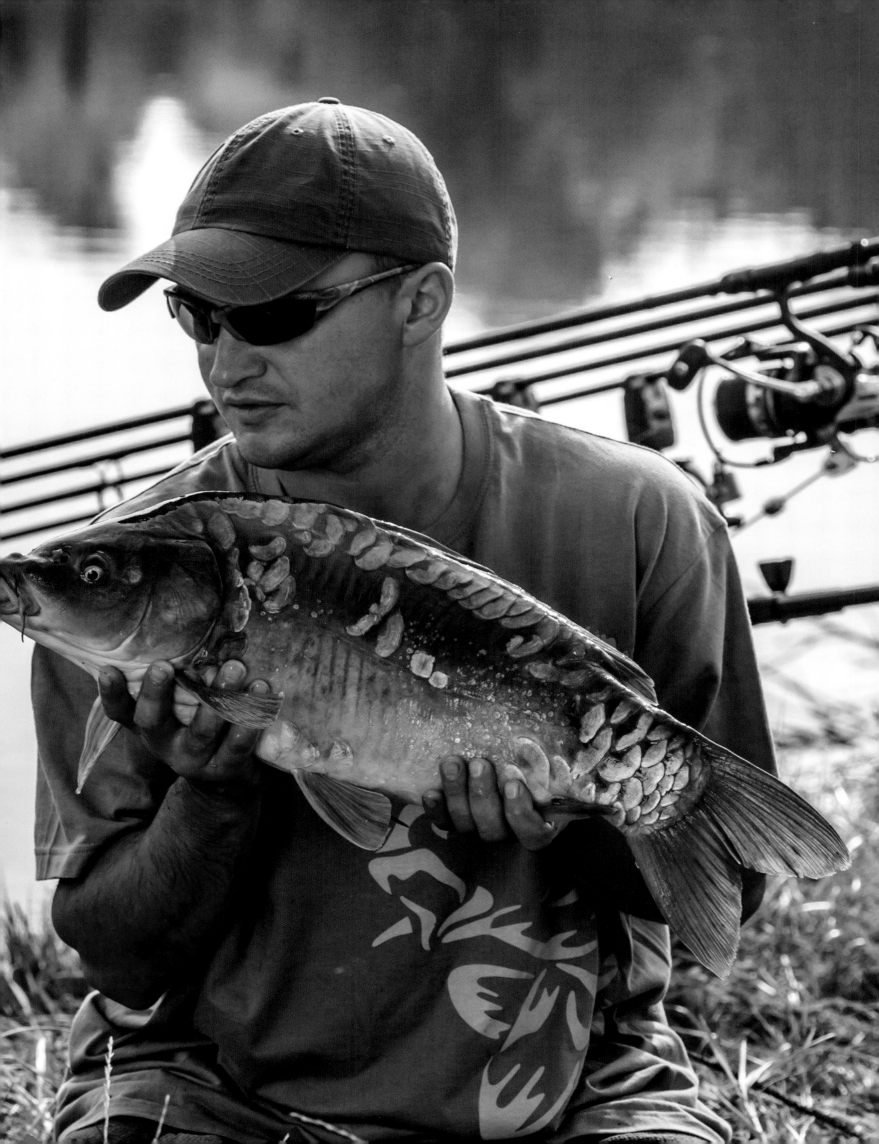

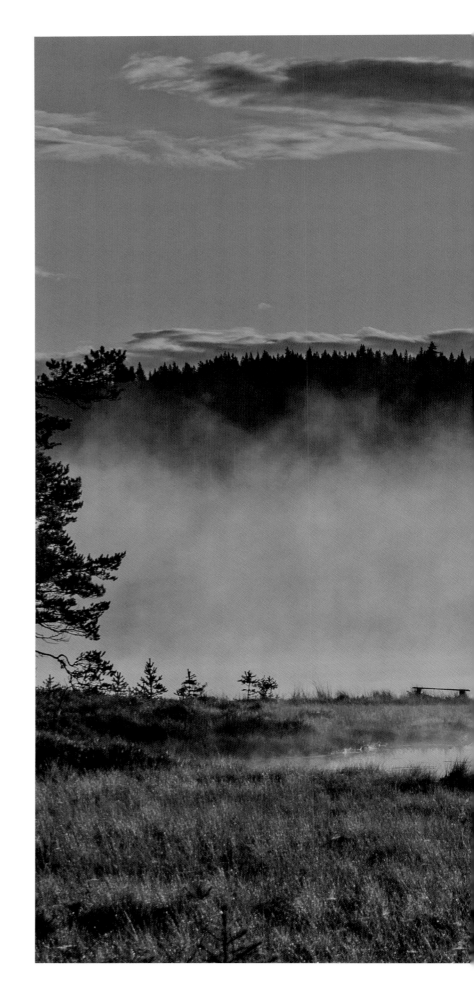

→ One angler in the morning mist. The morning and evening hours are often promising fishing times.

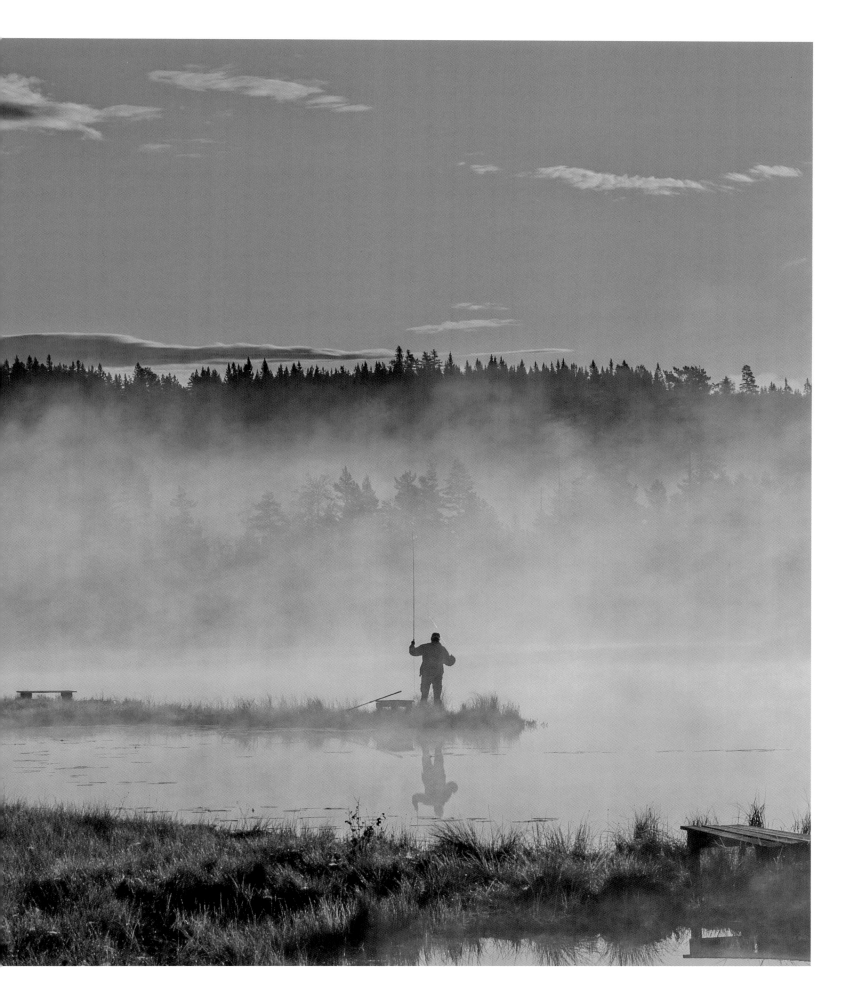

Ground Fishing

Strictly viewed, you can also offer a lure on a float rig at the bottom of the water. However, ground fishing here refers to fishing exclusively at or near the bottom using a lead. This method is particularly promising for catching fish that feed close to the bottom, such as carp. It also allows the bait to be presented unaffected by turbulence on the surface of the water. The bite is indicated by visual or electronic bite indicators that signal a pull on the line.

→ Just now everything seems to have fallen into complete silence. But at any moment the bite alarm can announce the hoped-for catch.

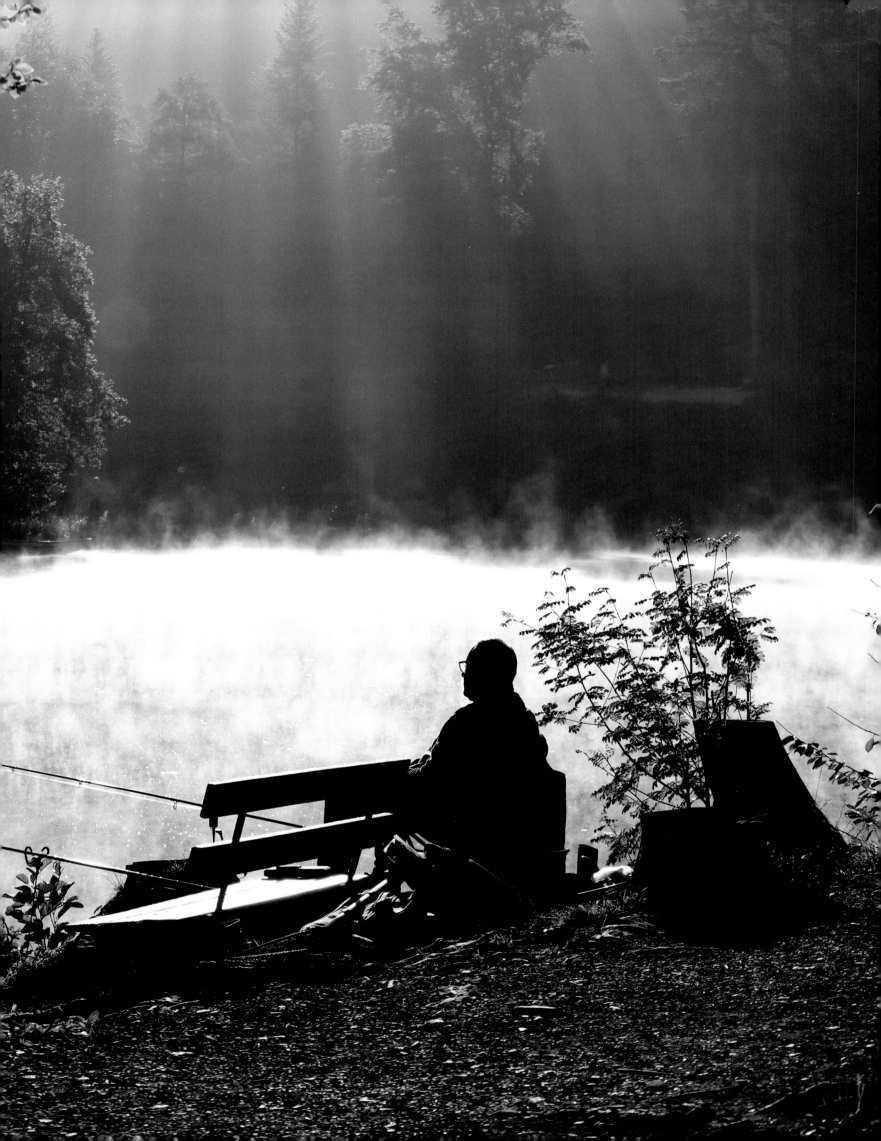

Stationary Fishing/Night Fishing

Typically, float fishing, and especially ground fishing, is conducted as stationary fishing, characterized by the proverbial »waiting for a bite«.

In stationary fishing, the angler usually selects a specific spot on the bank of a river or lake, chosen based on knowledge of fish behavior, the characteristics of the water, and other factors. This spot is often carefully scouted beforehand to find the best locations where fish are likely to pass by or stay.

This method can be applied to a variety of fish species and in different types of waters. It is a calm and relaxing way of fishing that requires patience

↓ Calm down: The anglers look at the cast rod from a careful distance.

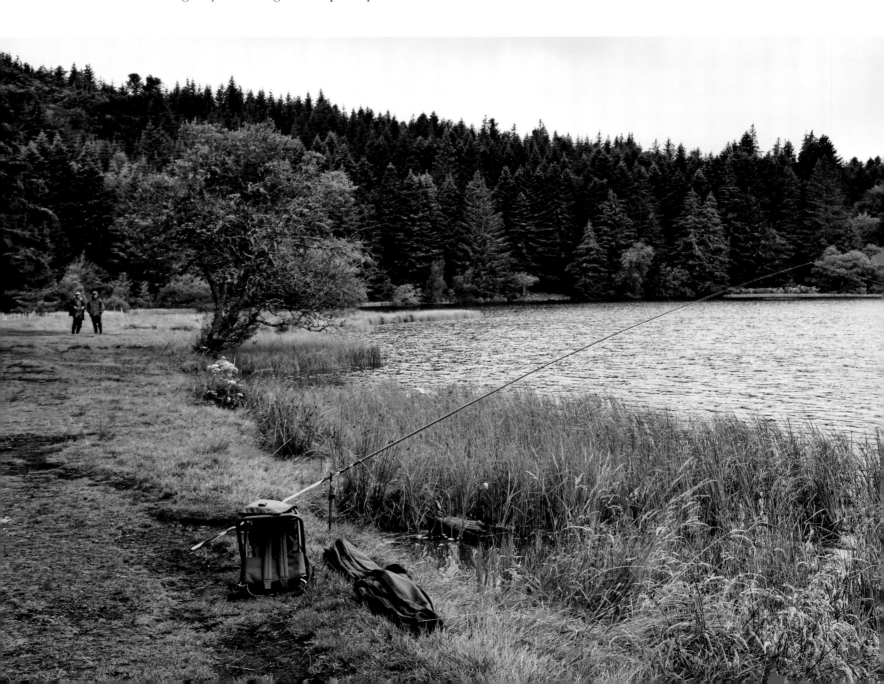

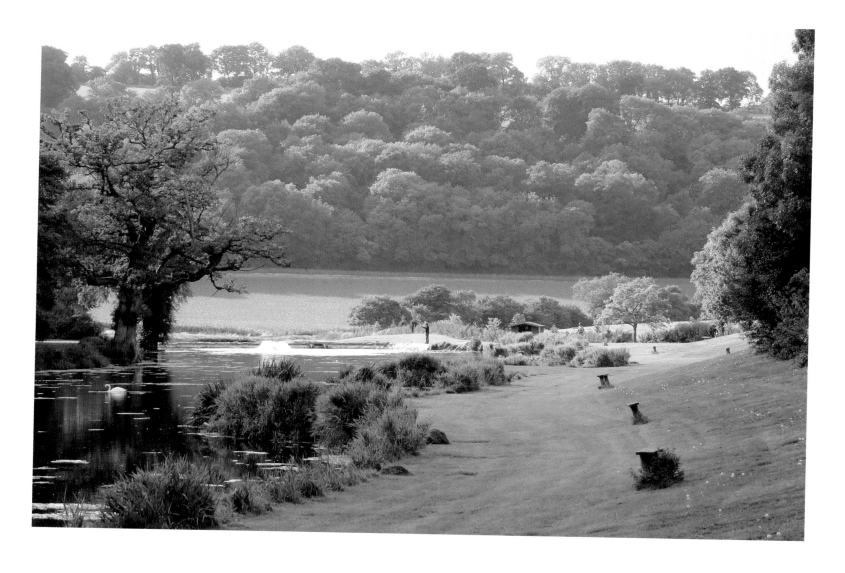

↑ The relatively static stationary fishing can not only be used on still waters, but also promises success on flowing waters.

and endurance but can often lead to rewarding catches. It's also a great way to enjoy nature and unwind from the hustle and bustle of everyday life.

Stationary fishing is often conducted at night and sometimes over several days. Various fish species are nocturnal, making night fishing a must for anglers. Depending on the targeted fish species, the time spans between bites can range from hours to even days—such as when fishing for large carp in heavily fished waters. Therefore, a certain amount of basic camping equipment is needed for longer sessions.

→→ At the water with bag and baggage. Only the illuminated tent of the anglers and the glow of their headlamps reveal the scenario.

→→→ Active instead of passive: A fly fisherman wades through the river bed to position himself within casting distance of the fish.

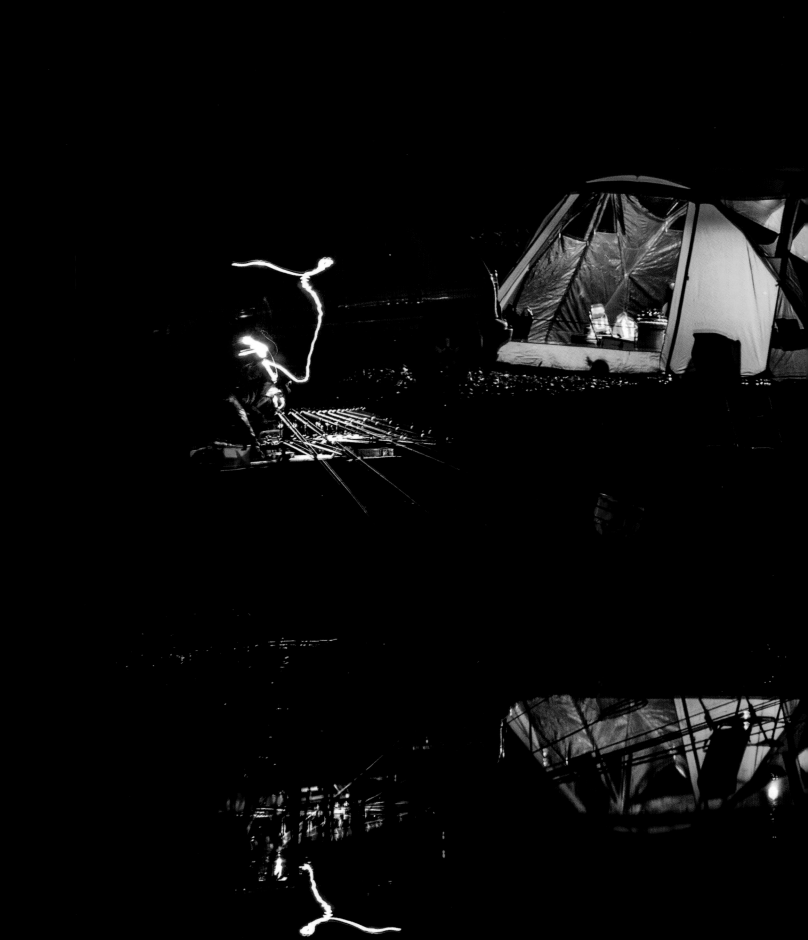

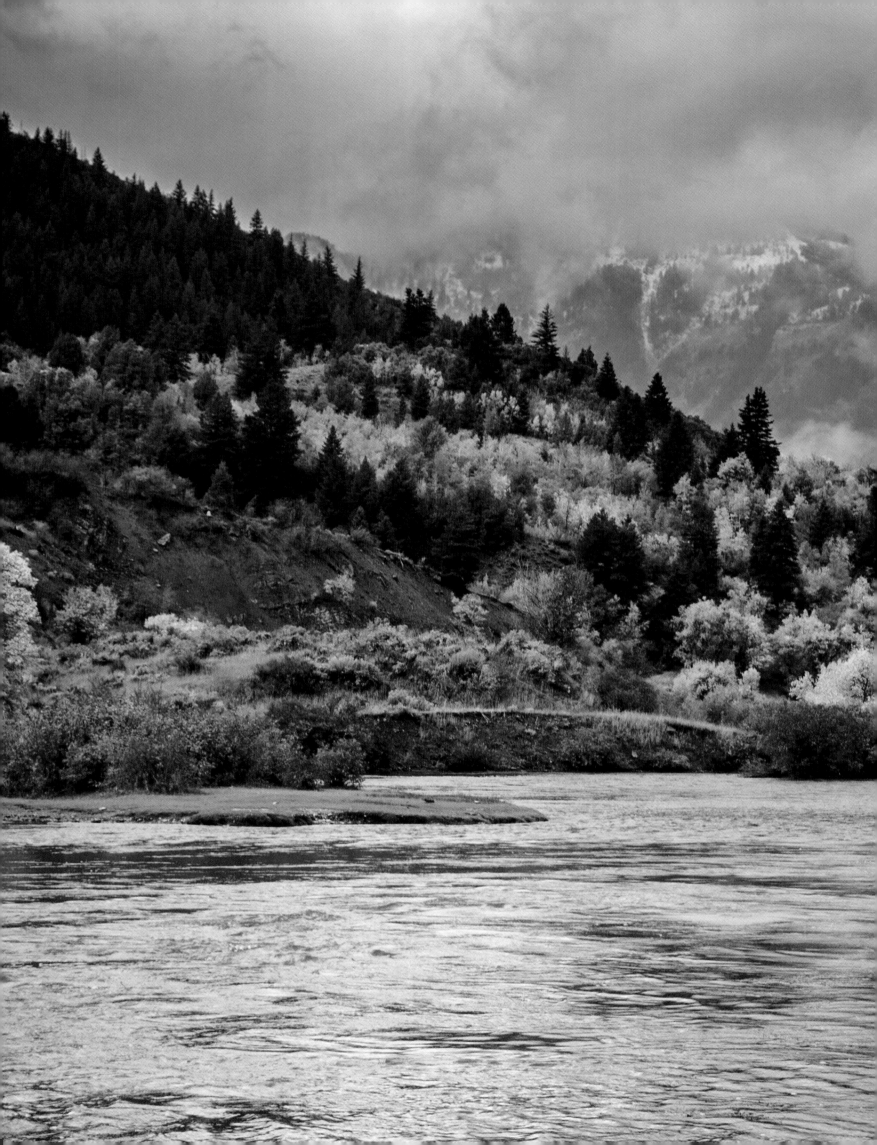

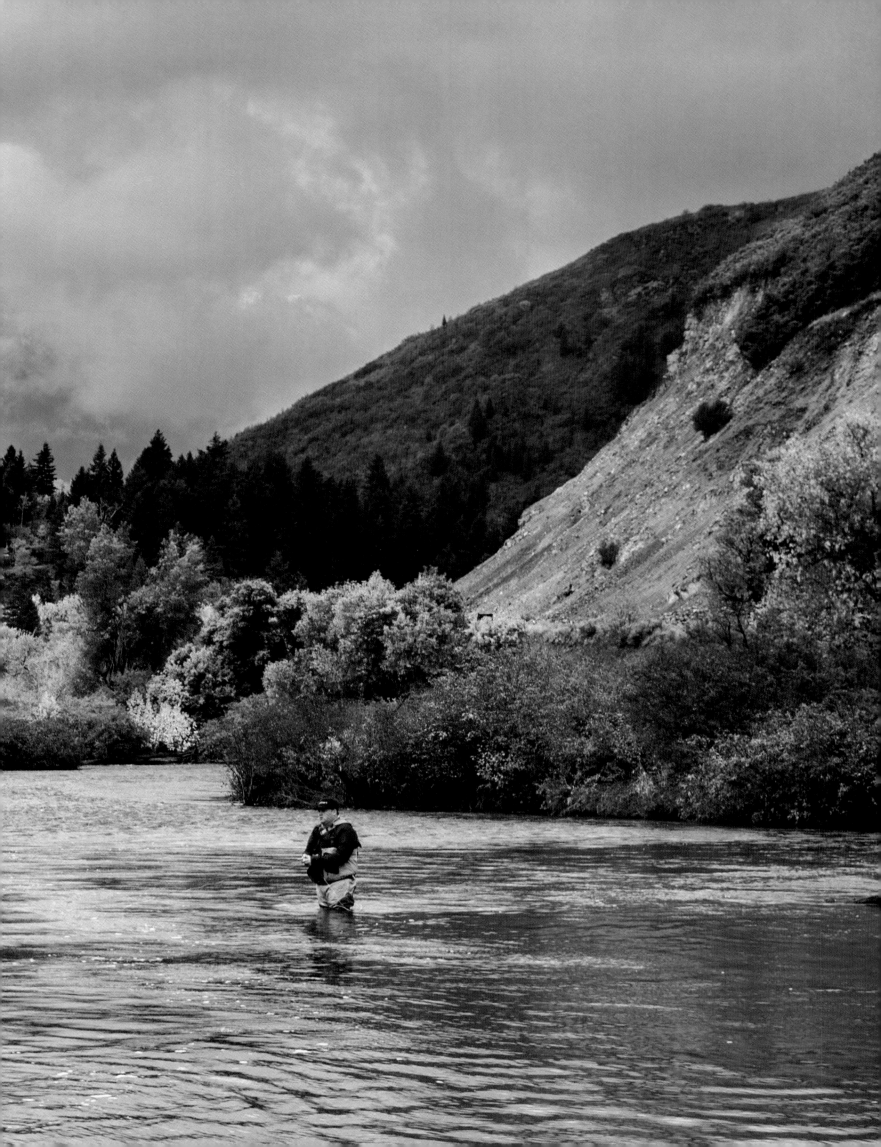

Active Fishing

Fishing with a lure and fly fishing are »active« fishing methods. Both techniques share the characteristic that neither a float nor a lead is used; instead, the bait is presented freely. In spin fishing, this means that the soft bait, crankbait, or spinner is actively pulled through the water, imitating a fleeing baitfish. In fly fishing, the fly is allowed to drift freely, while nymphs and especially streamers need to be guided more actively. Recognizing a bite requires a keen sense and a sharp eye. The smallest vibrations in the rod tip and movements on the line or water surface can indicate a biting fish.

↓ Here the angler was successful with a spinning rod. The catch can be gently landed in the water by hand and returned undamaged if necessary.

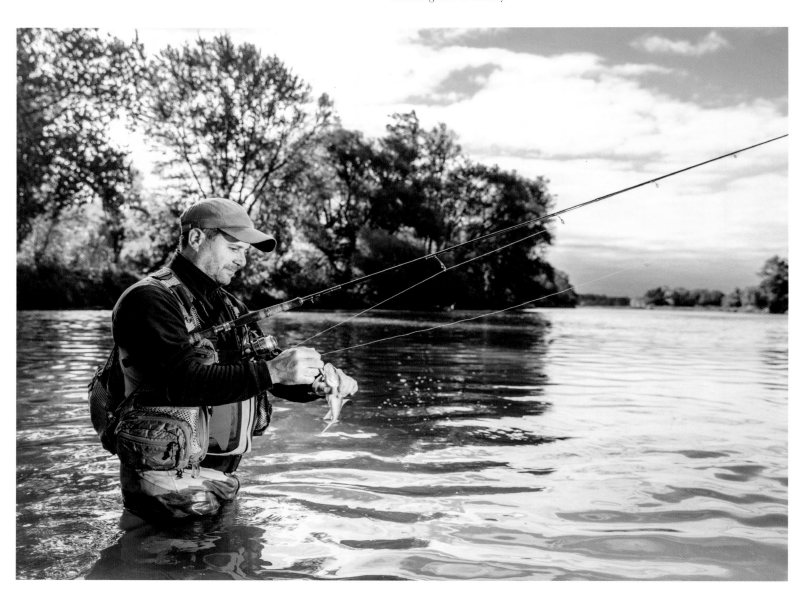

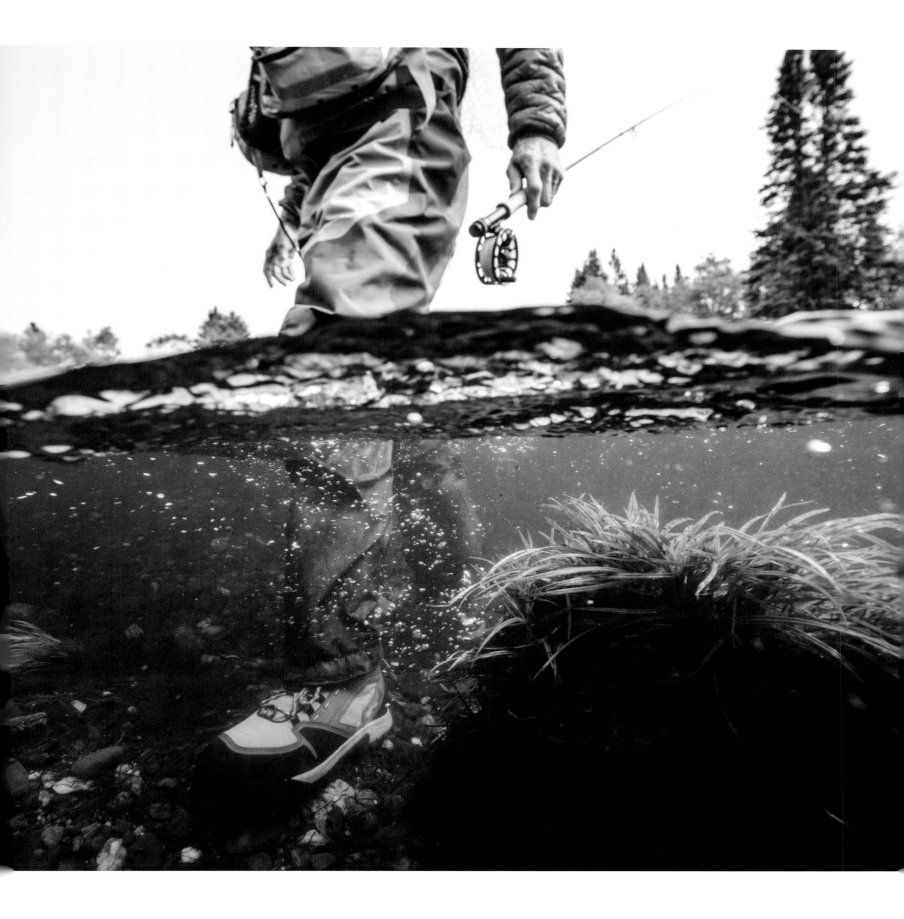

↑ Take care when wading through rivers and streams. Special felt-coated wading boots provide the angler with the necessary grip on slippery stones at the bottom of the water.

→→ In front of an impressive mountain panorama, this angler managed to catch an equally impressive brown trout. The special wading net is just enough to land the large salmonid safely.

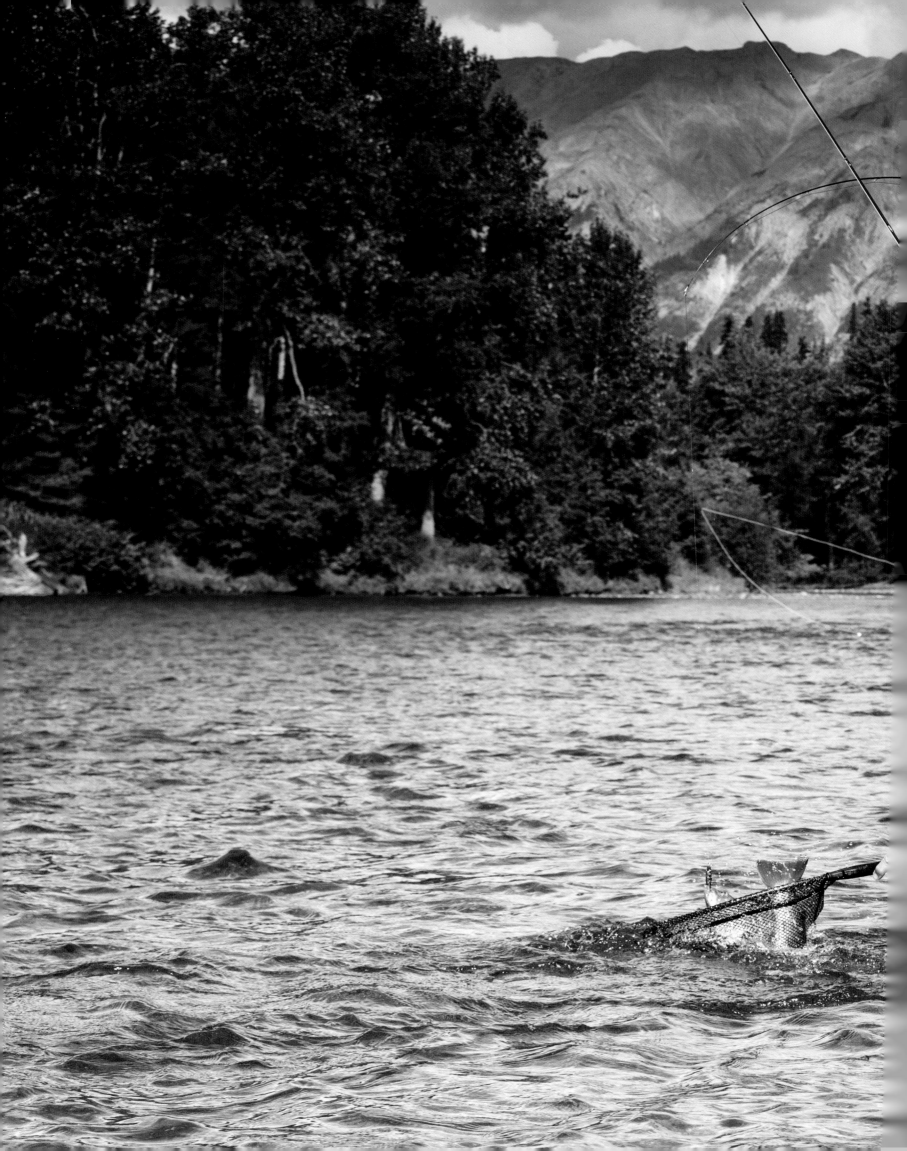

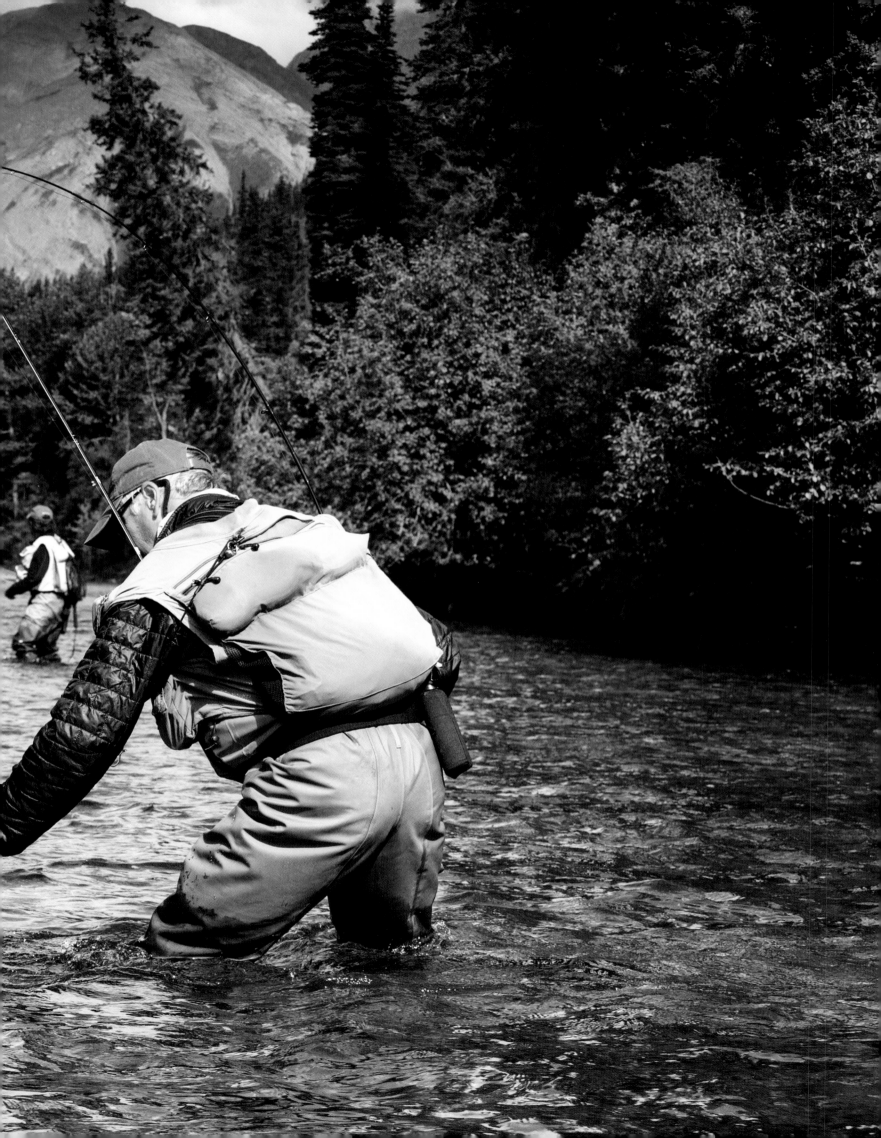

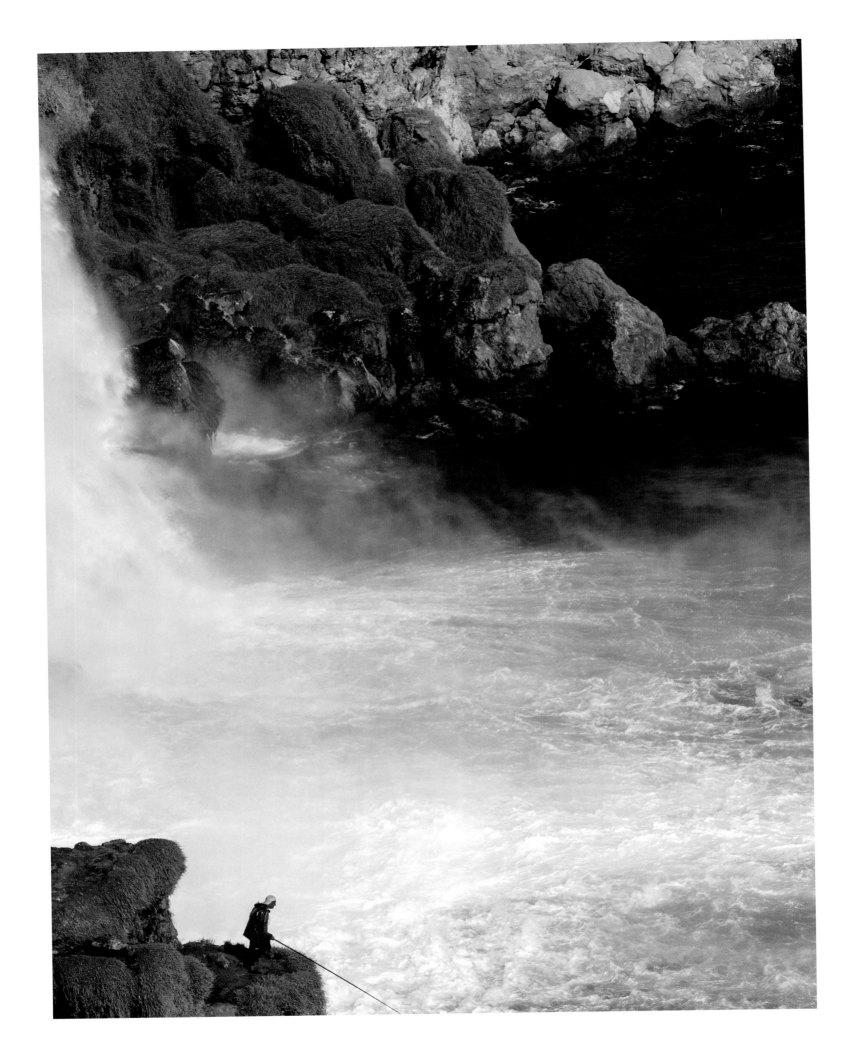

Target Fish

Many anglers dedicate their attention to a specific species or type of fish. Fishing for salmonids and predatory fish is particularly popular. Among the coarse fish, the carp can be considered as an extremely popular target fish.

Salmonids

Salmonids are fish from the salmonid family. The best-known species and most popular angling fish among salmonids include salmon, trout, char and grayling. Salmonids are primarily found in the colder waters of the Northern Hemisphere, particularly in North America, Europe and Asia. They inhabit rivers, streams, lakes and sometimes the sea, as some species migrate between both fresh and salt water.

Anglers appreciate salmonids for their powerful and enduring fights. They often live in picturesque waters like clear rivers, streams, and lakes with beautiful landscapes. Fishing for them thus also provides an opportunity to spend time in nature and enjoy the beauty of the surroundings. Last but not least, salmonids are considered delicious fish with tender meat and a distinctive flavor. Fishing for salmonids often has a long tradition in many

← As migratory fish, salmon can be found in both fresh and salt water. It is therefore worth fishing not only for their ascent in the rivers. There is also a good chance of success on the wild coasts of the Atlantic – like here in Ireland.

↓ The Rhine was once the largest salmon river in Europe. Around 100 years ago the water was still teeming with salmon. But industrial facilities increasingly prevented the salmon from spawning and the water quality also declined drastically. Thanks to intensive efforts to reintroduce the salmon, anglers can now enjoy very sporadic catches again.

→ What could be better for a fishing trip on one of the waters in the Salzkammergut in Austria than a traditional »Plätte«. In addition to char, the region is also home to coarse fish. The latter are often fished for with so-called »Hegenen« – a paternoster-system with three or five hooks.

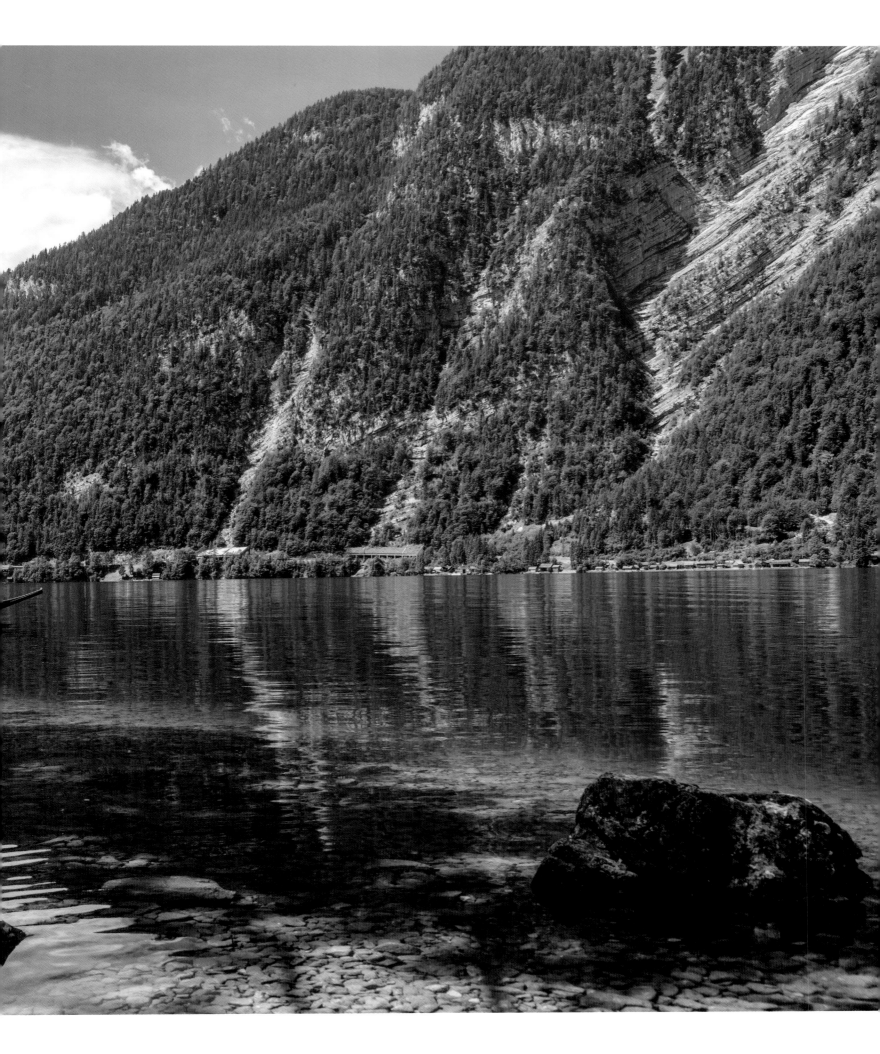

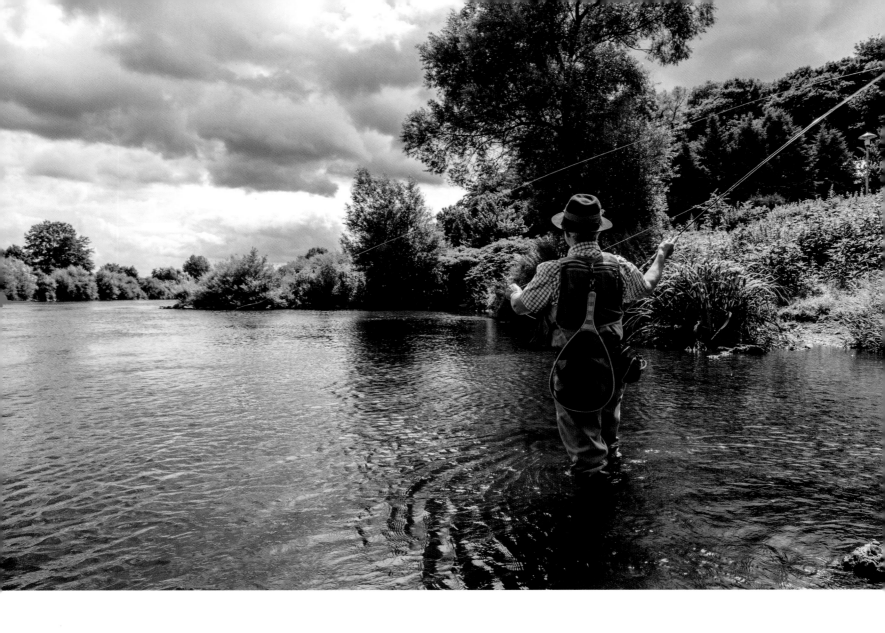

regions, especially in Europe and North America. There is a rich cultural history and practice around salmonid fishing, passed down from generation to generation.

Fishing mainly targets salmon, trout, and char. The preferred method for fishing these species depends on various factors, including location, season, and the angler's personal preferences. Common methods include fly fishing and spin fishing.

Fly fishing is particularly suitable for shallow and fast-flowing rivers and streams where spin fishing would be difficult. Additionally, there are many salmonid waters or sections where only fly fishing is allowed. This is often because fly fishing is considered a particularly gentle method and thus

provides the best foundation for the established, sometimes even mandatory, catch and release (no kill) practice. Spin fishing is well-suited for fishing salmonids in lakes, rivers, and coastal waters.

The so-called »trolling« is mainly used on larger lakes or in the sea, primarily for targeting salmon. In this method, a bait – usually an artificial one – is pulled behind a boat to attract the fish.

In Europe, »Sbirulino fishing« is also very popular for catching trout and char. This technique is based on using a special float named »Sbirulino« which allows the bait to be presented at various depths and adjusted as required. The Sbirulino float typically consists of a long, thin body made of plastic or balsa wood with a central bore. A fishing line is attached through this

← In this shallow water, the angler would have great difficulty successfully guiding a spinning lure. In addition, as in many sections of salmonid waters, only fishing with a fly rod is permitted here.

bore, connecting the Sbirulino float to the rod. The float is combined with a weight and a leader carrying the bait.

The Sbirulino fishing technique allows the angler to bring the bait to different depths by adjusting the length of the leader or changing the float's weight. This makes it possible to present the bait along the bottom of the water, where trout and char often dwell. Sbirulino fishing is mainly used in rivers, streams, lakes, and ponds with clear water where trout and char are found. This technique can be used both from the bank and from a boat, depending on the conditions of the water and the angler's preferences.

↓ Here the catcher releases an adult grayling. Thanks to the gentle fishing method and the special landing net, the fish remains unharmed and preserved in the gene pool.

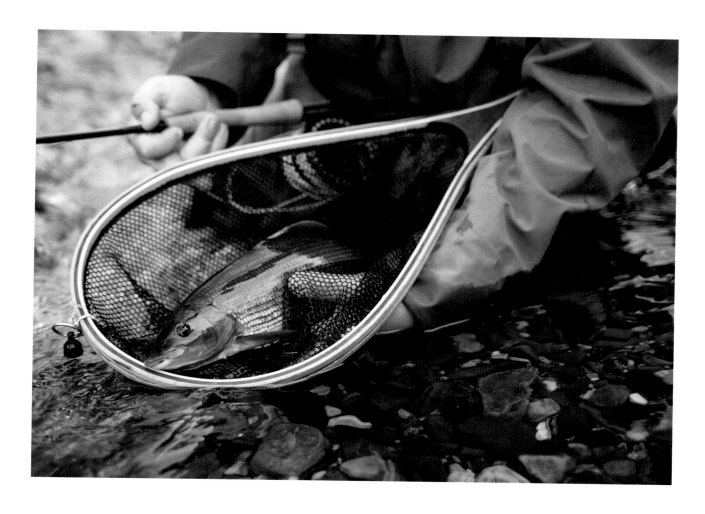

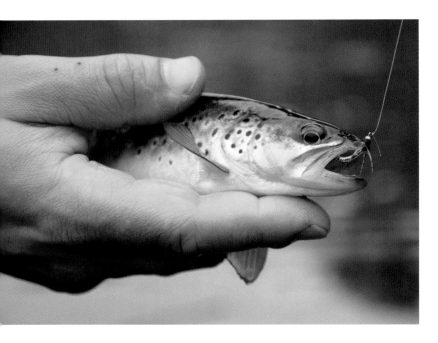

↑ This little brown trout has fallen for a nymph. Thanks to Catch and Release, it will hopefully grow into a handsome parent over the years and produce many offspring.

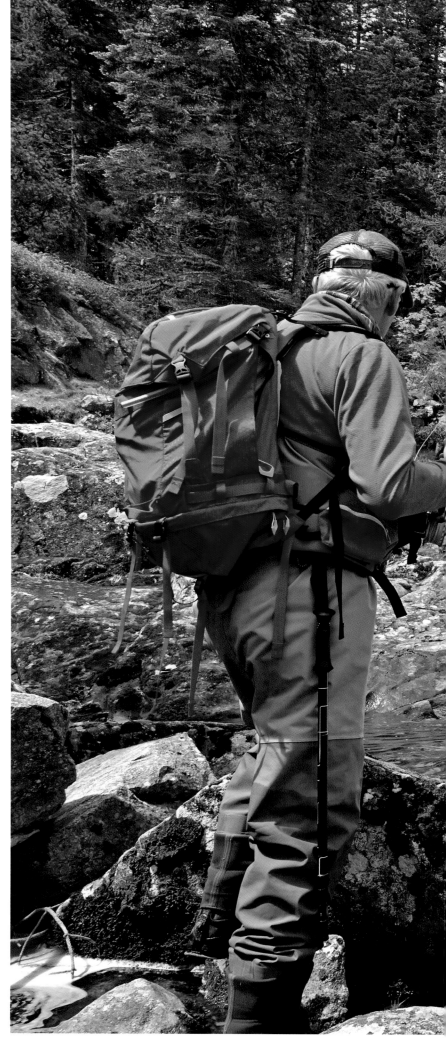

→ On the stalk with bag and baggage. Some fishing trips with a fly rod are like climbing a mountain.

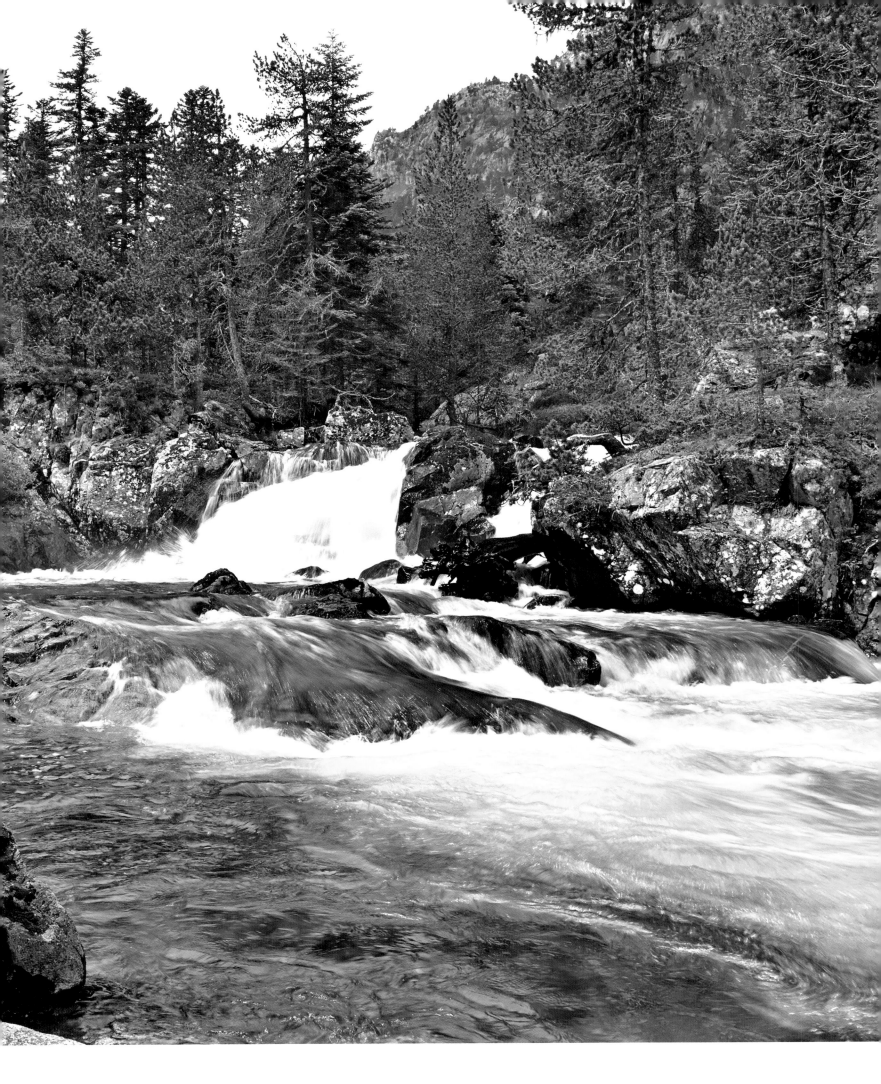

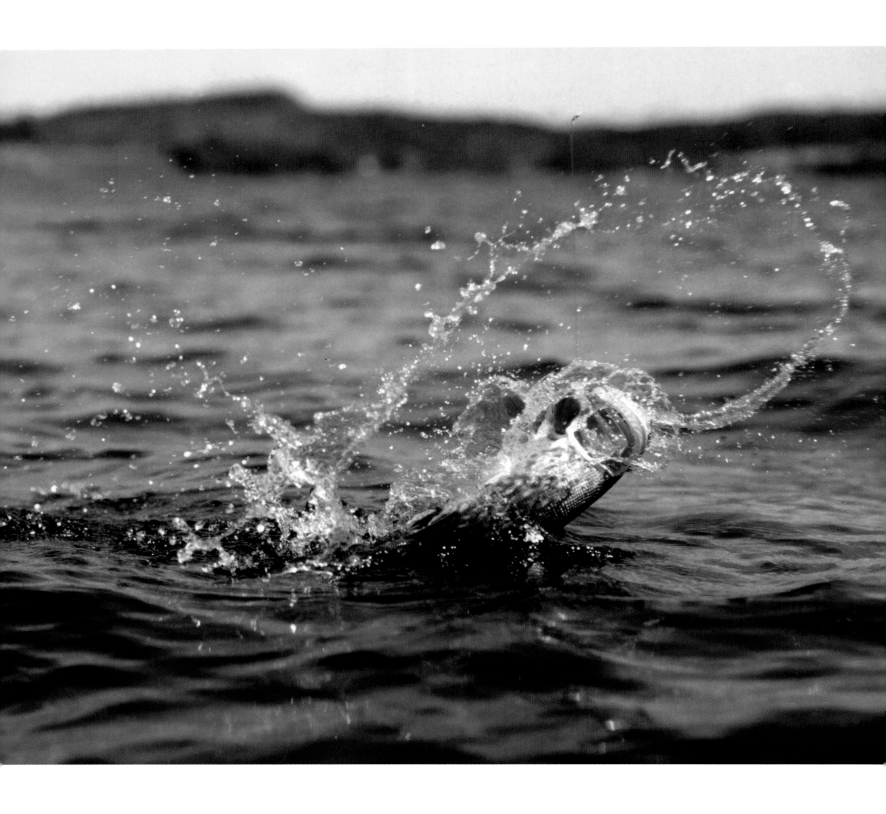

↑ Hooked pike often try to shake off the lure and hook
with acrobatic leaps and powerful headbutting. This is often
successful and the angler comes away empty-handed at the last
moment.

→ High-quality artificial lures such as these specimens
can make all the difference – provided they are presented
appropriately.

Predator Fishing

Predatory fish are generally defined as fish that primarily feed on other animals, including smaller fish, crustaceans, and insects. They often have a distinctive hunting technique and are known for their aggressiveness when attacking prey.

Predatory fish are renowned for their powerful fights and aggressive nature when hunting prey. Fishing for predatory fish thus offers an exciting experience, bringing tension and challenge. Anglers appreciate the skills of these fish and the thrill associated with catching a predator.

The most popular predatory fish among anglers include pike and perch and, in Europe, the giant catfish.

Various methods are used when fishing for predatory fish, depending on the type of predator, the water, and the angler's preferences. Common methods include fishing with lures (e.g., wobblers, spoons, or softbaits), live bait (such as baitfish [banned in some countries such as Germany] or worms), and special techniques like jerkbait fishing or drop-shot fishing. Fly fishing with large streamers can also be used for predatory fish.

Jerkbait fishing is a specialized technique that is very popular for pike fishing. This method uses special lures known as »jerkbaits«. Jerkbaits are artificial lures typically made of hard plastic or wood. They have a realistic shape and color of prey fish and are often equipped with reflective or glowing

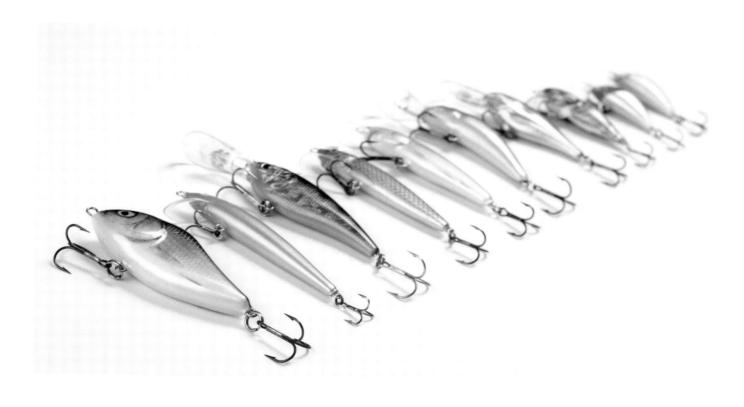

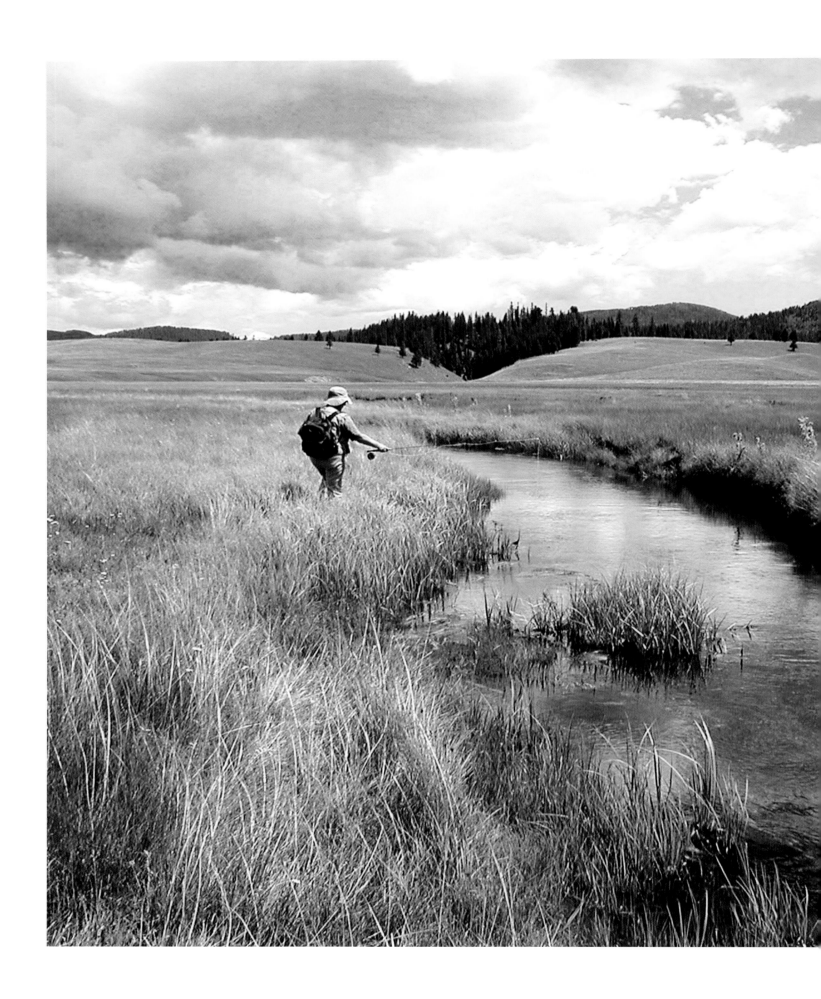

patterns to attract predatory fish. The technique of jerkbait fishing involves precisely casting the lure and then retrieving it with short, jerky movements of the fishing rod. The jerky movements of the jerkbait imitate the twitches and outbursts of a wounded or weak prey fish, attracting predatory fish searching for easy prey. Jerkbaits are often used in shallower waters where predators lie in wait, such as in shallow bays, over weed beds, or along shorelines.

Drop-shot fishing is a specialized technique originating in Japan that has spread worldwide. This technique is particularly popular for perch fishing from a boat. Drop-shot fishing uses a special rig consisting of a sinking weight at the end of the fishing line, followed by a short leader with a hook and a (artificial) bait. The bait is usually presented vertically above the weight, which rests on the bottom. The lure is guided with gentle movements to attract the fish's attention without lifting it off the bottom.

← It is also possible to fish for predatory fish such as pike with a fly rod. In this case, however, streamers are used. The usually strikingly colorful and large lures are reeled in with jerky movements along the surface of the water, enticing lurking predators to bite.

→ Small coarse fish like this rudd fit perfectly into the prey pattern of predatory fish. They are therefore ideal as bait fish.

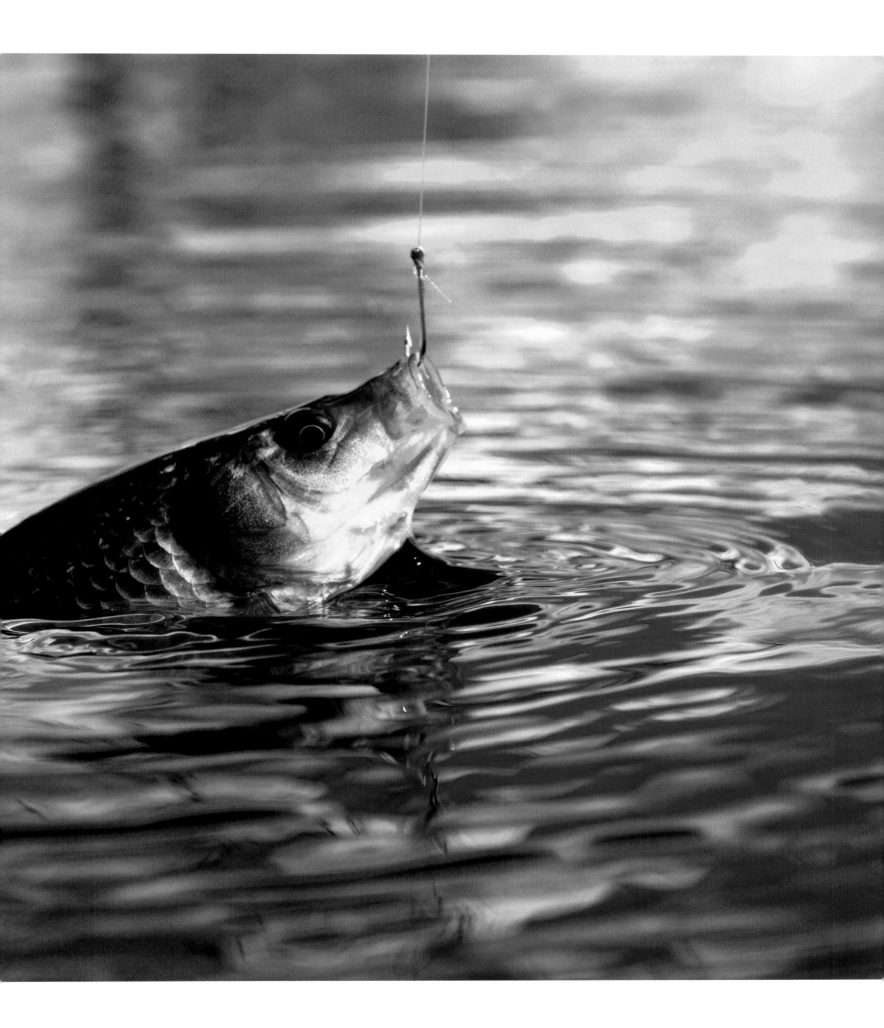

Coarse Fish

The definition »coarse fish« refers to various types of freshwater fish that generally have a non-predatory diet. The term »coarse fish« is used as a demarcation to predatory fish that primarily feed on other animals, such as small fish, crustaceans, and insects. Coarse fish often have a broader diet, mainly consisting of plant material, insect larvae, worms, and other invertebrates. They usually feed on organisms attached to the bottom or plants.

The habitats of coarse fish vary depending on the species, but they are often found in calm or slow-flowing waters such as lakes, ponds, canals, rivers, and streams. Coarse fish live in many waters worldwide and are often abundant. This makes them an easily accessible and frequently targeted species for anglers.

The most popular target fish among coarse fish include carp, tench, roach, and bream. Among coarse fish, the carp holds a special place for anglers.

Carp are clearly distinguished from other coarse fish due to their sheer size and enormous fighting power. Their behavior is often described by anglers as cunning, as they can be difficult to outsmart. This is mainly due to the so-called »dressage effect«. The dressage in carp fishing refers to the

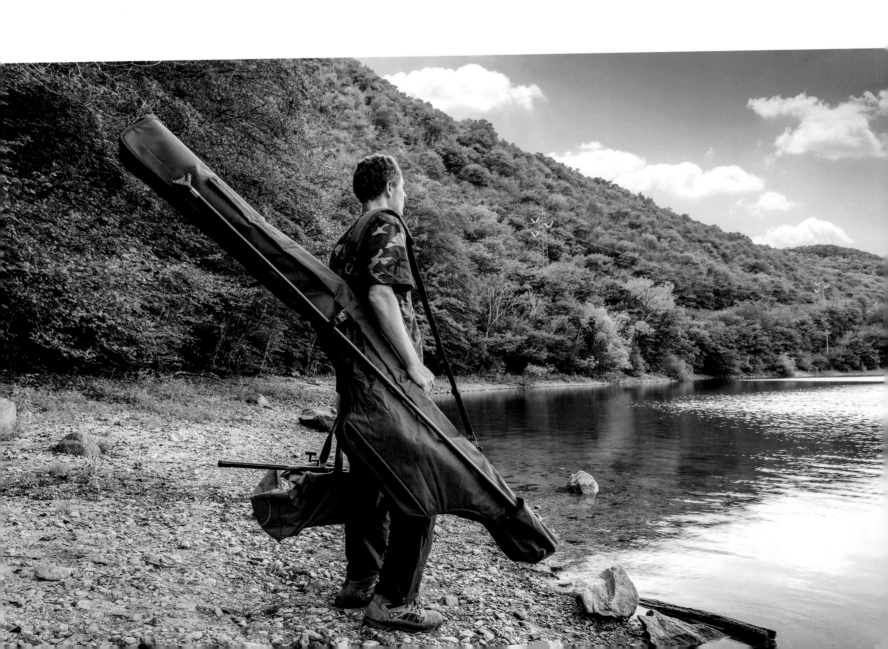

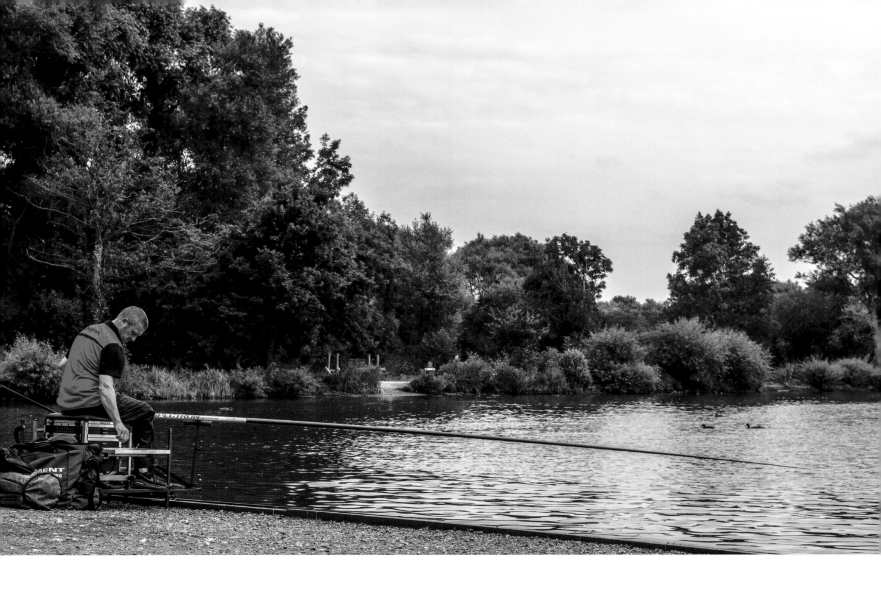

← Experienced carp anglers sometimes spend hours circling a body of water to find the right fishing spot. Carp often indicate their presence by jumping or rising air bubbles. The time invested in locating the fish in advance often pays off twice or three times.

↑ Fishing with a pole rod is particularly suitable for catching large quantities of coarse fish quickly and is therefore often used in competitions.

reaction of carp to repeated fishing activities and the associated pressure from anglers. When a lake is regularly fished, carp can become more cautious and shy over time as they learn to recognize and avoid potential dangers.

The dressage effect can cause various behavioral changes in carp. Carp may become more suspicious of baits and examine them more carefully before eating. They may also avoid certain areas of a lake that are frequently fished by anglers. Carp might retreat to less accessible or remote areas to escape fishing pressure. They could also become accustomed to specific baits or fishing methods and avoid them if they associate them with potential danger.

This challenge also makes carp a popular target fish for anglers. Anglers must be aware of these behavioral changes and adapt their fishing techniques to remain successful, especially in heavily fished waters. This could involve experimenting with new baits, presentations, and techniques, as well as locating less fished areas. In England and other European countries, the trend of target fishing goes so far that anglers spend weeks, months, or even years fishing for a specific—usually well-known—fish in a fishing water.

← Waiting for the hoped-for bite
can sometimes take days and nights
when carp fishing. Nevertheless, it is
important to stay alert and read the
water.

The History
of (Modern) Fishing

*»Angling may be said to be so like the mathematics
that it can never be fully learned.«* — Izaak Walton

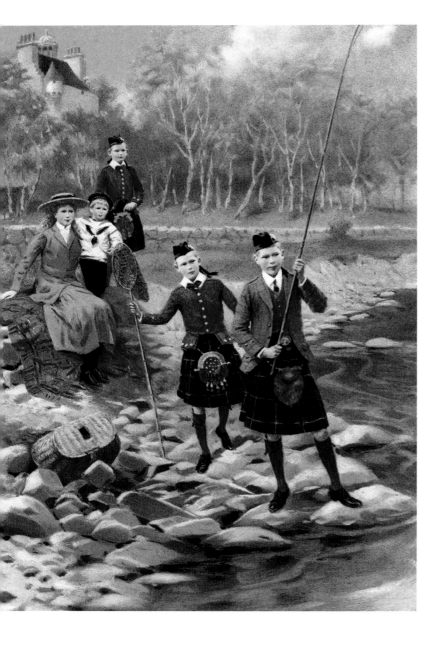

← Royal leisure activities: The children of George V
fishing in Scotland in 1911.

→ In the middle of the 19th century, fishing was a summer
pastime for high society.

England as the Birthplace

The origins of fishing date back thousands of
years. However, one of the most significant mile-
stones in modern fishing can be traced to the pub-
lication by Englishman Izaac Walton in the 15th
century. His book *The Compleat Angler* is still one of
the most frequently printed works in England and
triggered the first wave of enthusiasm for the sport
in the motherland of fishing.

In Izaac Walton's time the reel had not yet been
invented, which severely limited the range of bait
presentation and the ability to handle large fish.

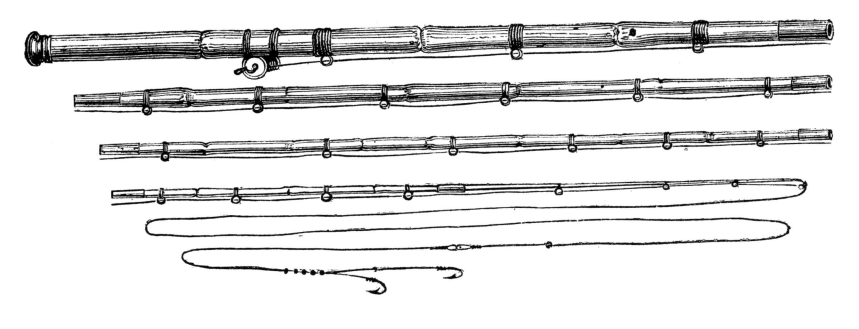

↑ Multi-part bamboo rod with brass connectors and the early version of a fishing reel.

→ At the beginning of the 20th century, casting, a type of target casting with a fishing rod, enjoyed great popularity. Even today, there are sports clubs that are dedicated exclusively to casting.

↓ For centuries, feathers, hair or yarn have been used to make fishing lures.

↑ The correct tying of the various fishing knots must be practiced so that the fishing hook does not come loose from the fishing line.

New Materials as a Game Changer

It took 200 years for this game changer found its way into the sport of fishing. The design of fishing reels at that time can best be compared with the multi-reels or baitcasters that are (still) common among spin fishermen today. With industrialization, new materials entered the fishing scene, revolutionizing the sport as we know it today. The advent of mass production made fishing gear affordable for the general population.

Modern monofilament and braided lines only emerged at the beginning to the middle of the 20th century. Bamboo, the dominant material for fishing rods for decades, was replaced first by fiberglass and then by carbon fiber in the middle of the 20th century. The most widely used reel today, the spinning reel, was invented in the beginning of the 20th century. Centerpin reels, used not only for fly fishing but also for traditional coarse fish fishing, particularly in rivers, appeared slightly earlier at the end of the 19th century.

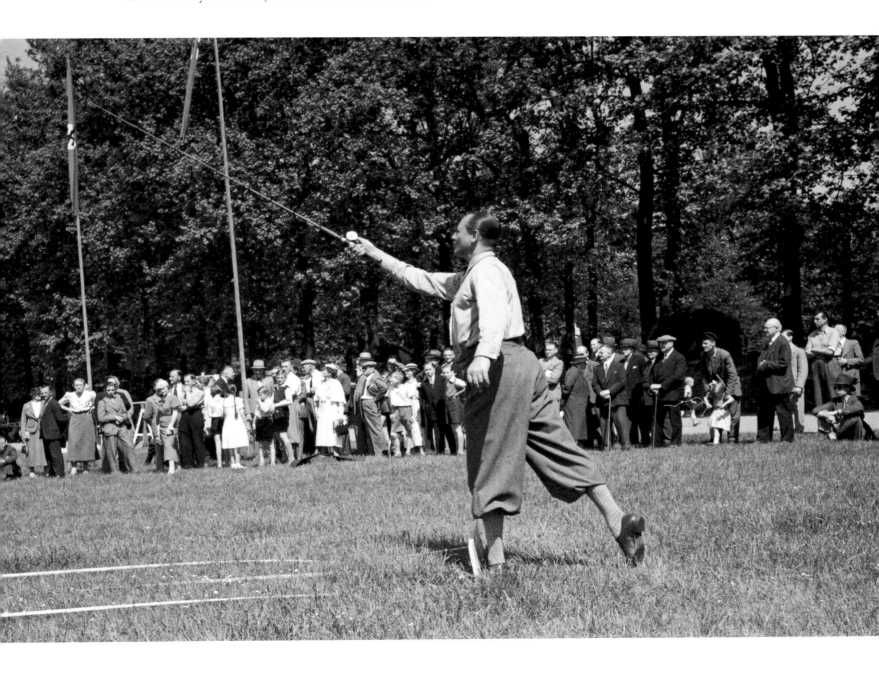

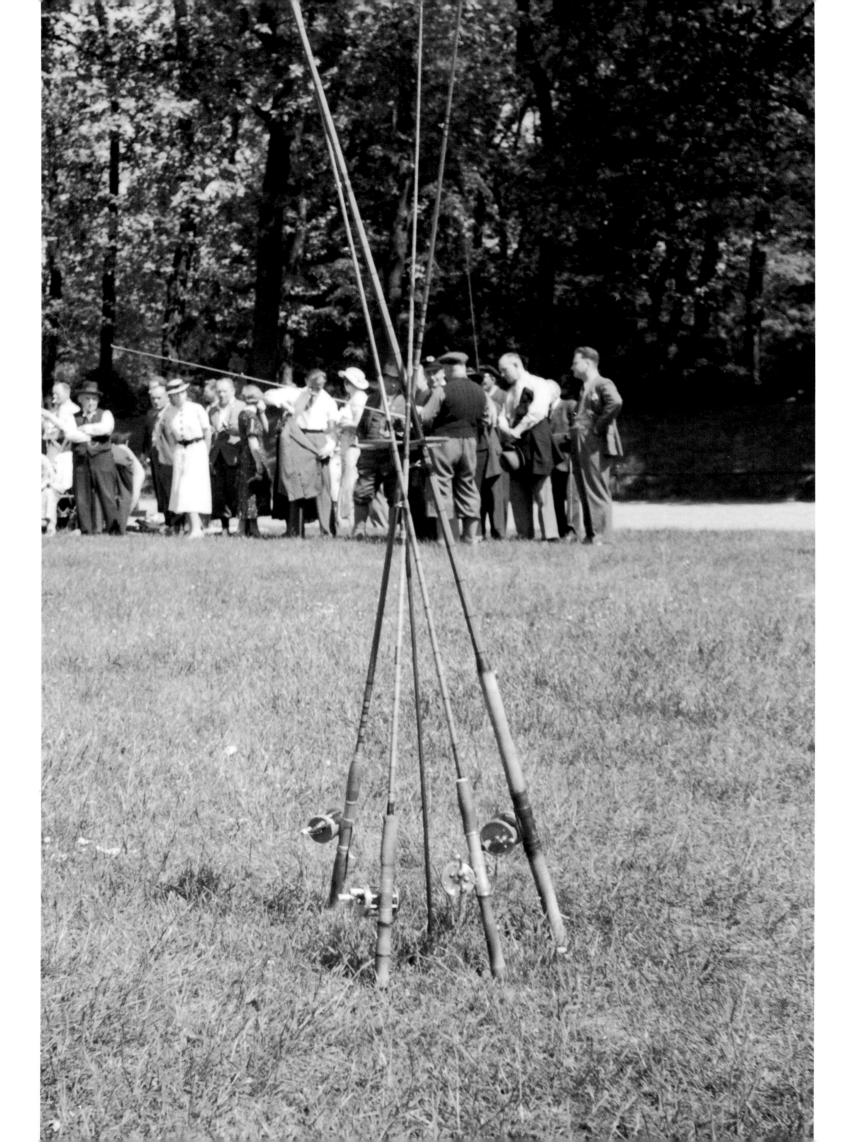

From Elite to Popular Sport

Historically, fishing was primarily a pastime for the affluent. Expensive equipment, limited leisure time, and the difficulty of accessing suitable fishing waters made it an exclusive activity.

Initially, the target fish species were as elite as the anglers themselves. In England, there has always been a distinction between »game fish« and »coarse fish«, although the perspective on these categories has evolved significantly. »Game fish« and »coarse fish« are terms used to describe different types of fish that are often fished for different purposes and often occur in different environments.

»Game fish« are species traditionally valued for their sporting qualities, including predators like salmon, trout, perch, and pike. »Coarse fish«, on the other hand, were traditionally valued more for their abundance and food value rather than their sporting appeal. These species, such as carp, bream, roach, rudd, tench, and crucian carp, are often found in still waters, canals, and rivers and usually swim in large schools.

As fishing transitioned from an elite pastime to a popular sport, the focus on target fish necessarily shifted. Anglers wanted and needed to pursue their hobby closer to home, leading to an increased interest in coarse fish. Today, nearly every fish species has its specialized fishing techniques. The outdated notion of categorizing fish as more or less valuable has been replaced by the concept of target fishing. Modern sport anglers often aim to catch a specific species, striving to land a particularly large specimen.

← The next round of the casting competition in 1930 may have brought the decision: the fishing rods for the participants were already ready.

→ In the 1930 fishing competition, the women who took part also thought they had a good chance of winning.

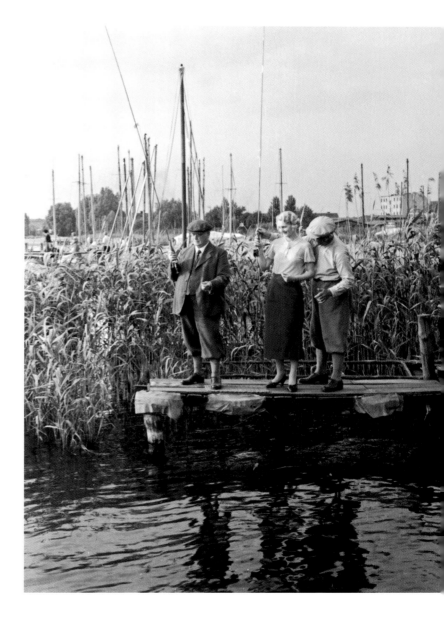

Equipment

Essentials

Less is more – this principle applies to fishing, in my opinion. Fishing is a sport that involves a lot of gear, no doubt, but too much, especially the wrong equipment can be more of a hindrance than a help. Often, it's the courage to focus on the essentials that brings the right focus. Quality is far more important than quantity because the harmony between individual components should never be neglected. Mobility and flexibility are crucial

in fishing, and these are also limited by the chosen equipment.

Describing a universal gear set is challenging because target fish and methods are too varied. However, I believe there is a basic set of equipment that can be adapted to most fishing methods. For longer sessions, some camping equipment is also necessary.

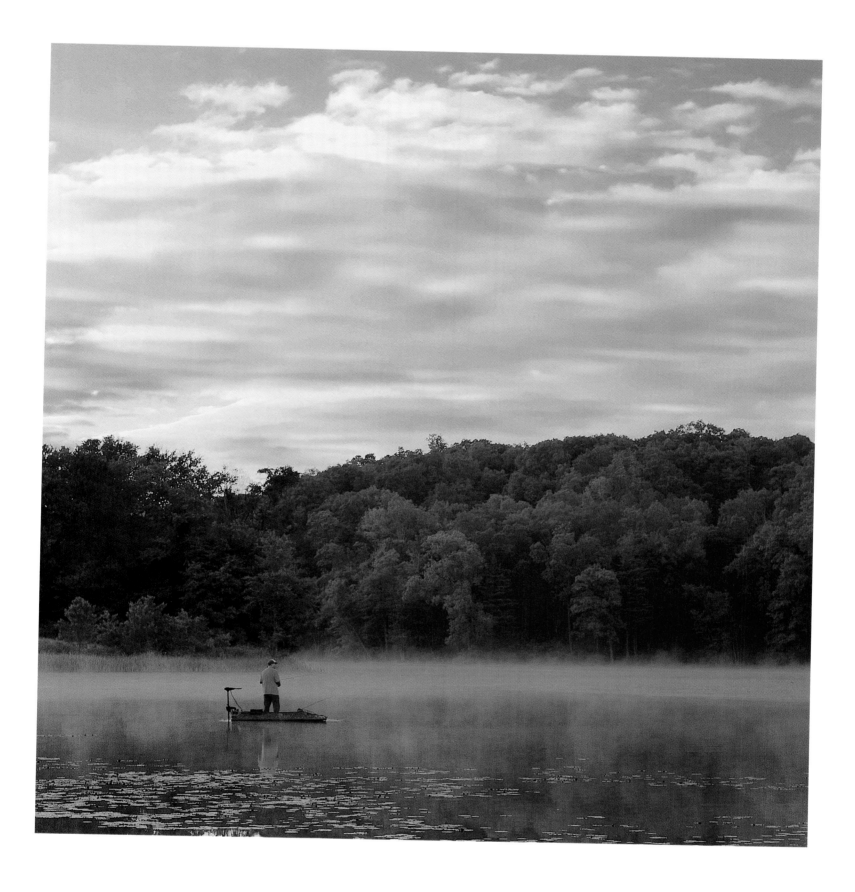

← A rod, landing net and bait are certainly part of every angler's basic equipment. But if combined incorrectly, even good fishing tackle can, in the worst-case scenario, completely thwart the chance of a bite – the devil is in the details.

↑ A boat with an electric motor and fishfinder is not necessarily one of the essentials for every angler. However, it can be a real game changer when fishing with artificial lures.

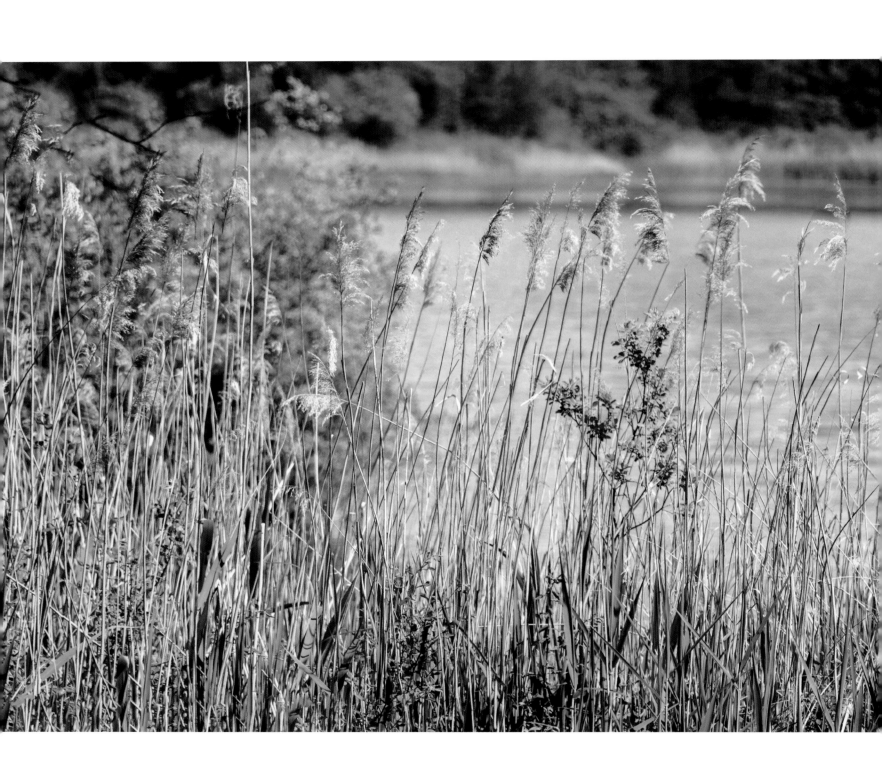

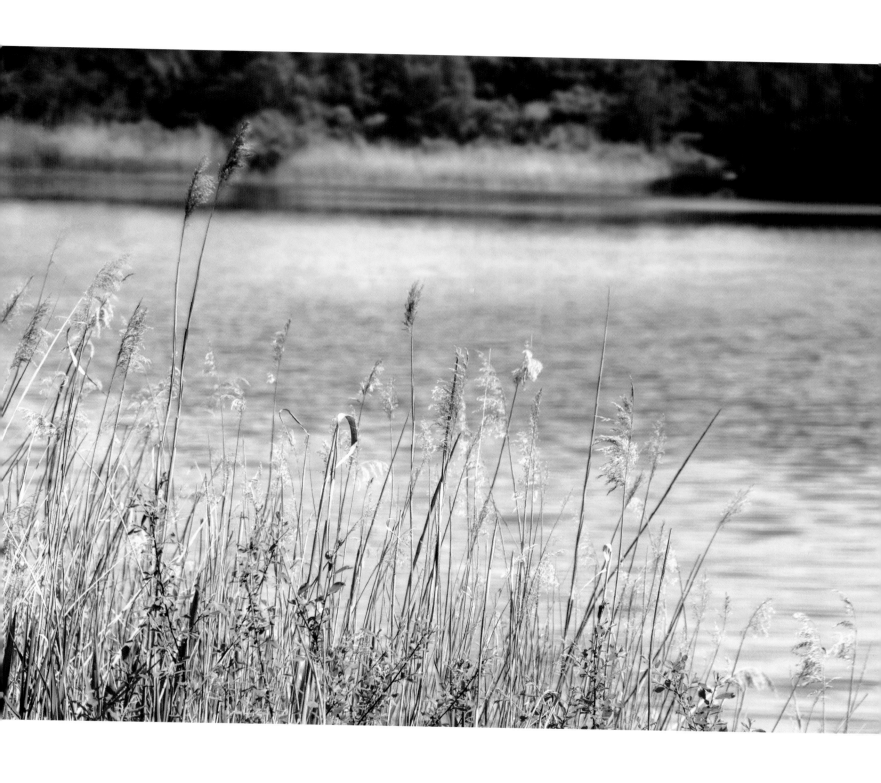

↑ Many fish species love reed beds; they provide shelter and food. Even shallow water depths should not deter anglers from trying to present their bait here.

Fishing Rods

The triumph of carbon fiber as a material for fishing rods began in the 1970s. For about three decades before that, fiberglass had replaced bamboo, which had been the predominant material for fishing rods for decades. The extremely light and simultaneously strong carbon fiber allows the fishing rod industry to produce rods with high sensitivity and stiffness. These properties are ideal for fishing rods. At least for active fishing methods like fly and spin fishing, the rod is constantly held in hand, making the weight relevant for good handling. The stiffness of the material is important to give the rods the necessary tension for casting and fighting fish.

Carbon fiber has revolutionized the fishing rod industry and is now a standard material for almost all fishing rods. While mass production has continuously positively affected the price-performance ratio of blanks, it unfortunately also means a progressive loss of quality in the craftsmanship of the rods for many enthusiasts.

The various constructions of fishing rods can be roughly divided into those with and without guides (and thus without reel seats) and into multi-piece and tele(scopic) rods. It's hard to establish a universally valid formula, but if one had to choose, one could say that tele(scopic) rods are particularly common in the low-budget segment, while two- or three-piece rods are usually more expensive.

Most fishing rods have guides and a reel seat, making them suitable for casting the bait and fighting the fish through the outgoing and retrieved line.

In addition to the basic constructions of fishing rods, there are further details. These are primarily due to the different fishing methods and target fish as well as their special requirements.

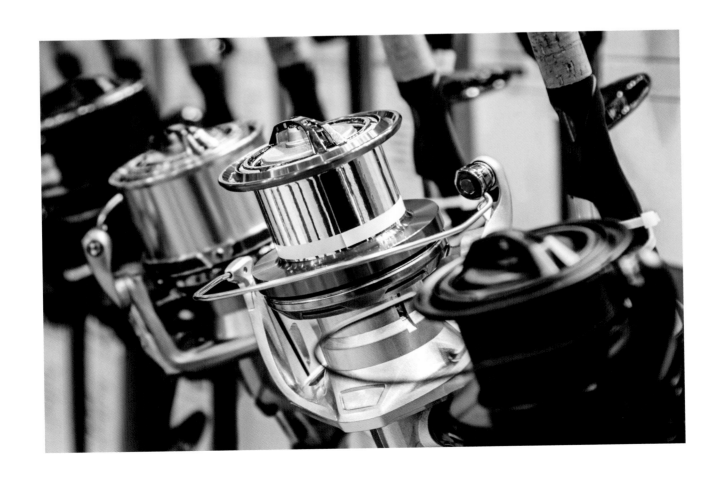

↙ Brothers in arms: Fishing rod and reel should be closely matched.

→ Many entry-level and low-priced models are tele(scopic) rods. However, there are also high-quality models among the extendable rods.

↓ Classical multi-piece rods usually consist of two or three parts. Due to their design, they are said to have a more even action of the rod blank and a higher breaking strength.

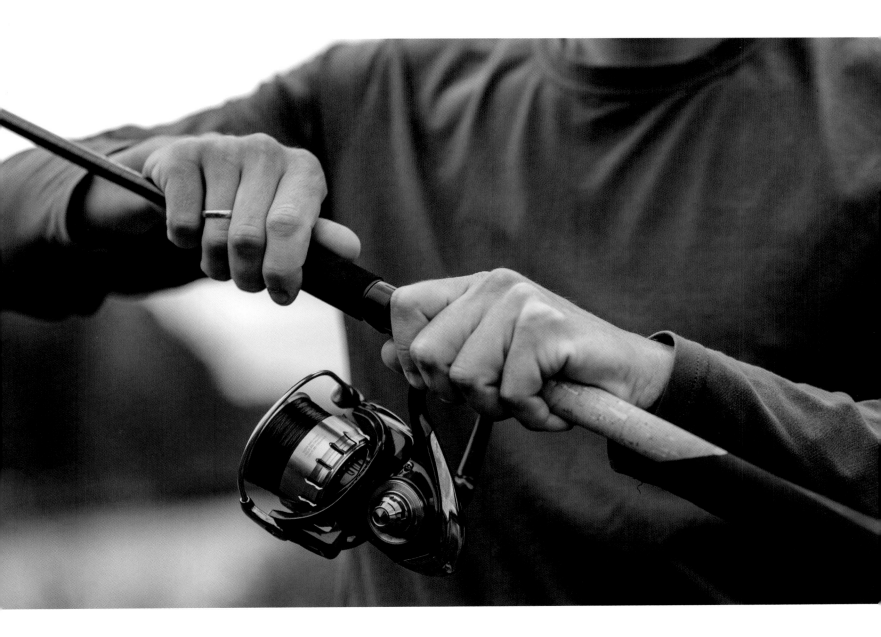

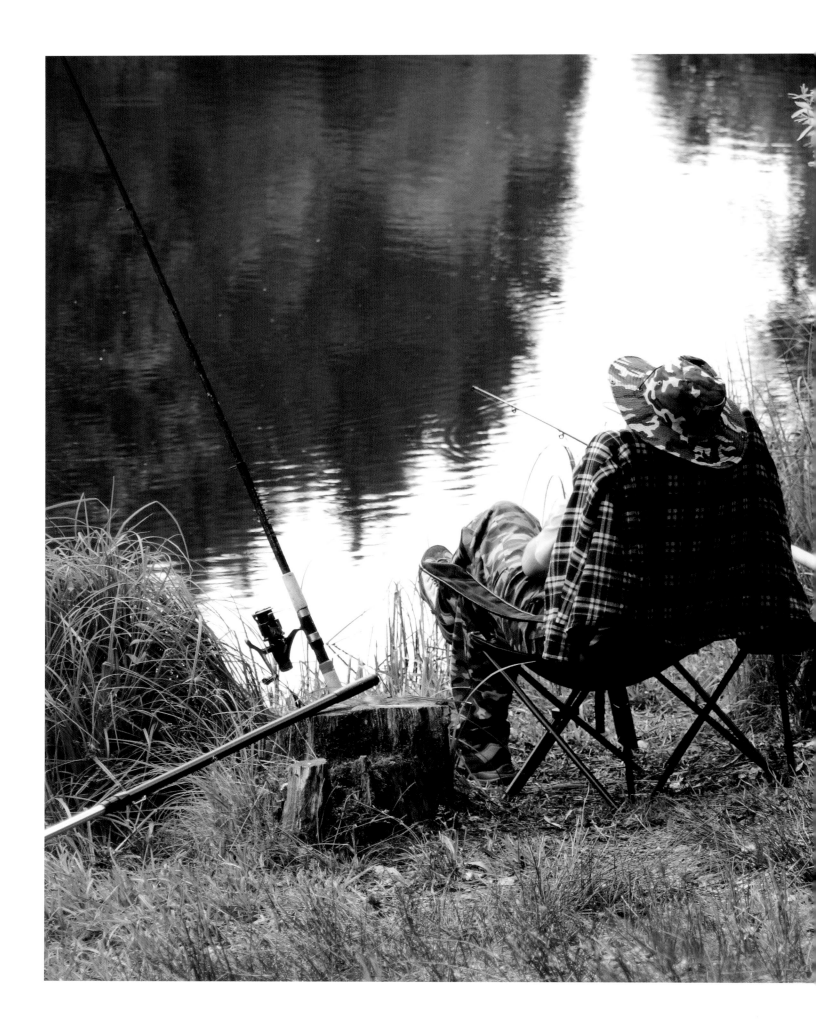

Pole Rods

Rods without guides and reel seats are particularly common when fishing for coarse fish. They are called »pole rods« and can reach lengths of over 33 feet (10 meters). When pole fishing, the float and rig are presented directly under the rod tip, making an actual cast unnecessary. The fight with the fish involves disassembling the rod. For larger fish, elastic bands inserted into the blank are sometimes used to give the fleeing fish some play during the fight, preventing the line from breaking.

Match Rods

The term »match rod« is derived from its original design as a competition rod. It is intended for catching smaller to medium-sized coarse fish.

A match rod is typically long and slim to cast light float rigs over long distances and simultaneously allow precise presentation of the bait. Match rods are usually between 11 and 18 feet (3.5 and 5.5 meters) long. They often have fine tips to detect subtle bites and enable the angler to set the hook. They are also equipped with numerous small and closely spaced guides to facilitate the use of light fishing lines and maximize casting distance.

← »One fits all?«: Anglers with all-round rods in a telescopic version. These models are particularly popular with anglers on a smaller budget and because of their small pack size.

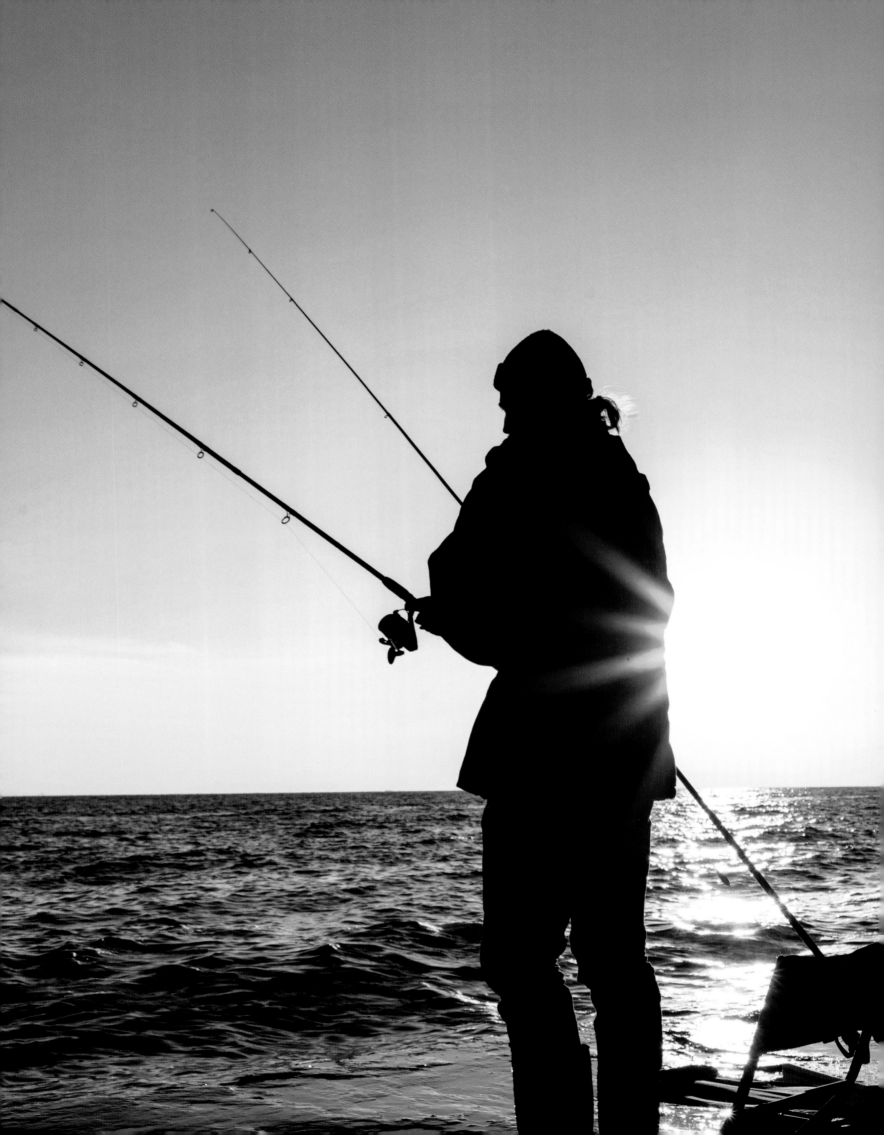

→ Before casting, you should carefully check that the carp rod is properly mounted. Distance casts far beyond the 110-yards mark generate enormous forces.

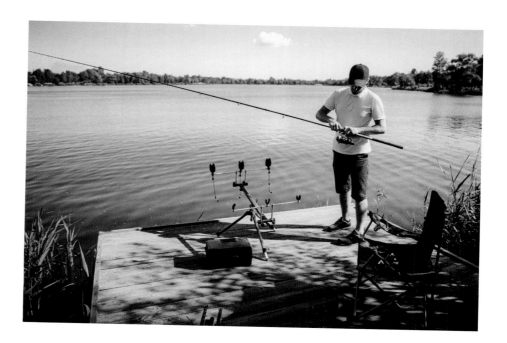

Quiver Tip/Feeder Rods

The quiver tip rod is mainly used for ground fishing for coarse fish. The name is derived from the method of bite detection (quivering, picking, jerking). The rod has very sensitive interchangeable tips. Even the finest bites are transmitted through the line to the rod tip, which then quivers or jerks. A quiver tip rod is generally short and light, often between 7 and 11 feet (2.1 and 3.3 meters) long. It is suitable for smaller waters and coarse fish.

The feeder rod could be described as the big brother of the quiver tip rod. Feeder rods are generally longer and stronger than quiver tip rods, typically between 12 and 15 feet (3.6 and 4.5 meters) long. They can cast even larger feeders to the fishing spot. The term »feeder« is derived from the feeders used with these rods, which originally consisted of feathers. Feeder rods can also cast heavy rigs long distances and are suitable for larger coarse fish and waters.

Carp Rods

Carp rods, like other representatives of so-called »specimen rods«, are designed for catching a specific large fish species. Carp fishing requires distinctive characteristics in a rod to meet the particular challenges of this fishing style. The dimensions of carp rods are still given in feet and pounds due to their origin in England.

They are typically between 12 and 13 feet long and have test curves of 2.5 to 3.5 lbs (sometimes even more). The length and casting weight allow anglers to cast the rod further and reach greater distances. Carp rods often have a semi-parabolic action, meaning they bend into the backbone of the rod when pressure is applied. This allows anglers to safely hook and land even strong carp without overloading the line or losing the fish.

The test curve of a carp rod refers to the weight required to bend the rod at a certain angle. Carp rods often have a high test curve, meaning they are stiff and have high casting power. This allows anglers to use heavy baits and rigs and cast them precisely to the desired location.

← On large fishing waters, anglers have to offer their rigs at sometimes great distances in order to reach promising fishing grounds. Even heavy feeders can be catapulted far out with the feeder rod.

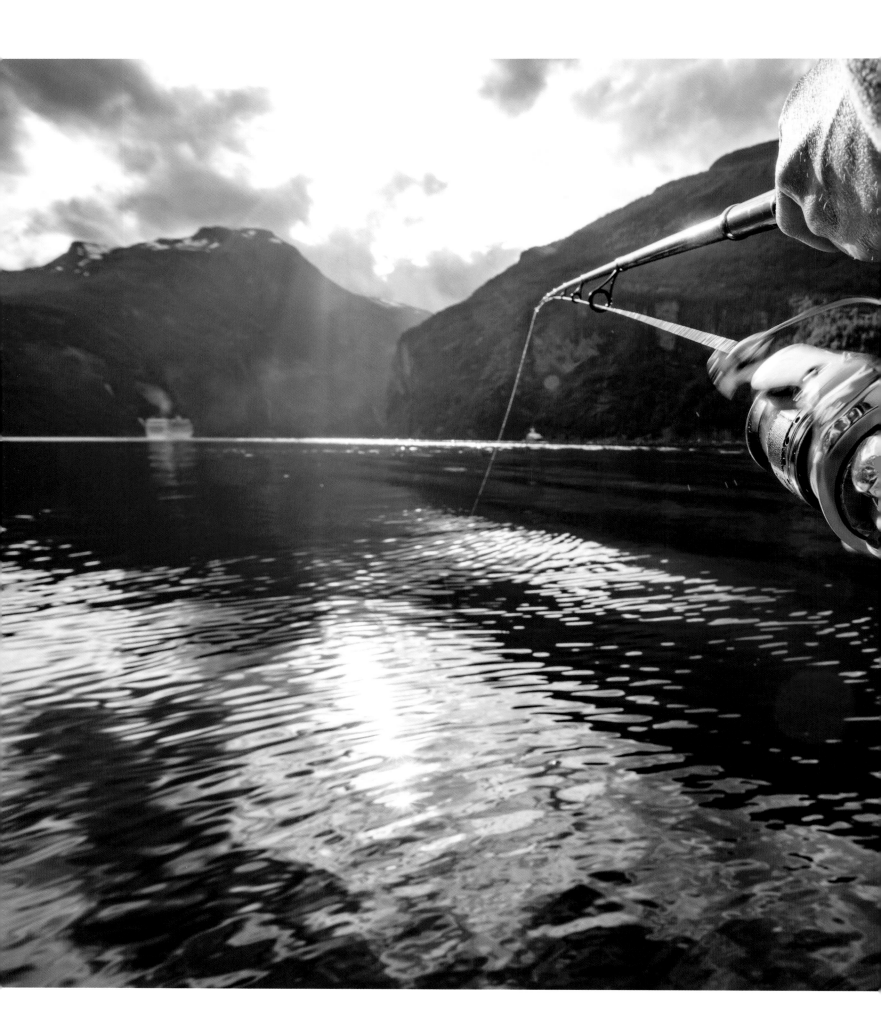

Spinning Rods

There are various types of spinning rods, which differ from each other to varying degrees. The differences are mainly due to the target fish and their size, the type and presentation of the bait, and whether fishing is done vertically from a boat or from the bank. Depending on the reel used, it is decided whether the rod guides are placed below or above the blank. Due to better bait control, multipliers or baitcasters are often used in spinning fishing. In this case, the rod is fished with the guides facing upwards. The rod grips and reel seats are often designed for this type of reel.

All types of spinning rods use artificial baits such as hard-, soft-, and spinnerbaits to catch predatory fish like pike, perch, and trout.

The rod action is of particular relevance in spinning rods. There is no standard value. For example, rods for drop-shot fishing require very fine tip actions, while rods for jerking are usually very stiff.

← When spinning, the lure is usually guided with the rod tip lowered. The bite is usually indicated to the angler by a more or less intense deflection of the rod tip.

Fly Rods

Since fly fishing requires a casting technique that is distinctly different from other fishing methods, the construction of fly rods is also unique.

The length of fly rods is usually given in feet, following English tradition.

Regarding the casting weight or action, there is a particularity. Here, it's not the bending behavior of the blank (as with carp rods) or the ideal casting weight in ounces or grams that is indicated, but the so-called »AFTM number«.

The AFTM number stands for the »American Fishing Tackle Manufacturers Association« and is used to specify the casting weight of a fly rod and the corresponding fly line. This numbering scale was developed to help anglers select the appropriate fly line for their fly rod and achieve optimal casting performance. The AFTM number is typically indicated on both the fly rod and the fly line. It is a number between 1 and 15, with lower numbers representing lighter equipment and higher numbers representing heavier equipment. The number indicates how heavy the fly line is when cast over a certain length.

Overview of the corresponding AFTM numbers for different fly rod classes:

- AFTM 1–3: Light rods for fishing small fish like trout in small streams and rivers.
- AFTM 4–6: General-purpose rods for fishing a variety of fish species like trout, perch, and smaller predators in medium-sized rivers and lakes.
- AFTM 7–9: Heavy rods for fishing larger fish like salmon, pike, and sea trout in larger waters such as rivers, lakes, and coastal areas.
- AFTM 10–15: Very heavy rods for fishing very large fish like tarpon, large pike, and marine predators in open waters and saltwater environments.

It is important to choose a fly line with an AFTM number that matches your fly rod to achieve optimal performance and the best casting weight.

Fly rods typically range in length from 8 to 13 feet (2.4 to 3.9 meters). They often have a slow to medium-fast action to distribute the energy evenly over the entire length of the rod and allow for a smooth, precise presentation of the fly.

Fly rods have a special reel seat, which is attached at the bottom end of the grip section, unlike most rods. This is due to the unique casting style in fly fishing combined with the type of reel used.

→ Fly rods have a wide range of prey. When the non-expert thinks of fly fishing, he usually has trout and salmon anglers in mind – as here. But fly rods can even be used to fish for freshwater giants such as catfish or big-game fishing in the sea.

→→ In fly fishing, the line itself is cast, not the bait, as is the case with other fishing methods. The special fly line contrasts clearly with the magnificent river panorama.

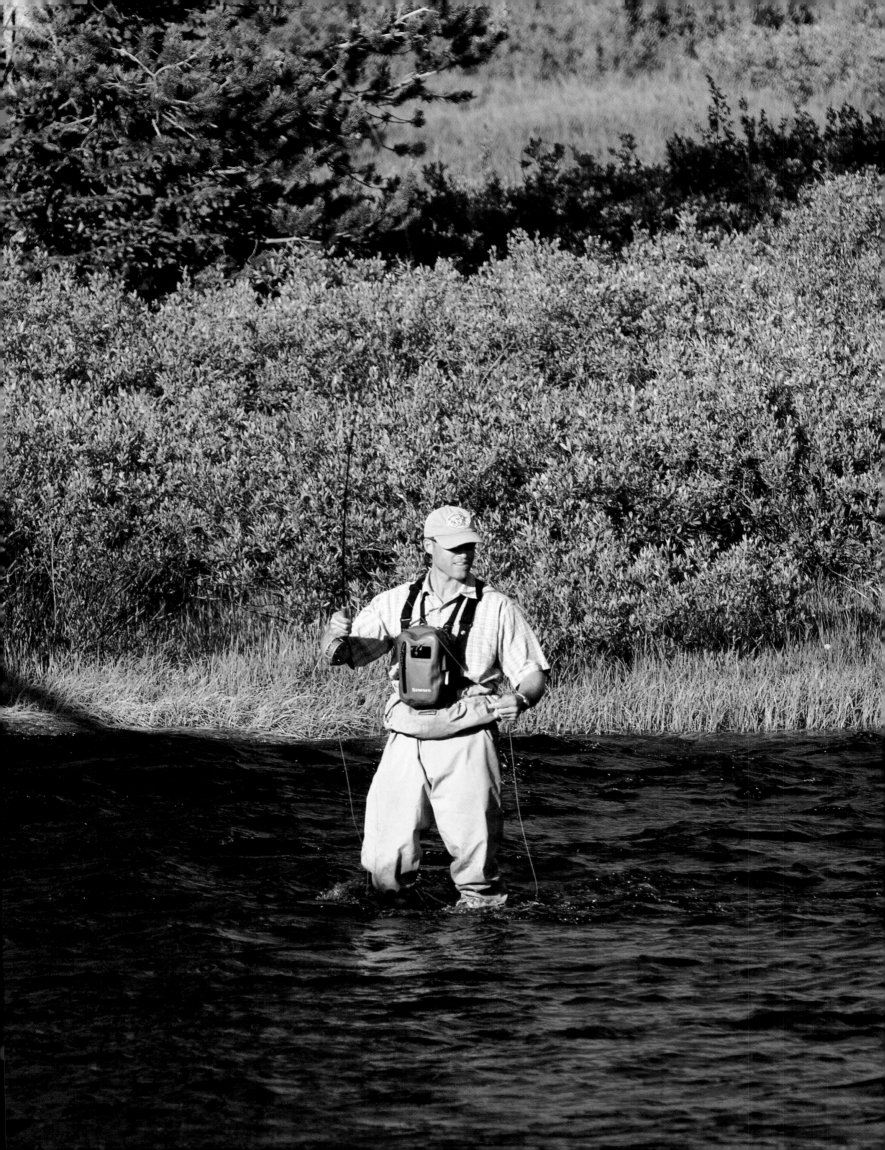

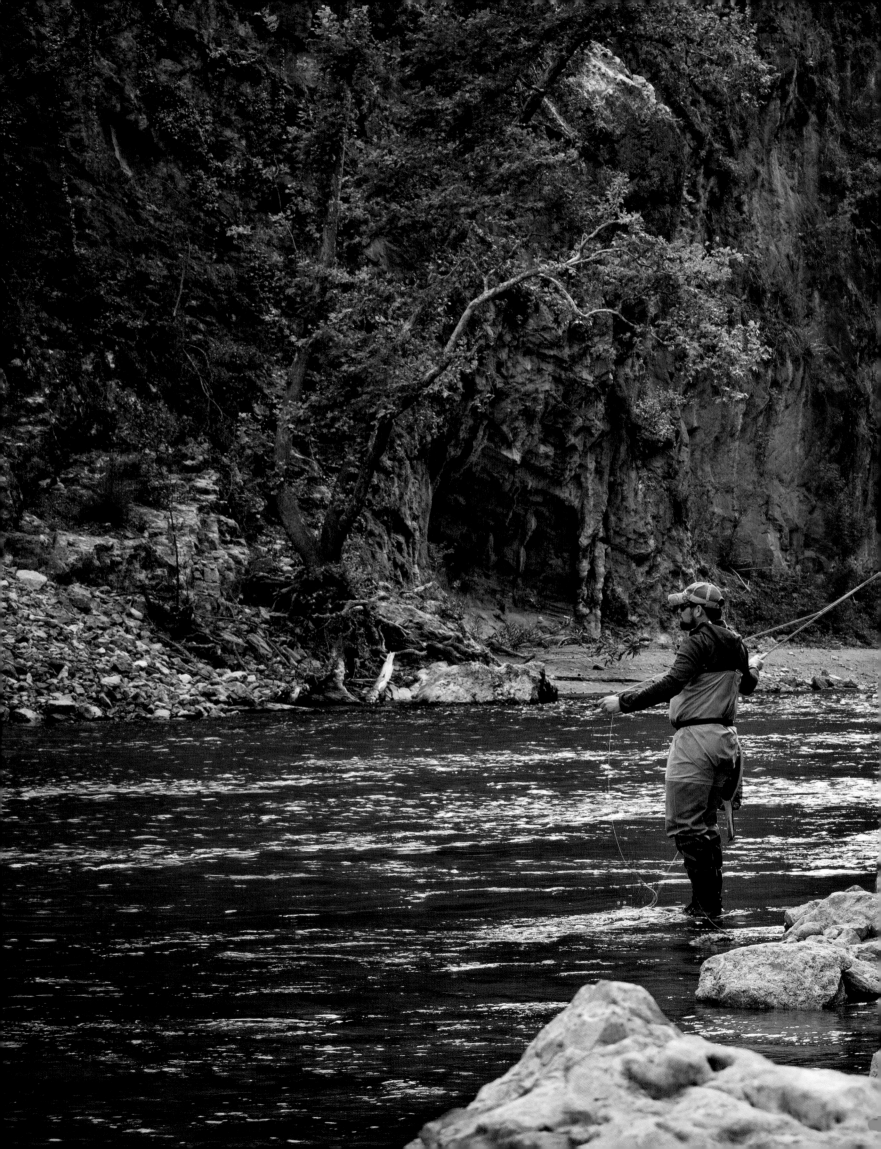

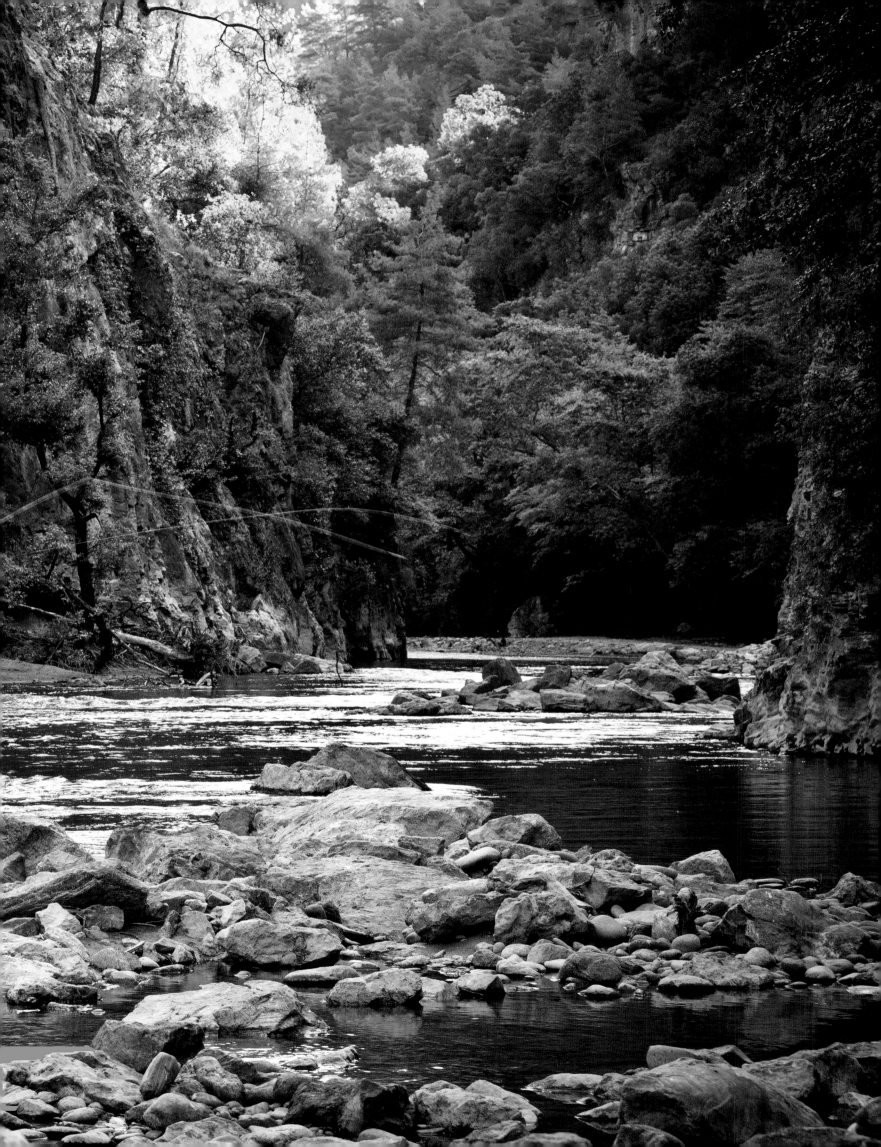

↘ Spinning reel with rear drag: Models with a rear drag are often used by bottom anglers, among others. A rotating knob on the rear of the reel allows the line to be released quickly, making it easier to handle the feed basket and other items.

↘ Spinning reel with front drag: Front drags are considered by anglers to be superior to rear drags in terms of robustness and precision. They are therefore often used for spinning and large fish reels.

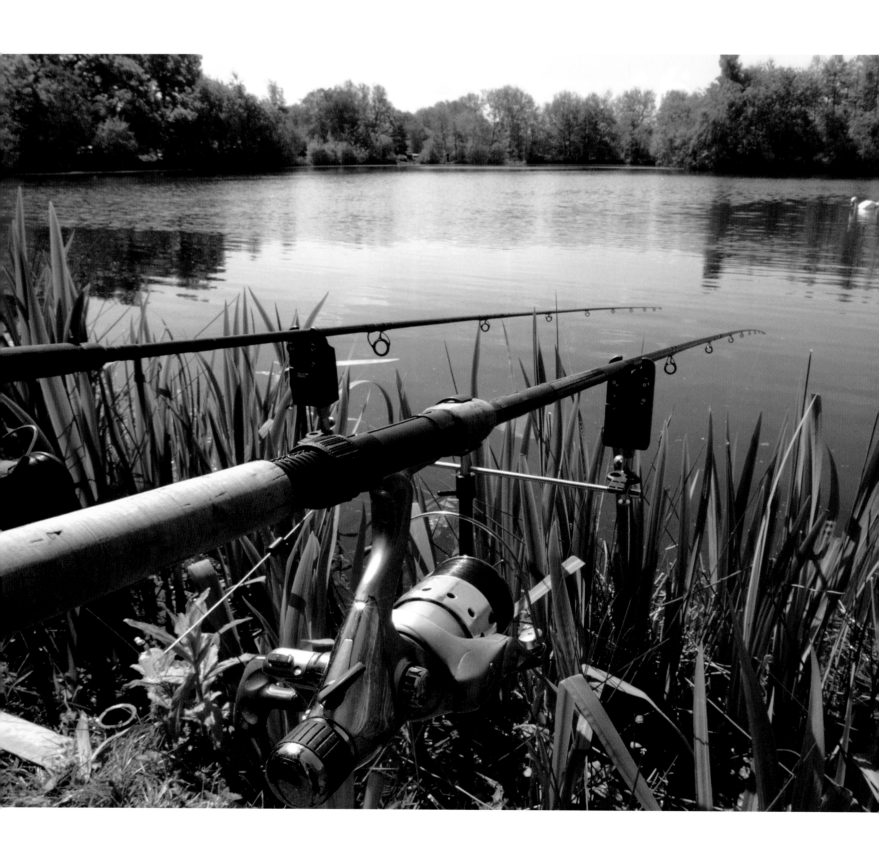

Fishing Reels

Spinning Reels

A spinning reel is one of the most common and most versatile fishing reels today.

The term »spinning reel« refers to the way in which the reel is used to retrieve the line: The angler turns the reel while the spool remains stationary and does not rotate, comparable to a spinning wheel that turns and the spun thread is wound onto the rigid spindle.

In contrast, there are also baitcasting reels, where the spool rotates during the retrieve. The term »spinning reel« is used to highlight the difference between these two types of fishing reels.

With a spinning reel, the line is wound onto the spool solely by the rotation of the bail arm and the up-and-down movement of the spool. The spool itself only rotates when the line is being let out via the reel's brake system. The brake system can be located either in the reel housing (rear brake) or on the spool head (head brake), with the latter being common in high-quality reels designed to handle significant brake pressure. Additionally, the spool does not rotate during casting. By flipping the bail, the line can freely glide off the spool, making spinning reels well-suited for long and tangle-free casts.

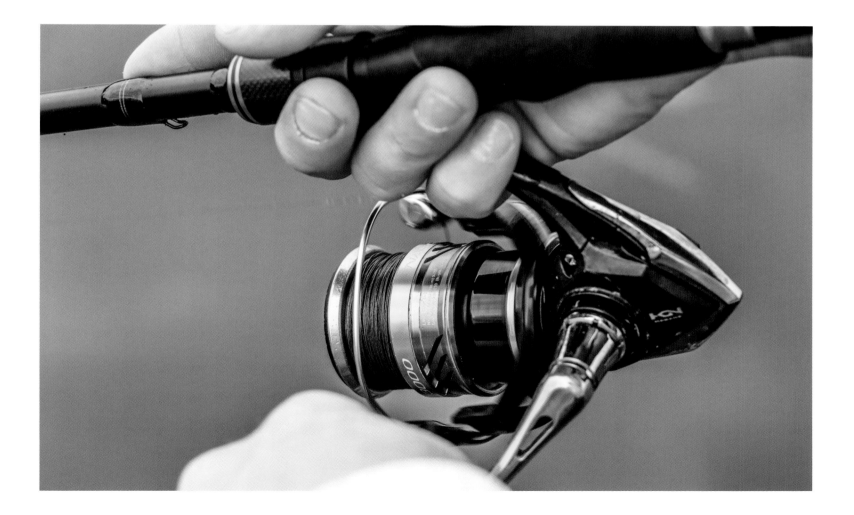

Fly Reels

Fly reels are specialized fishing reels designed for fly fishing. They consist of a housing that closely surrounds the central spool. Inside the housing, there is a spool core onto which the fly line is wound.

The spool of a fly reel is often large and wide to provide sufficient space for the specialized, relatively thick fly line.

Fly reels have a small reel attached directly to the spool. Depending on the application, fly reels may feature a brake system and gear ratio. Such systems become increasingly important as the target fish size increases.

Casting with a fly reel is different from other reel types. It involves manually pulling off the desired length of line before the cast. For long casts, shooting or line baskets can be used. These allow the line to be neatly organized, preventing it from tangling in rocks, aquatic plants, or drifting away with the current. Additionally, shooting baskets can theoretically enable longer casts, as the line is not impeded by water or current at the end of the cast.

Centrepin Reels

At first glance, centrepin reels resemble very large, notably narrow fly reels. However, these classic reels, especially popular in England, are primarily used for float fishing in rivers, targeting species like chub, bream, barbel, and other coarse fish. While some anglers use them in still waters, centrepin reels, also known as Nottingham reels, truly shine when fishing in flowing water.

Centrepin reels were developed mainly for »trotting«, which is fishing with a drifting float in a river. This method is particularly effective for targeting fish like ide, chub, barbel, and other coarse species.

Near the water's surface, the current is stronger than near the bottom. If the float is allowed to drift freely on the surface, the bait will be dragged along by the fast-moving float. To allow the bait to drift naturally, the float must be slightly braked.

With a spinning reel, »dragged fishing« would require opening the bail and manually controlling the line release. This is much easier with a centrepin: The current pressure alone is enough to set the extremely free-running spool in motion. The

← Practical aid: A fly fisherman has attached his mounted fly rods to a special rod rest on his car using a suction cup.

↓ »Old but Gold«: Fishing with a centerpin in the river is not very common, but it is recommended. This is as close as a float angler can get to fly fishing.

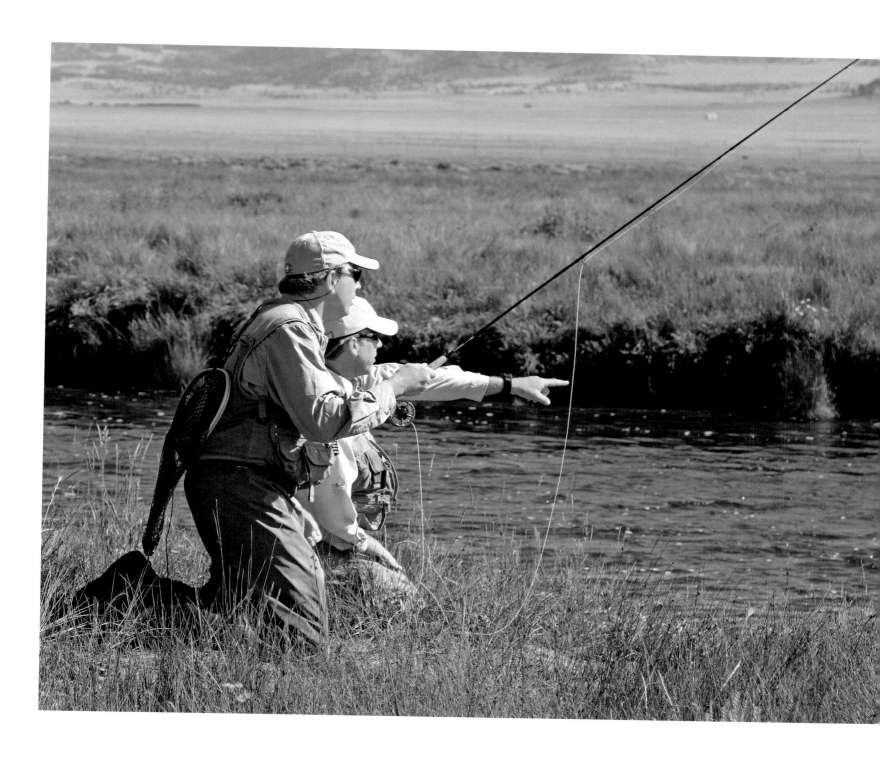

line is automatically and slightly braked as it is released. Centrepin reels thus allow for very simple, consistent, and controlled drifting of the float.

Centrepin reels are usually paired with longer match rods or Avon rods, and are specifically designed for fishing in rivers. They are not suited for casting. The maximum fishing distance is roughly the same as the rod length.

Collectibles and Classics

Even though the same principle applies to fishing reels as to rods, and the equipment has generally undergone a positive price-performance development over the years, some old reel models are still highly sought after today. This is especially true for Japanese fishing reel manufacturers like Daiwa and Shimano. Collectors particularly prize the so-called »Japan models«, reels that were still made directly in Japan and not in low-wage countries, and are thus considered especially high-quality. Some reels have achieved cult status over the years due to their features and use by renowned anglers.

When it comes to traditional manufacturers of fly reels, Hardy & Greys Limited is one of the most respected and oldest brands in fly fishing. Founded in 1872 in Alnwick, England, Hardy has a long history of producing high-quality fishing gear, including fly reels. Hardy fly reels are known for their handcrafted quality, precision, and durability. The reels are often appreciated for their classic aesthetics and their ability to meet the demands of fly fishing in various environments. Hardy has gained a loyal following among fly fishermen worldwide and continues to be regarded as one of the leading manufacturers of traditional fly reels.

→ The fiberglass blank shimmers honey yellow against the light. No longer completely up to date, but for many anglers a popular classic and collector's item that still catches fish.

Fishing Baits

Choosing the right bait is considered by anglers to be crucial for success or failure, alongside selecting the right location. The range of possible fishing baits seems endless. Generally, baits can be classified into ready-made artificial baits and natural baits prepared by anglers.

In addition to baitfish, worms, larvae, and maggots, seeds like sweetcorn and bread are excellent natural baits.

Among the fly, the classic of artificial baits, wobblers, spinnerbaits, and rubber lures have become established. These are usually categorized into hard- and softbaits.

Flies and Streamers

Dry fly fishing is considered by many anglers to be the classic form of fly fishing. It uses artificial flies that float on the water's surface. This is achieved by greasing the fly and/or using buoyant materials (e.g., deer hair).

Dry flies typically imitate adult (water) insects, either those laying eggs on the water surface (imagines), those emerging from their larval shells and breaking the water surface (emergers), or post-spawning, spent insects floating on the surface with spread wings (spents). Additionally, dry flies include imitations of terrestrial insects like grasshoppers, ants, or beetles.

↓ This rainbow trout has fallen for a nymph.
Nymphs imitate the larval stage of aquatic insects.

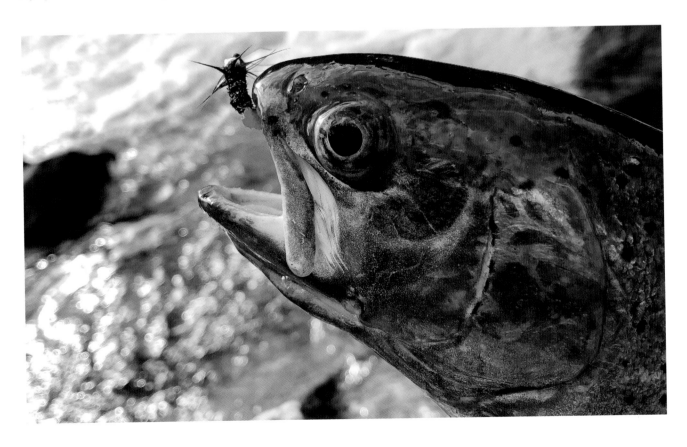

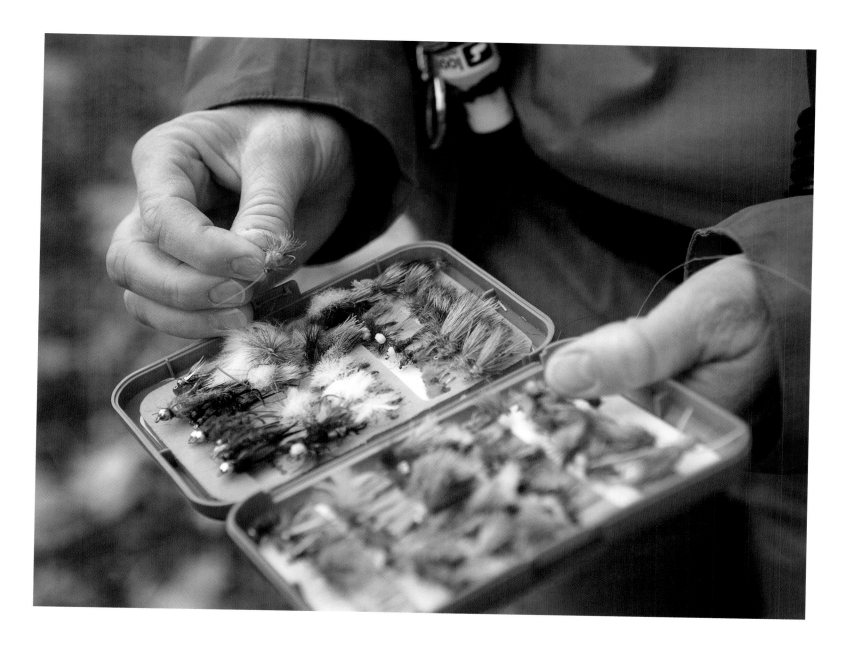

Dry fly fishing mainly targets fish that rise to the surface to feed on airborne insects.

Streamer fishing represents the boundary between fly fishing and spin fishing. Streamers are artificial baits that imitate small fish, mice, or similar prey (imitation streamers) or lure predatory fish with their bright colors (attracting streamers). These lures are only »flies« in that they are made from fly-tying materials like feathers, hair, or yarn.

Streamer fishing targets predatory fish and therefore often requires heavy fly fishing gear.

↑ A well-stocked bait box: It is essential for fly fishermen to carry a wide selection of different flies and streamers with them in order to adapt them to the current food supply and other conditions on site.

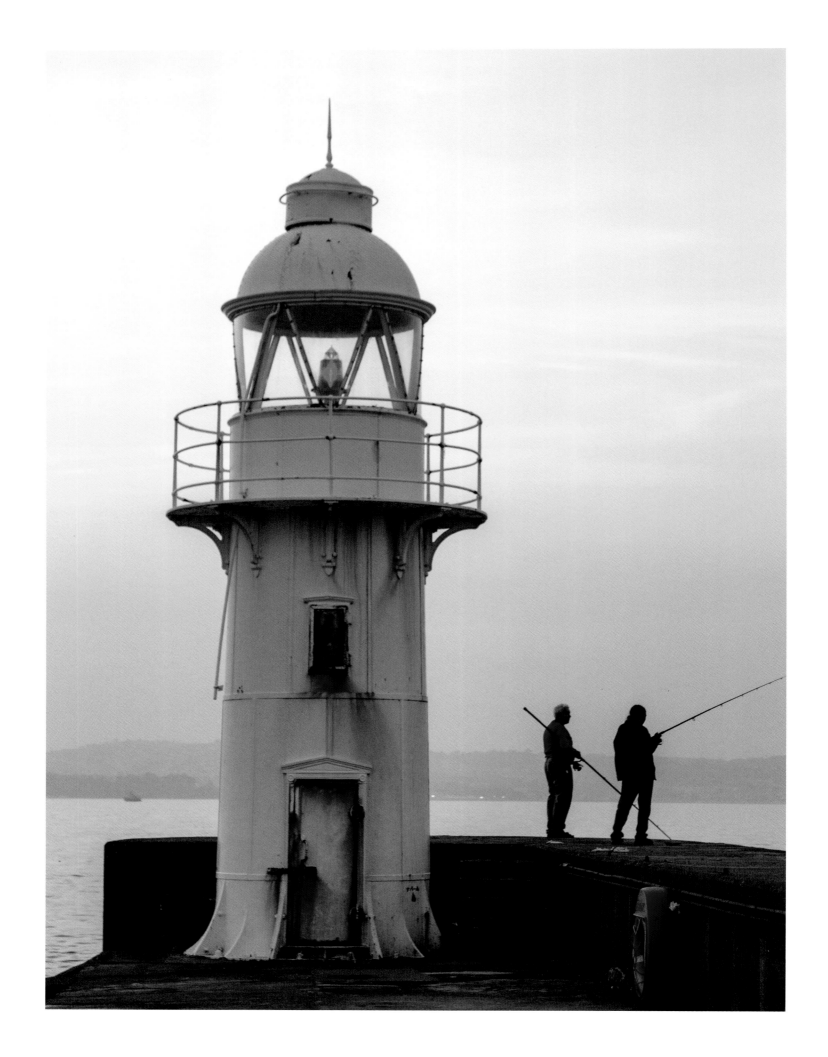

Wobblers

Wobblers imitate the movement and appearance of prey animals such as small fish or insects to attract predatory fish. They typically have a diving lip or bill that creates a side-to-side movement when the lure is retrieved. This movement mimics the swimming action of prey and catches the attention of predatory fish.

Most wobblers are designed to sink or float when not actively retrieved, allowing anglers to fish at various depths. By adjusting the retrieval speed, angle, and movement of the wobbler, anglers can vary the swimming action and depth of the bait to attract and catch predatory fish.

There are various types of wobblers and hard baits that differ in shape, size, movement, and intended use. These include crankbaits, jerkbaits, surface wobblers, and those for vertical fishing.

This list is not exhaustive, as there are many other types of wobblers and hard baits designed for different fishing techniques and species. The choice of the right bait often depends on prevailing conditions, fish preferences, and the angler's personal preference.

Boilies

Few natural-based baits are as selective as the boilie. The invention of the boilie is considered a milestone in targeting large carp.

The origin of the boilie can be traced back to the 1970s when carp anglers began making homemade baits from flour, eggs, and flavorings. The exact person or place where the boilie was invented is not definitively known.

The boilie quickly became a popular bait for carp anglers and is now one of the most commonly used bait types in carp fishing. Undoubtedly, the boilie – derived from the English word »to boil« – originates from the homeland of (carp) fishing, England.

Due to its hardness created by boiling and its size (about 20 mm), the boilie is highly selective. Only particularly large coarse fish, such as carp, can consume this bait and crush it with their pharyngeal teeth. At the same time, the high-calorie content is very attractive to heavy carp.

Boilies can be differently colored and flavored with adventurous aromas and are fished as both sinking and floating variants (pop-ups). Some mixtures have achieved cult status today.

← The two anglers are hoping for a good catch as dusk falls.

Bite indicators

A sensitive bite indicator is essential for successful fishing. The chosen bite indicator must be easily visible and/or audible and allow the fish to take the bait with as little resistance as possible.

The float is the classic among visual bite indicators. For ground fishing, quiver tips are traditionally used. The eel bell is another classic.

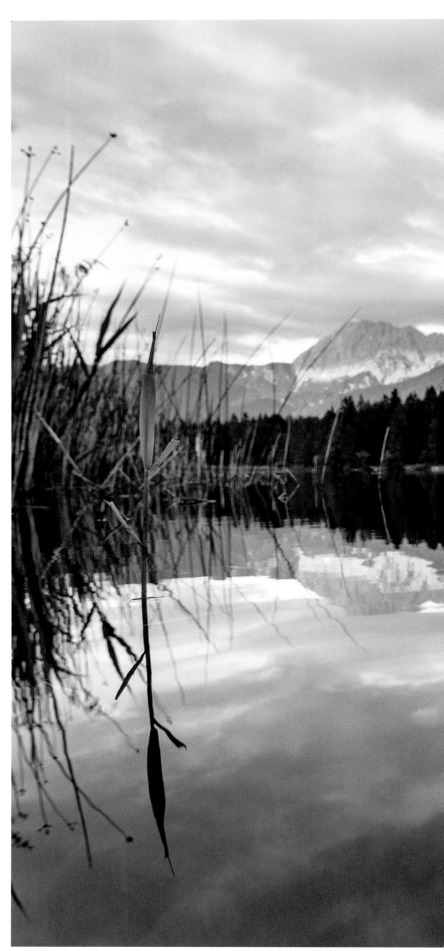

↑ Tautly tensioned, the quiver tip waits for the next swing.

→ This waggler protrudes only slightly from the water. The rod-like float also effectively indicates lifting bites. It is important to lead out precisely and to sound out the depth of the water accurately.

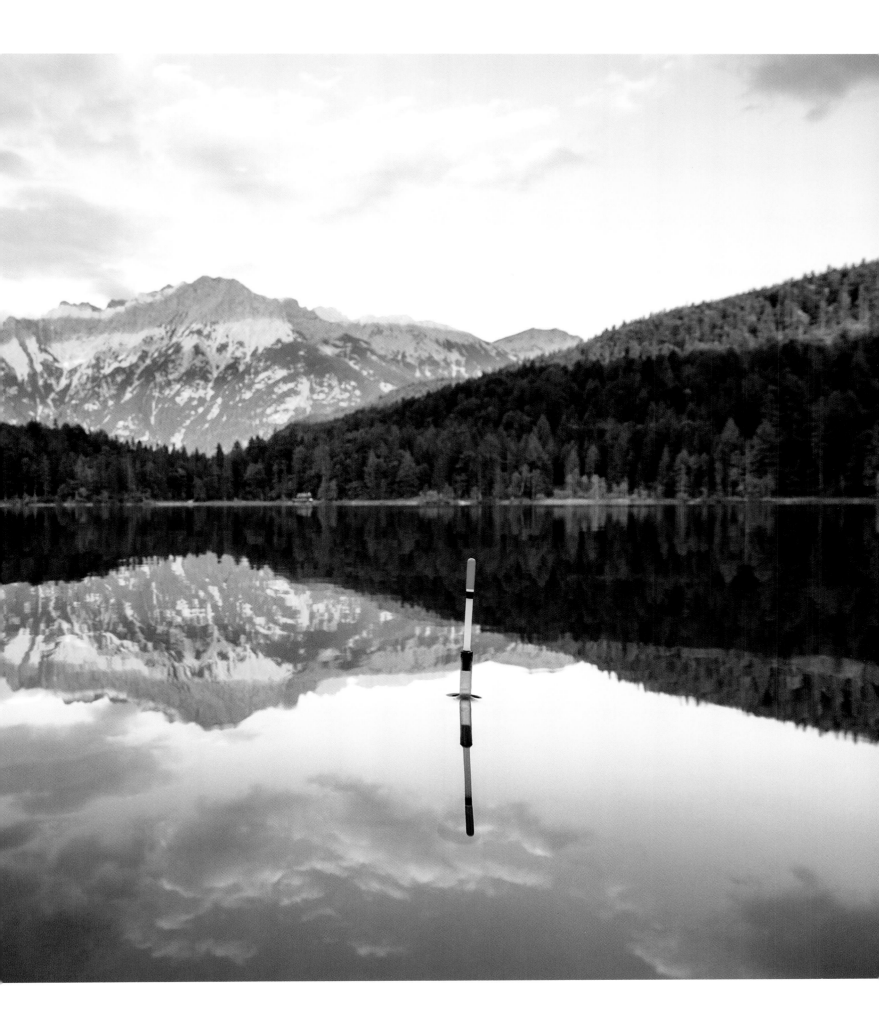

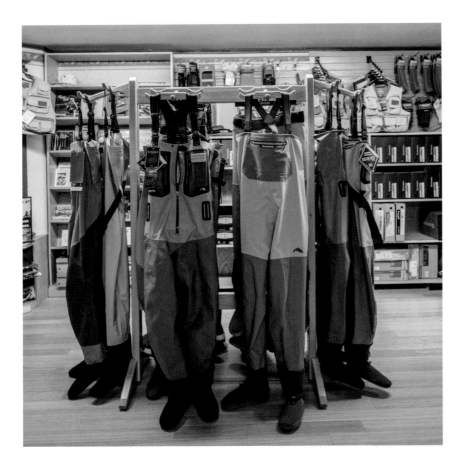

Accessories

In addition to the primary fishing gear, waders, polarized sunglasses, and a boat can be essential accessories depending on the fishing situation.

Waders

Waders are practically indispensable for fly fishing. They allow the angler to stand in the current and better reach the fish, which means being able to cast effectively. However, waders are also extremely helpful for other fishing methods. For instance, in carp fishing, it may be necessary to move a bit away from the bank and wade through the shallow water to obtain a clear casting path or to facilitate the seamless landing of the fish with a net. A large fish is typically difficult to pull through knee-high water to the margins and even harder to release gently back into the water.

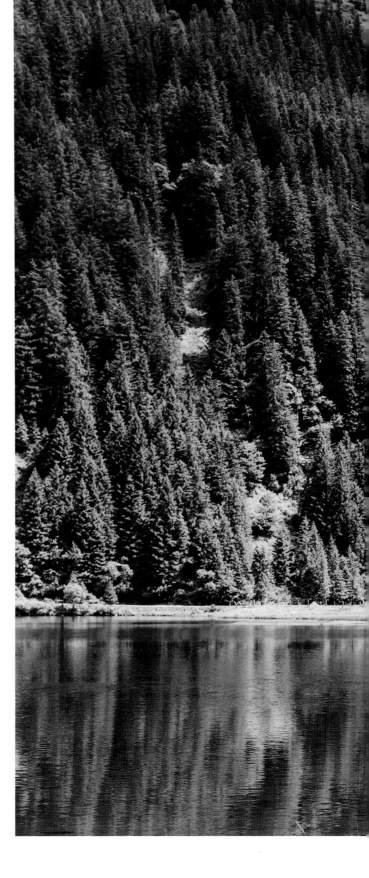

↖ Large selection of high-quality waders. Fly fishing versions often have booties and are worn with separate shoes. Versions with more or less elaborately designed breast pockets are also common.

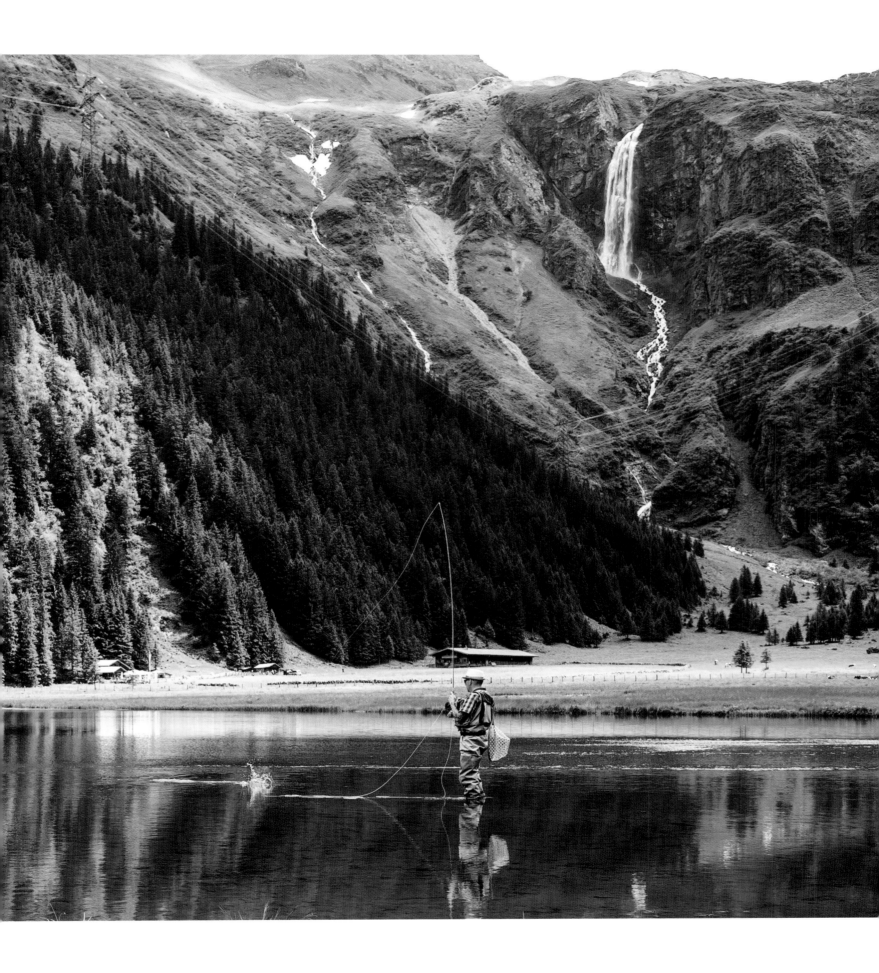

↑ In shallow water, waders are indispensable for landing your catch safely.

← Everything in view thanks to polarized glasses. In addition, the goggles protect the fly fisherman's eyes from the whipping fly when casting.

↓ Sometimes it is only possible with a boat, e.g. when using a »Wallerholz« for vertical fishing for catfish with a dew worm bundle.

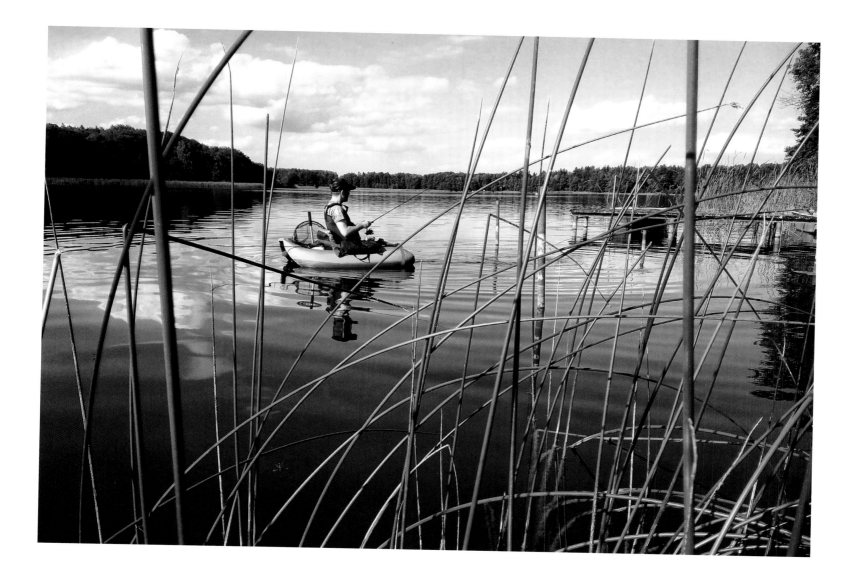

Polarized Sunglasses

Polarized sunglasses are another must-have for every fly fisherman but can also be very useful for predator or coarse fish anglers. These glasses enable a remarkable view into the water by reducing surface glare, helping to spot fish and obstacles and better identify underwater structures.

↑ With floating tire and diving fin: The bellyboat is particularly popular with predatory fish anglers.

→→ The dreamy Lake Burgäschi in the canton of Solothurn in Switzerland is a popular fishing spot.

Boats

Boats can also be not just useful but crucial when fishing. While boats are less common in fly fishing and are often avoided by purists, they are important for fishing in large lakes where a significant part of the water surface cannot be effectively fished from the bank. In fishing for large carp or even catfish, a boat can be necessary to safely land the fish and avoid losing it in aquatic plants or woody debris. Spinning anglers also frequently use boats, as they allow for vertical lure presentations.

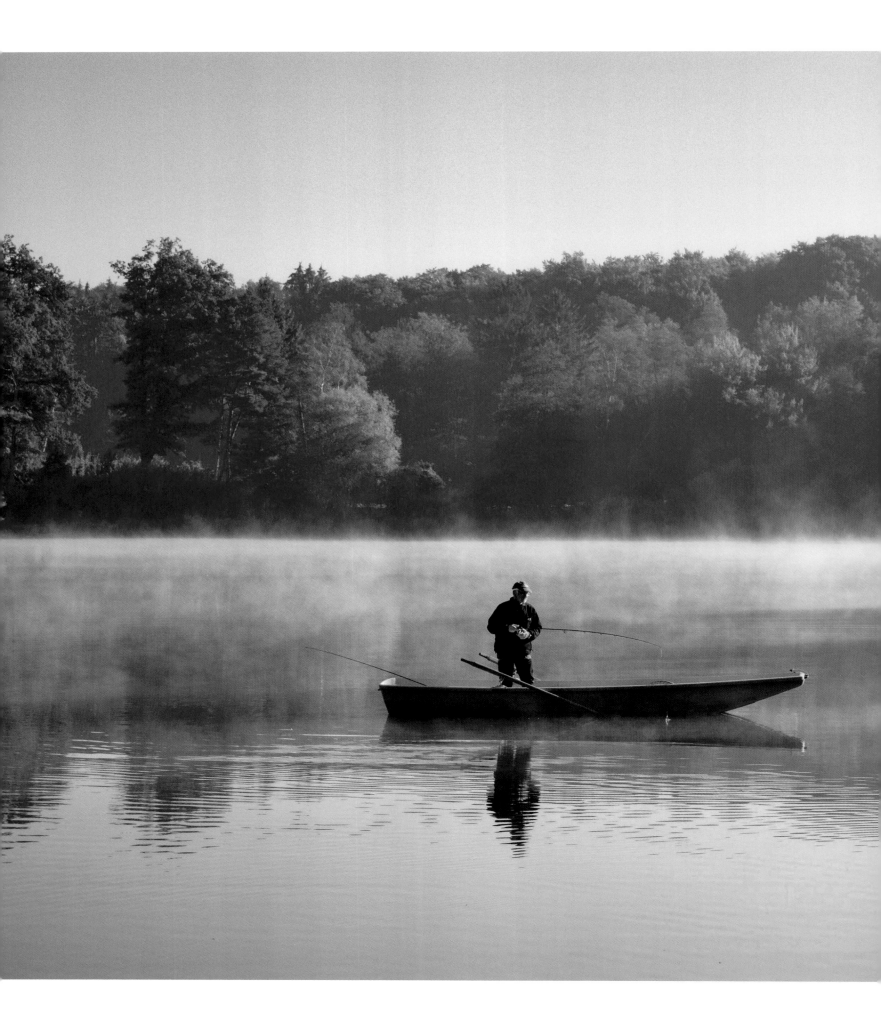

Clothing

There is no strict dress code among anglers, but muted colors like olive green or brown have become standard, except perhaps for spin fishers. This parallels the attire of hunters, who also aim for maximum visual blending with their natural surroundings.

→ For many people, waders rightly symbolize typical fishing clothing.

↓ Function often determines the dress code. Fly fishermen typically wear a peaked cap, waders and sunglasses. Fishing vests with countless pockets are somewhat out of fashion.

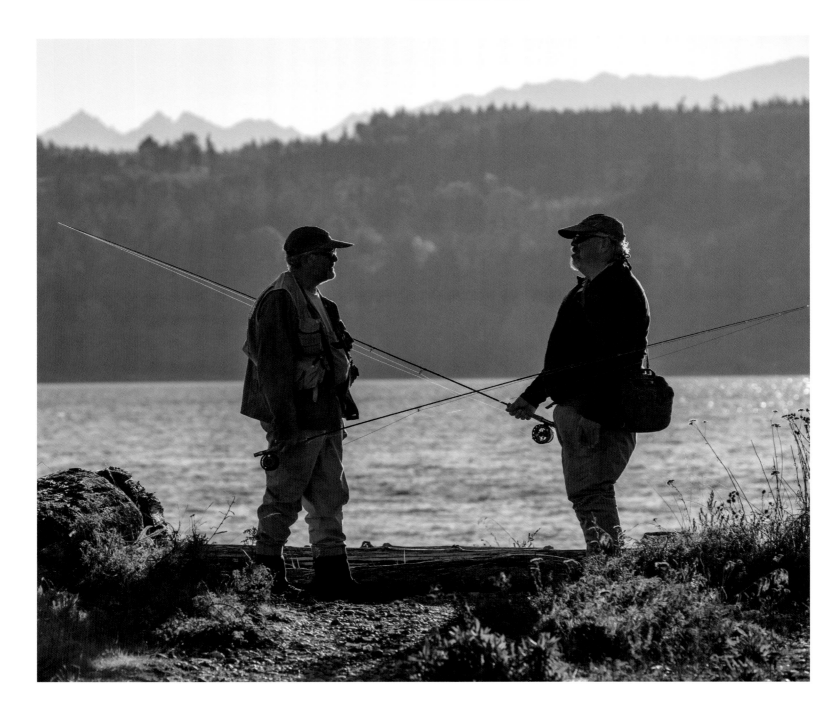

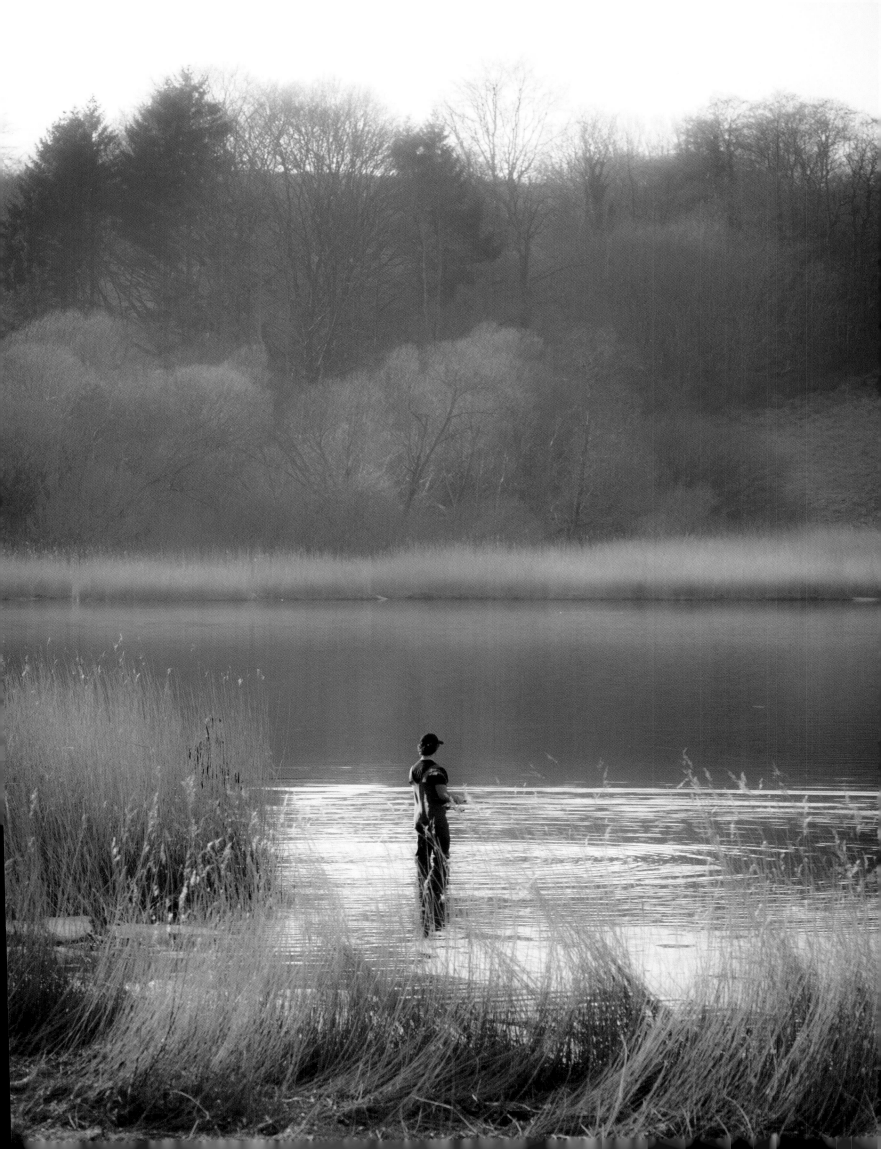

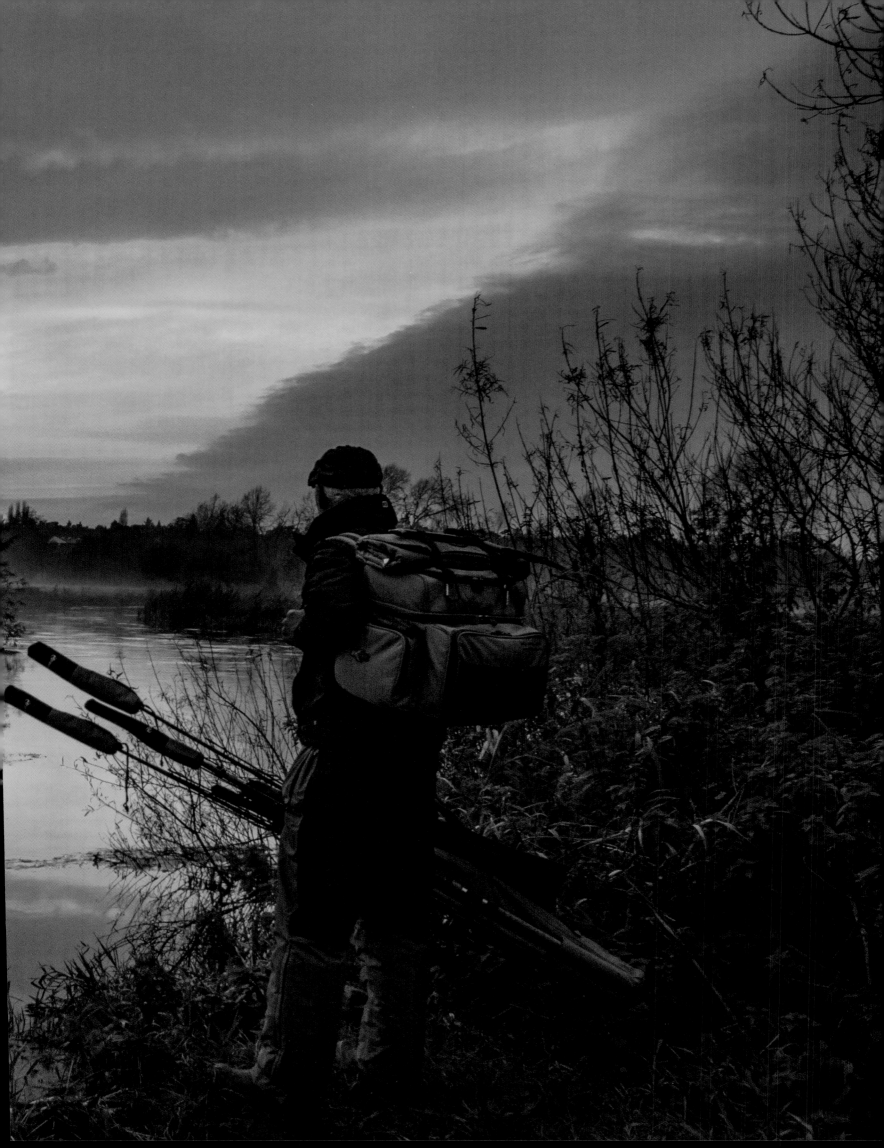

Camping Equipment

For longer sessions, especially night fishing, anglers need additional equipment. A headlamp is essential for any night angler.

For those wishing to stay overnight at the lake, shelter and bedding are necessary. A traditional and stylish option is the so-called »brolly«. More than just an umbrella, a brolly is an olive-green umbrella tent designed specifically for night fishing, originating in England. A proper brolly perfectly accommodates a bedchair, a fishing bed designed for night fishing.

A constantly simmering kettle over a gas stove is also a hallmark of the English big fish scene, particularly among carp anglers.

←← Typical appearance in England: specimen hunter with fishing backpack and quiver.

→ Basecamp at Lake Balaton in Hungary. The wind on large fishing waters like this can sometimes be fierce, so a sturdy olive green tent is a must for every carp angler.

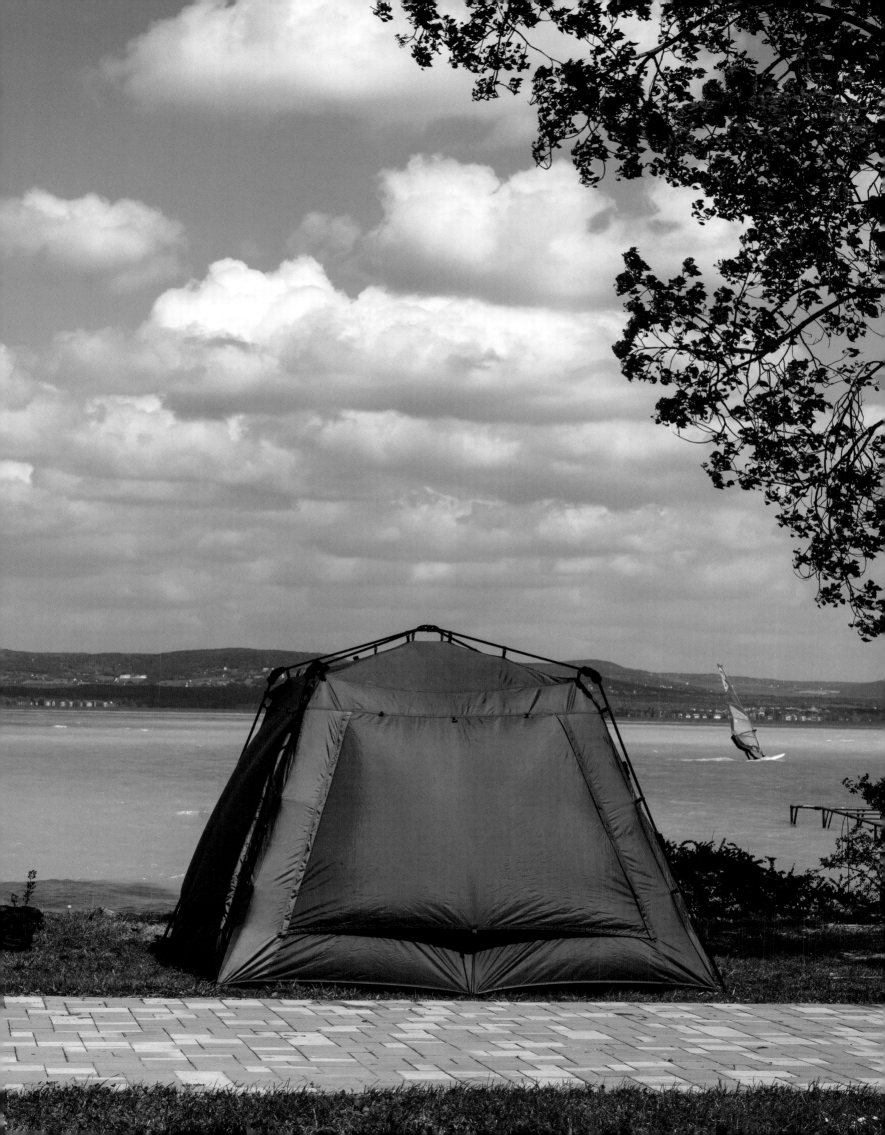

Techniques

»All the gear but no idea«

Nowadays, most tackle stores offer everything an angler want or might need, from pre-made rigs to every type and variety of bait.

However, there is a crucial skill that cannot be purchased, one that distinguishes a skilled angler from a lucky one. The English call it »watercraft«.

Watercraft is the understanding of the environment in which one is fishing. It involves knowing how the weather affects the fish, understanding the reasons behind fish behavior, and predicting when they will act in certain ways. It is about reading the water and using one's knowledge to draw the right conclusions.

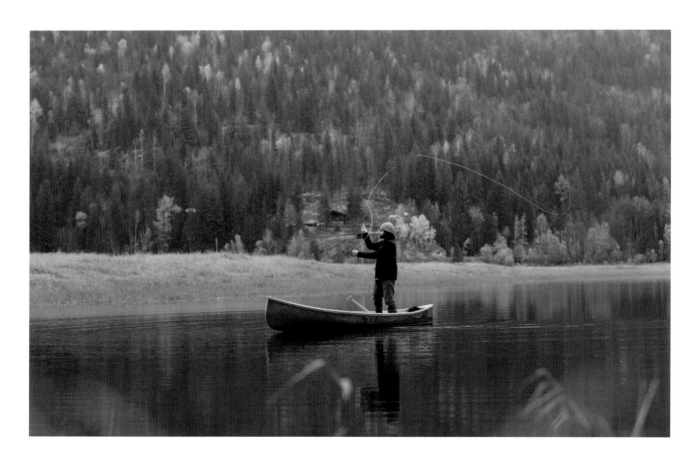

↑ Finding the right balance when throwing the rig is sometimes not easy.

→ Fly fishing is also popular with many anglers because of its purism. But even with other types of fishing, less is often more!

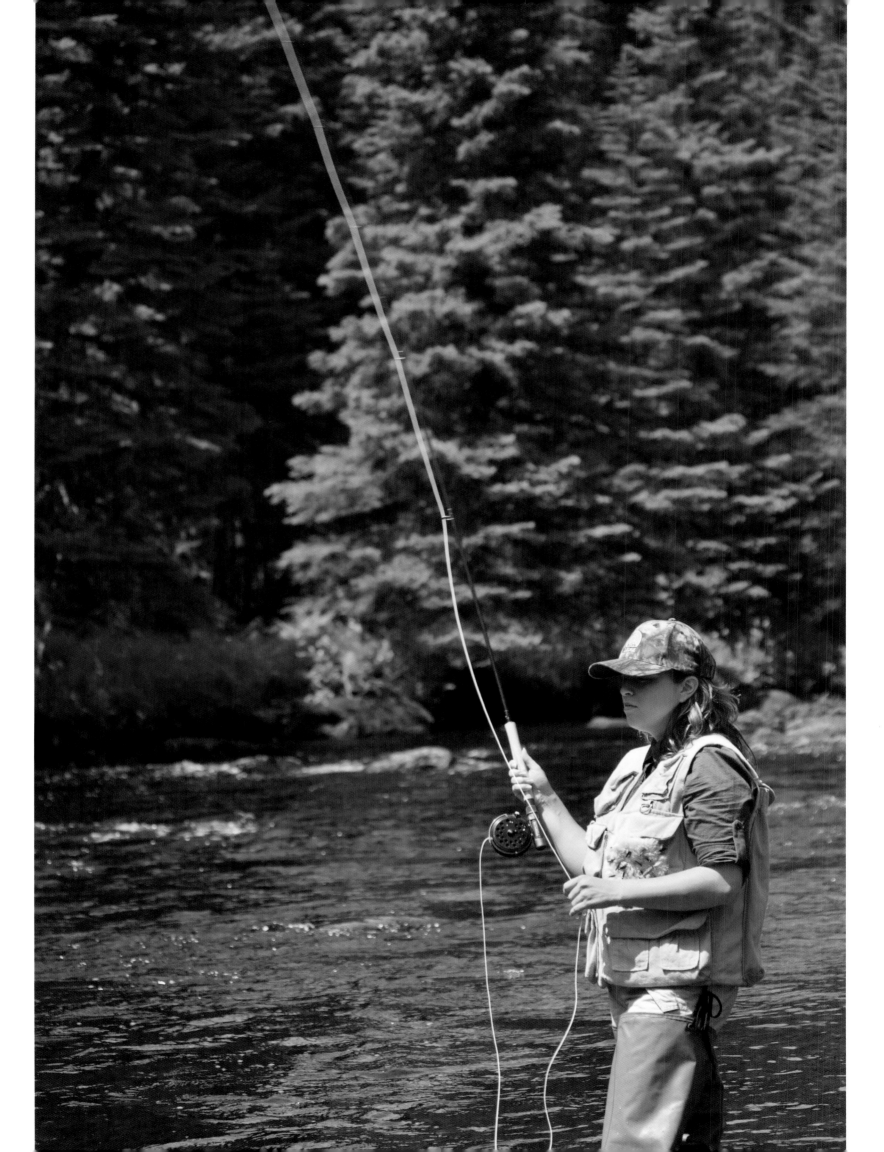

Float Fishing vs. Ground Fishing

Float Fishing

Generally, float fishing can be practiced in both still and flowing waters. The bait can be presented at various depths to match the feeding behavior of the targeted fish. Simultaneously, the float serves as a bite indicator, which can be equipped with a glow stick for night fishing. There is a wide variety of fishing floats available, each suited to different fishing techniques, water conditions, and target fish species. Choosing the right float is crucial for successful fishing and depends on factors such as

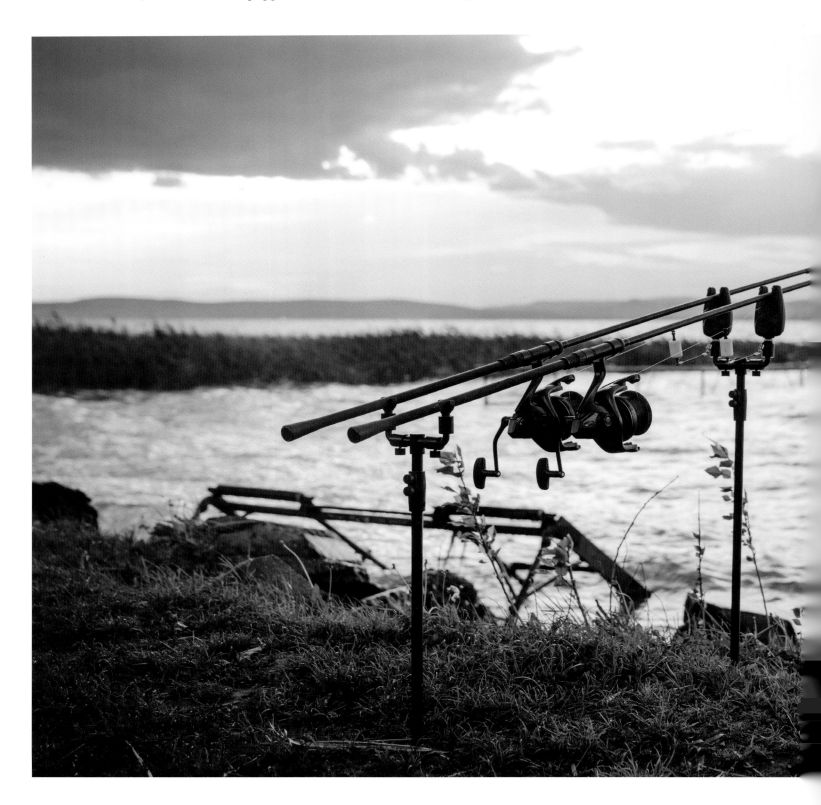

the type of bait, the depth of the water, and the behavior of the fish.

Overall, floats can be categorized into fixed and sliding floats. Fixed floats have the line attached firmly to the body of the float, often with a tight rubber band. They are ideal for fishing in still or slow-moving waters at shallow to moderate depths. Sliding floats having an opening through which the fishing line can move freely. They are often used when fishing at greater depths.

Proper weighting when setting up the float is essential. Weights placed on the line below the float ensure the bait sinks to the desired depth and allow the float to indicate even subtle bites (usually by sinking or laying flat) without alarming the fish.

Traditionally, floats were made from balsa wood, cork, porcupine quills, or feather quills. Today, many fishing floats are made from synthetic materials like plastic or foam, as they are often more durable and cost-effective. However, traditional floats made from natural materials are still appreciated by some anglers for their aesthetics and authenticity. Watching a drifting float can be very relaxing.

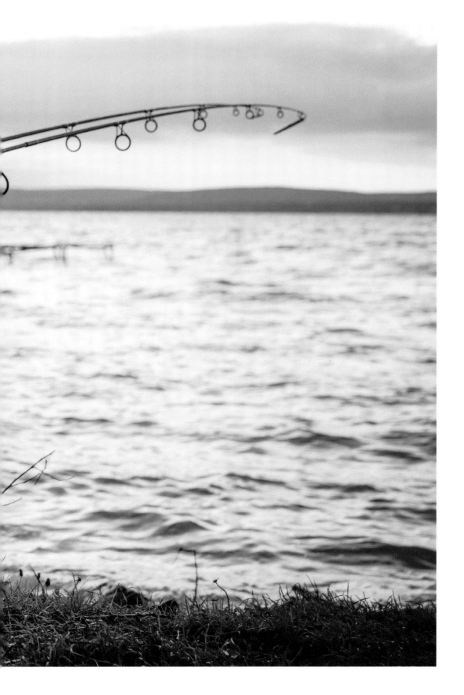

← Waiting for the next »run«: When carp fishing, the rods are placed securely on so-called banksticks or rod pods.

↓ Lake and float rest quietly.

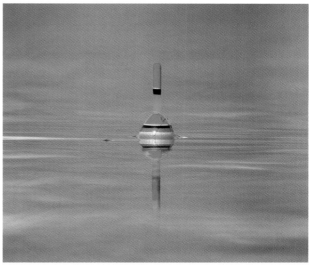

→ »In the Margins«: Fishing in flooded bank areas is often very promising.

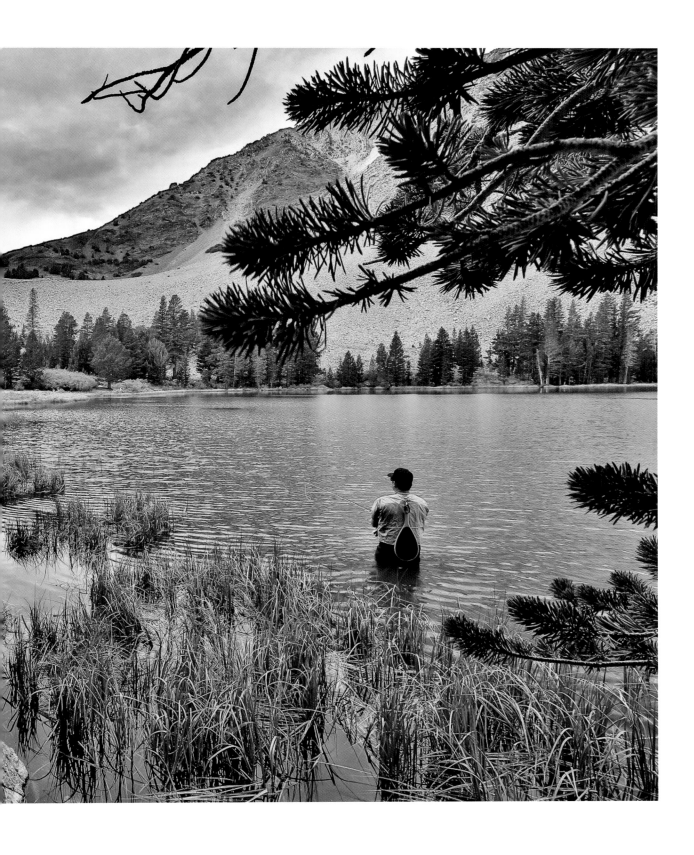

Ground Fishing

In ground fishing, the bait is presented on or near the bottom of the fishing water. A lead or a feeder is used for weighting and casting. There are numerous designs of leads and feeders available.

Ground fishing is particularly effective for species that live on or near the water bottom, such as carp. With ground fishing using a feeder, ground bait can be delivered to the fishing spot simultaneously with the rig. Baiting is essential for successful coarse fishing. Additionally, ground fishing allows the use of self-hooking rigs, which are standard in carp fishing and ensure secure and gentle hooking of the fish.

When fishing for large carp, it may be necessary to stay a considerable distance from the fish and present the bait on the water bottom for an extended period. Active monitoring, as with a float, is not required. In carp fishing, bite indication is usually electronic.

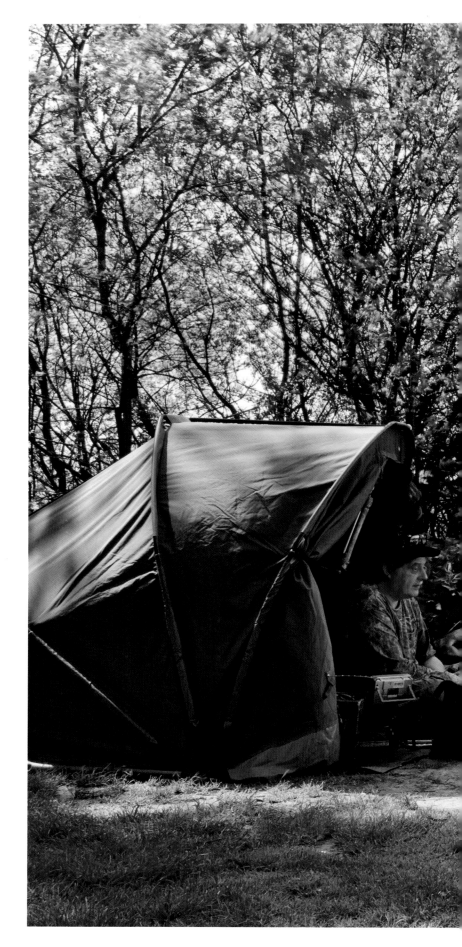

→ The bivvy is an integral part of the carp fishing scene. No wonder, as their fans spend days and weeks in them.

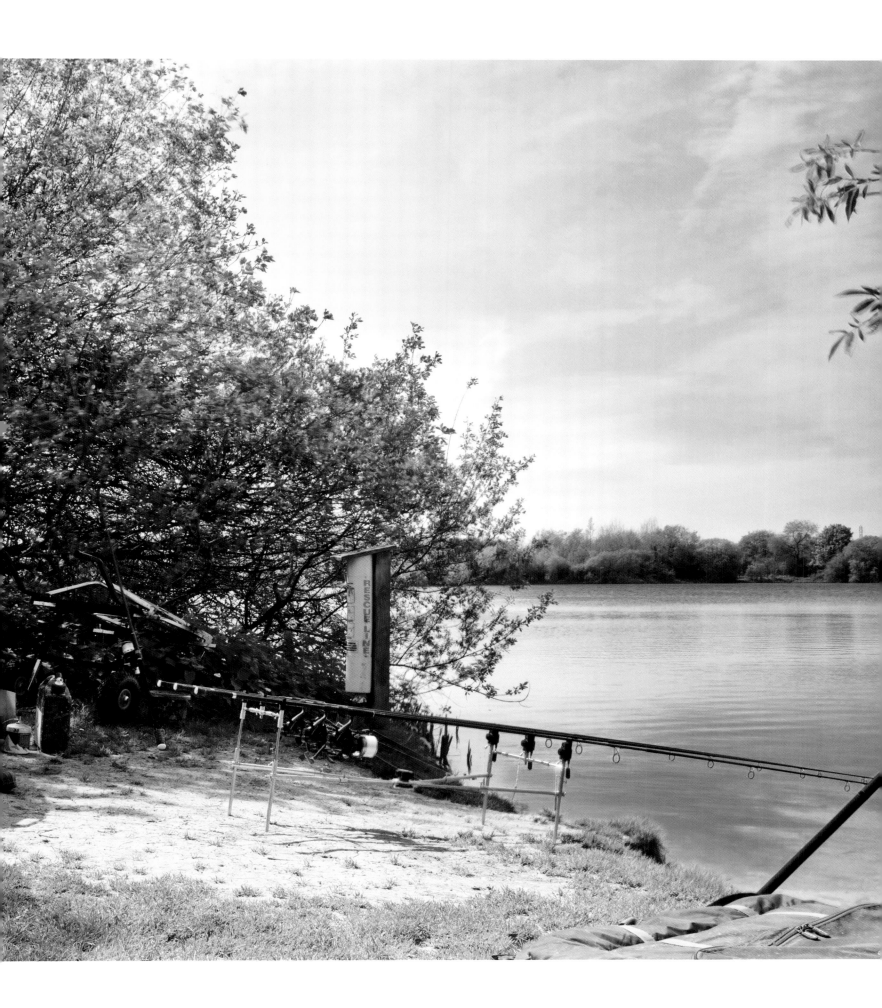

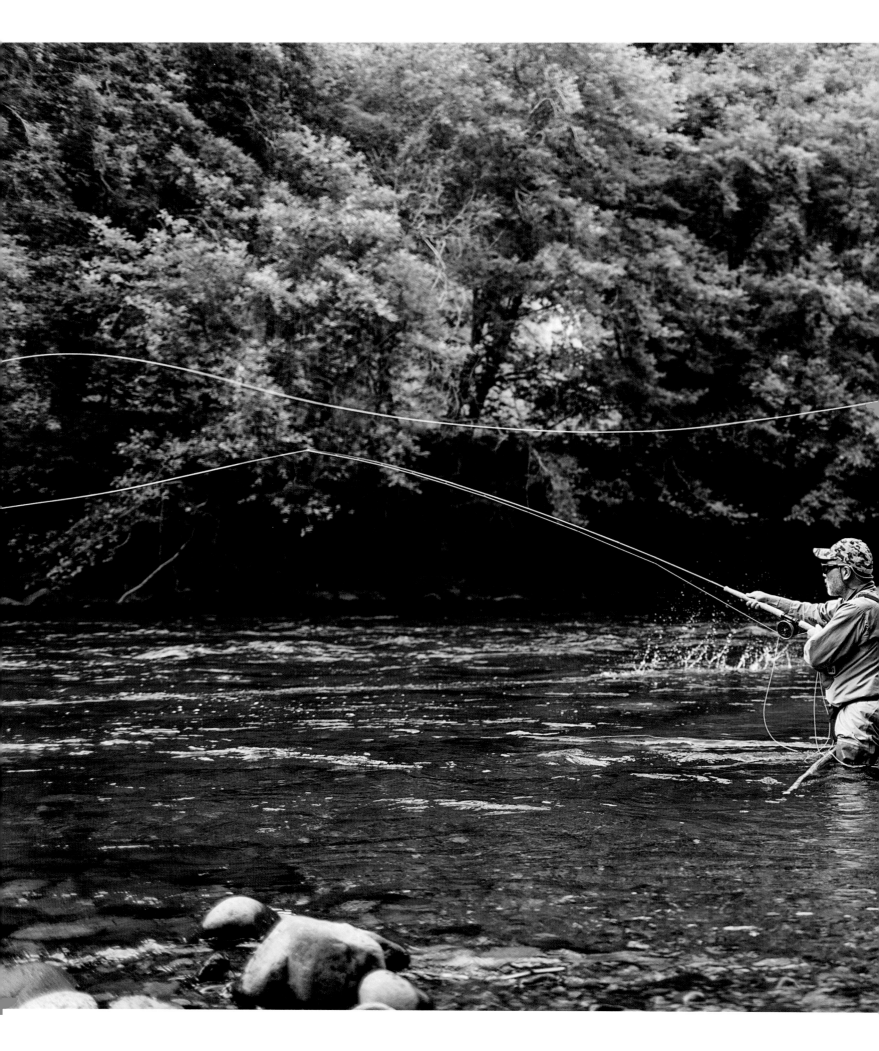

Casting Technique

The proper casting technique is essential for fishing success because it ensures the bait lands where it should – near the fish. What might seem trivial at first can be quite challenging with certain fishing methods and target species.

For example, fly fishing requires a unique casting technique where the line provides the casting weight, not the bait or the rig. Mastering this technique requires intensive practice and full concentration.

In spin fishing, the bait also needs to be placed accurately. Hotspots, such as overhanging trees, are attractive to fish but pose a risk to anglers due to the danger of snagging. Skilled anglers place their baits with the highest precision.

Occasionally, casting skills are also needed in carp fishing. To reach elusive large carp, anglers may need to cover immense distances. Casting distances over 460 feet (140 meters) are possible but demand a lot from both the angler and the gear.

← Perfect loop: The right timing determines the loading of the rod and thus a proper course of the line in the air.

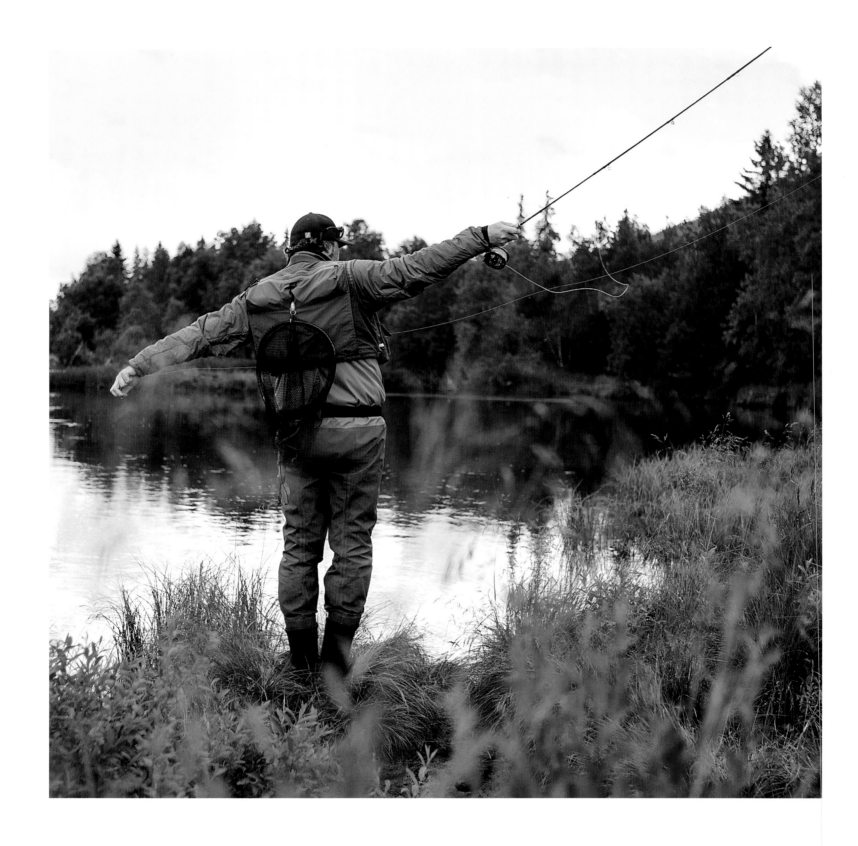

↑ When fly fishing on smaller rivers and streams, casting often plays a subordinate role. However, good bait and line management is always important.

→ The overhead cast is the most reliable method for carp fishing to achieve long casts with pinpoint accuracy.

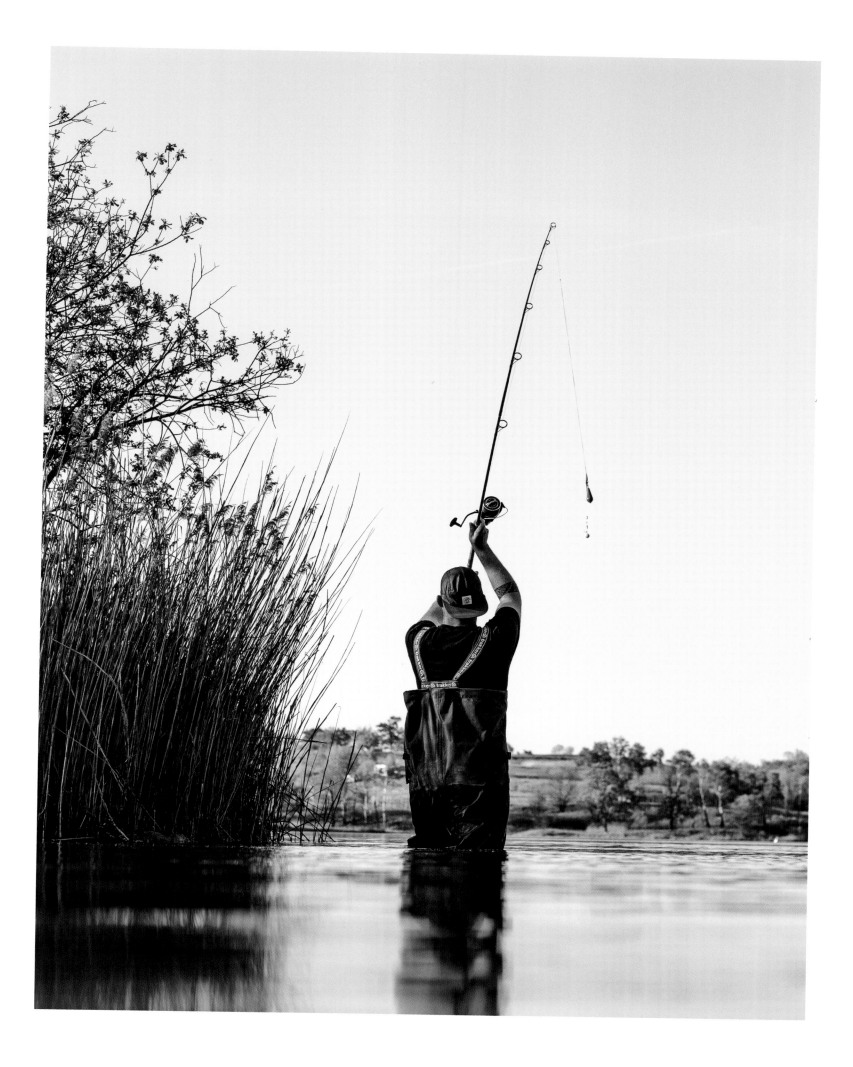

Catch & Release

Catching and releasing fish is a widespread practice in recreational fishing where the fish caught is not consumed but gently released back into the water after possibly being measured, weighed, and photographed.

The catch and release method was developed to conserve fish populations. Conservationists advocate for this method to ensure sustainability and prevent overfishing.

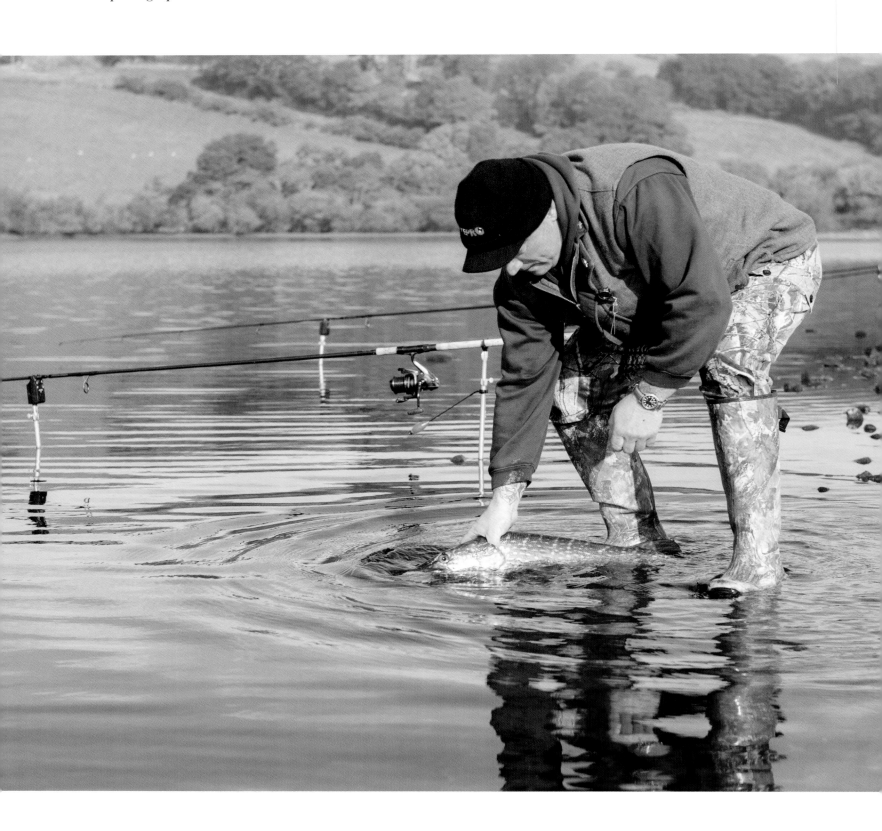

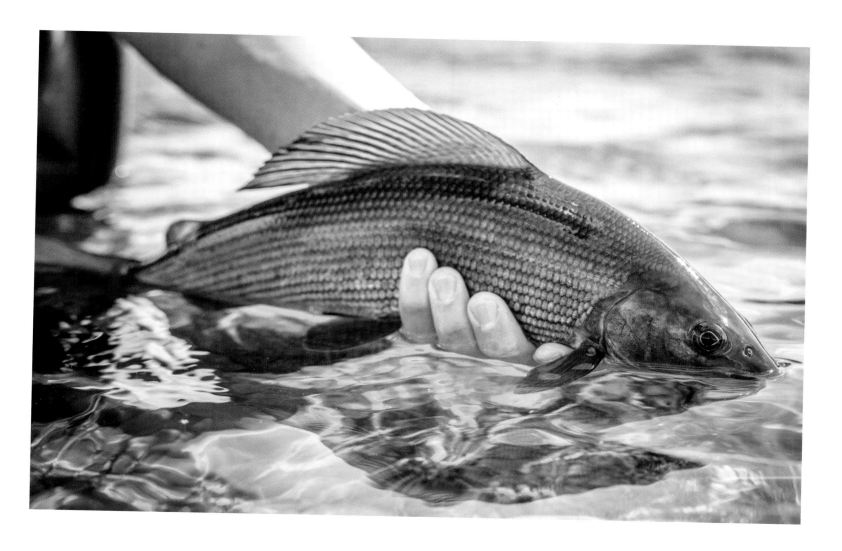

For successful catch and release, a gentle fishing technique is essential, where the fish is hooked in the front part of the mouth, causing minimal injury. This method is particularly suitable and popular among fly fishermen and carp anglers, but it is also commonly practiced in predator fishing with lures.

Anglers around the world have been practicing catch and release for decades. While the method is not only accepted but sometimes even mandatory in places like the United Kingdom and the United States, catch and release is a controversial topic in Switzerland and Germany, conflicting with local regulations.

↑ The flag of the grayling, as the distinctive dorsal fin of the salmonid species is called, shimmers magnificently in the sunset.

← Catch and release when deadbaiting. This angler gently releases his pike caught on dead baitfish.

→→ Releasing a brown trout. The release of native salmonids is mandatory in many waters. Thanks to the landing net with a silicone net, this is particularly gentle.

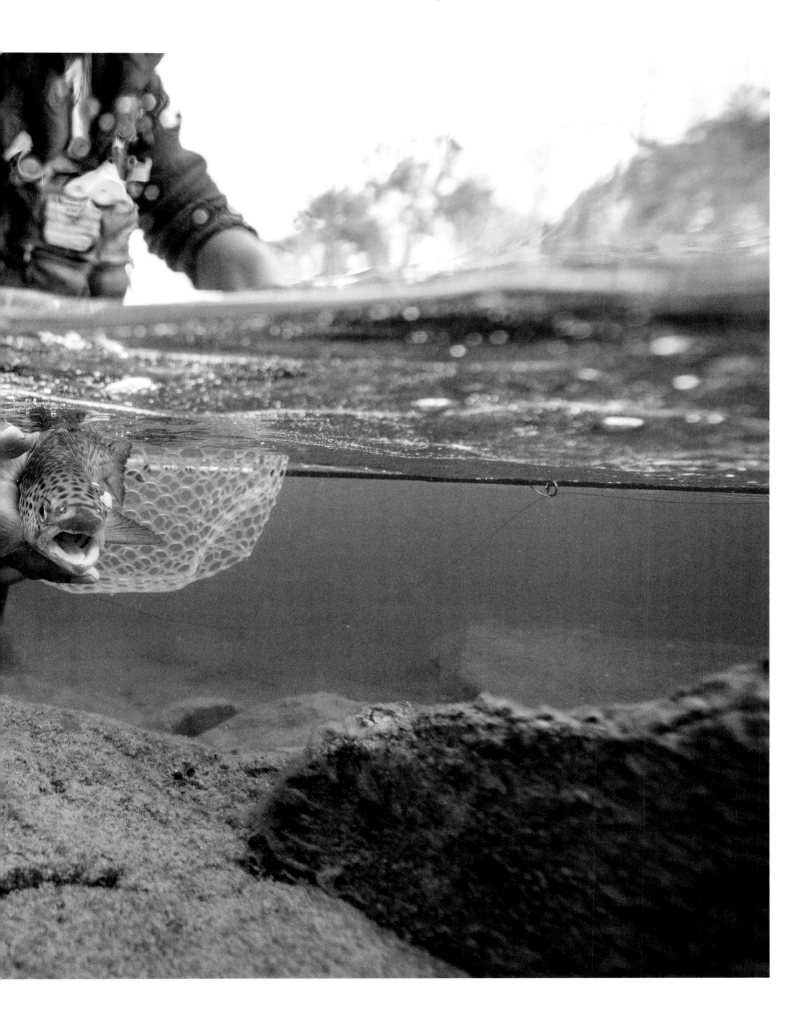

↓ Opinions differ when it comes to landing nets. Some anglers swear by so-called »hand landing« to reduce abrasion of the mucous membrane to a minimum.

→ The angler gently presents his catch just above the surface of the water. A snapshot captures his flying visit.

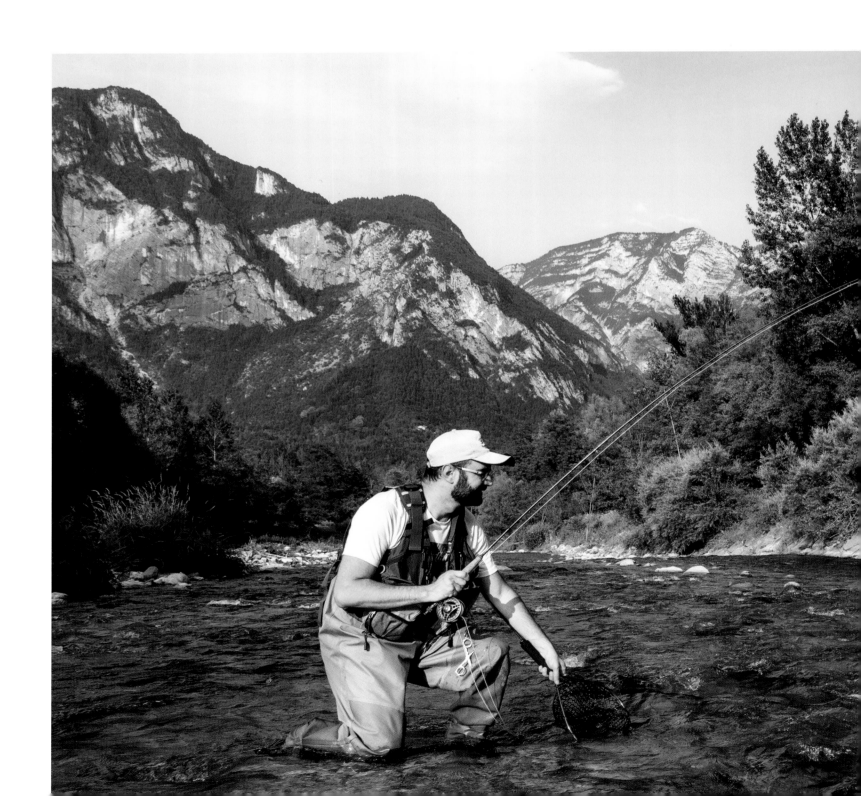

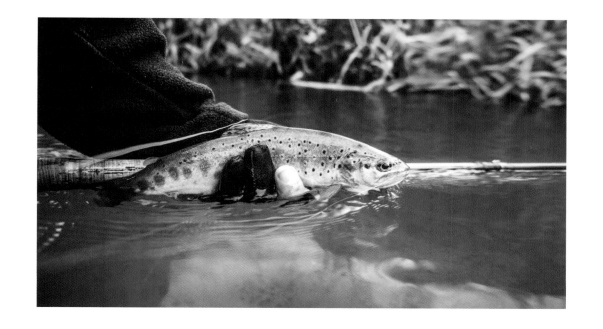

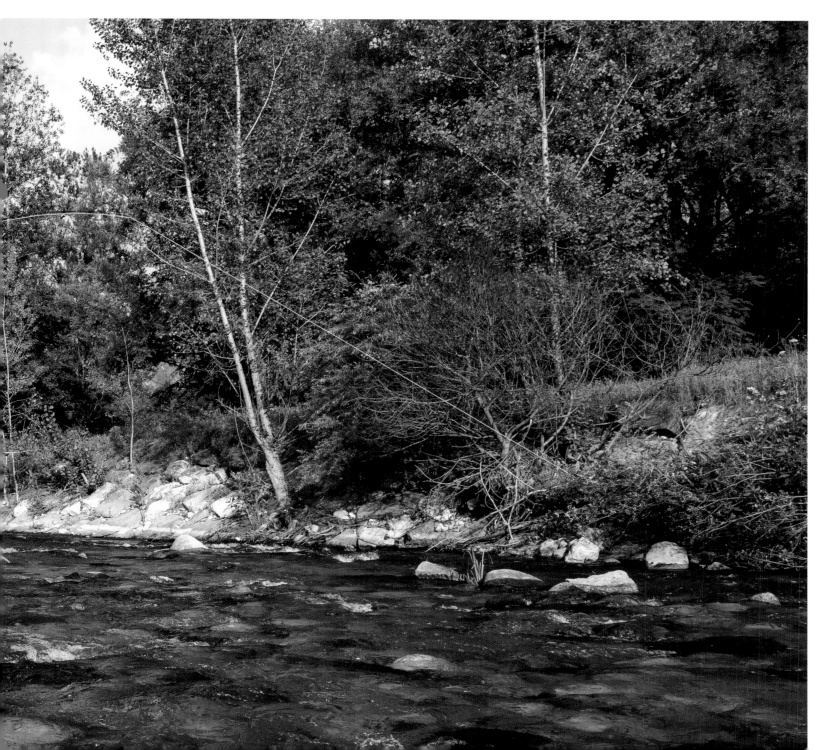

Waters and Seasons

»The world is water, and we are all connected by its deep, flowing rhythm.« — Roderick Haig-Brown

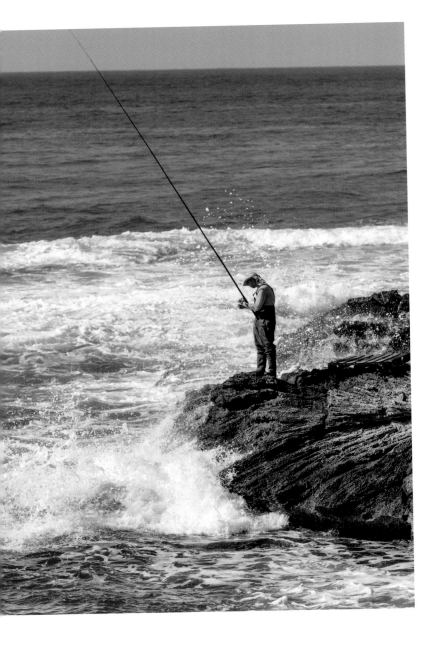

Still and Flowing Waters

Water has always a special allure for humans, offering a versatile range of fishing locations.

Commonly, waters are classified into flowing and still waters, but this distinction doesn't fully capture the diversity of fishing environments available. There are small streams and roaring rivers, industrial canals and small ditches, large reservoirs and tiny ponds. Additionally, there are regional variations in water bodies.

Each type of fishing water has its own unique charm and fishing challenges, providing habitats for different fish species.

← Not exactly calm, but not flowing water either. The waves lash wildly against the rocks by the sea.

→ Even in such turbulent watercourses, fish can be found.

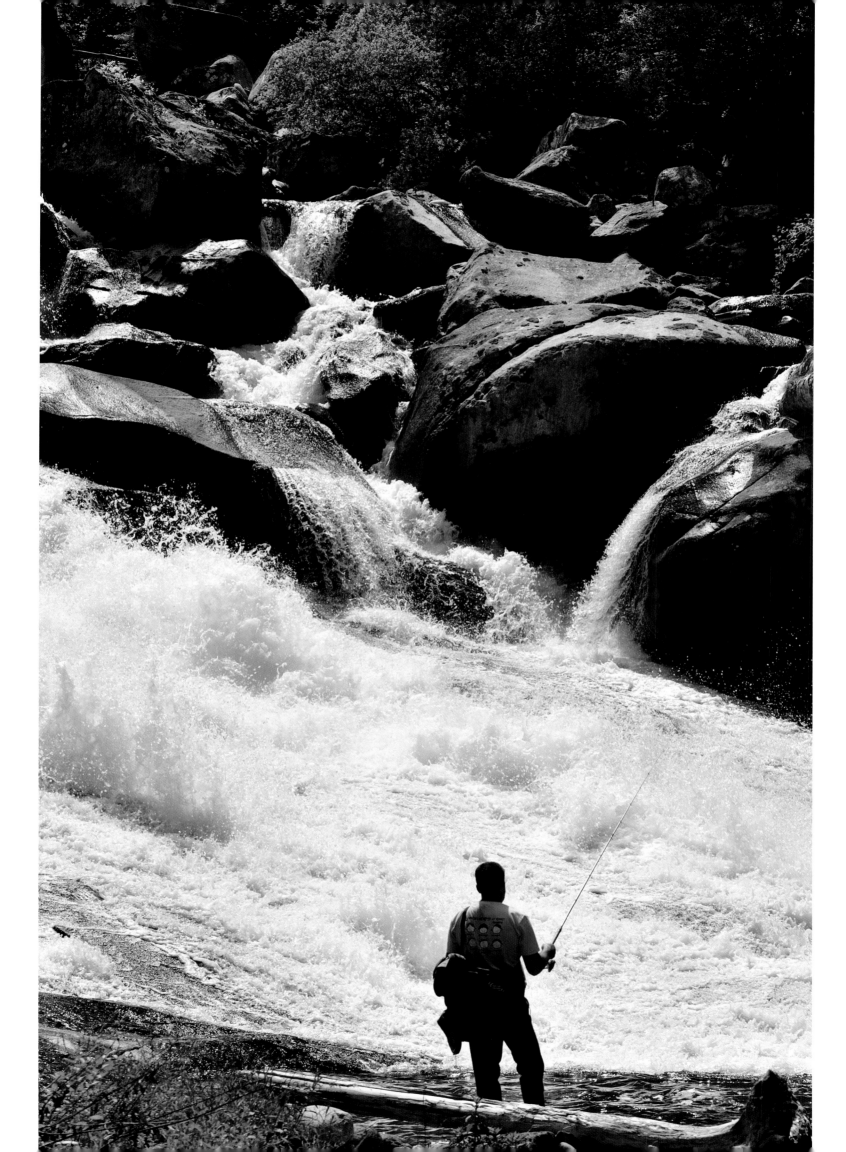

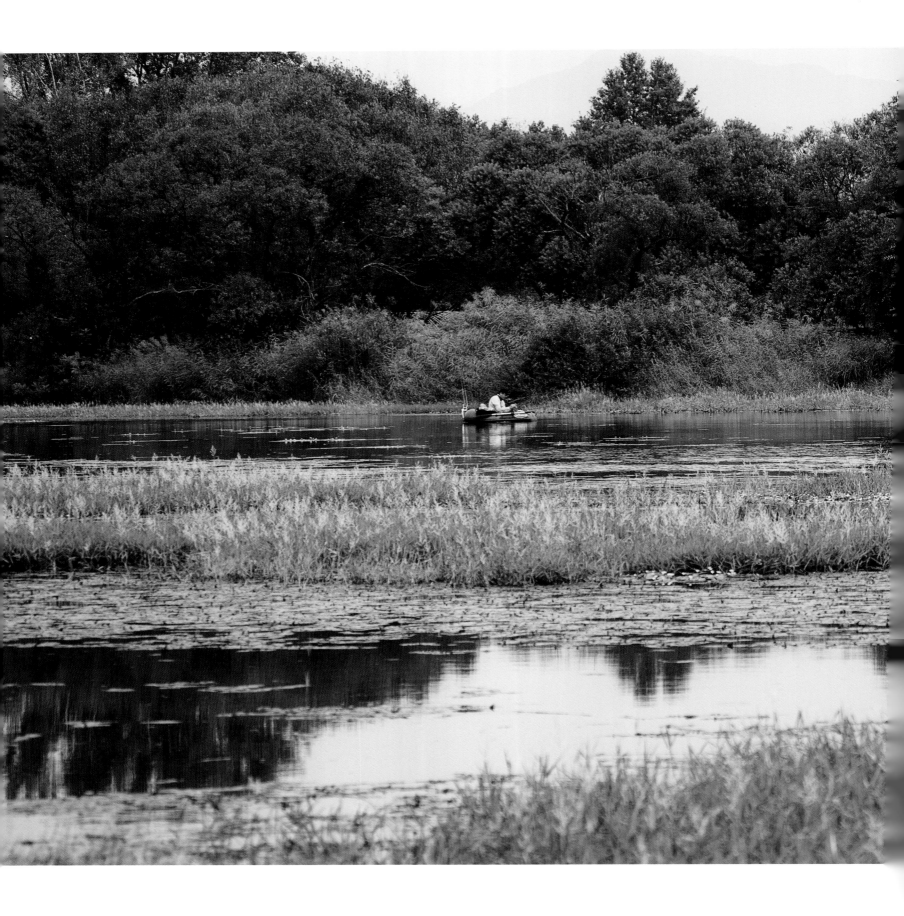

↑ In the calm shallow spots of a lake, these anglers prepare
their feeding grounds with a rubber dinghy.

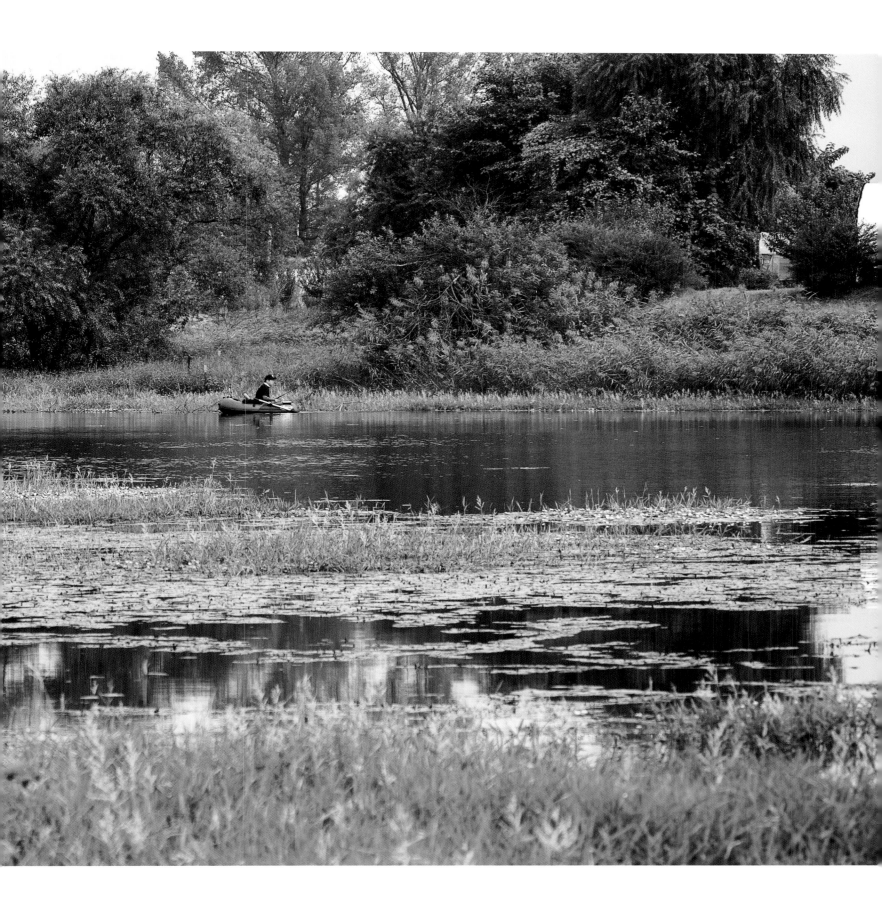

→→ The wonderfully relaxing spectacle of the rolling surf is combined with fishing here.

←← The small river Bode in the Harz Mountains promises a wonderful nature experience and a good catch.

→ Wood, stones and a handful of water for the fish, combined with a magnificent view for the Bode angler.

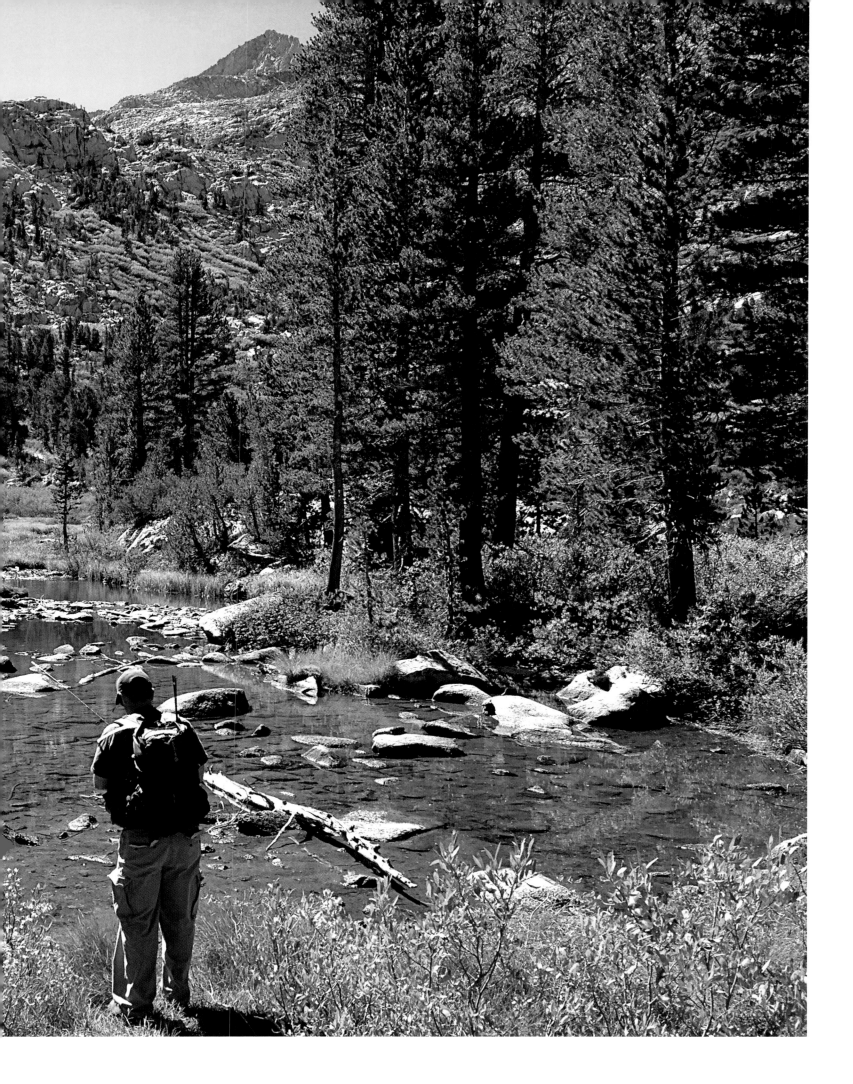

↑ The Netherlands stands for canal fishing like no other
country. Lock times and shipping traffic set the tone in the often
unstructured waters.

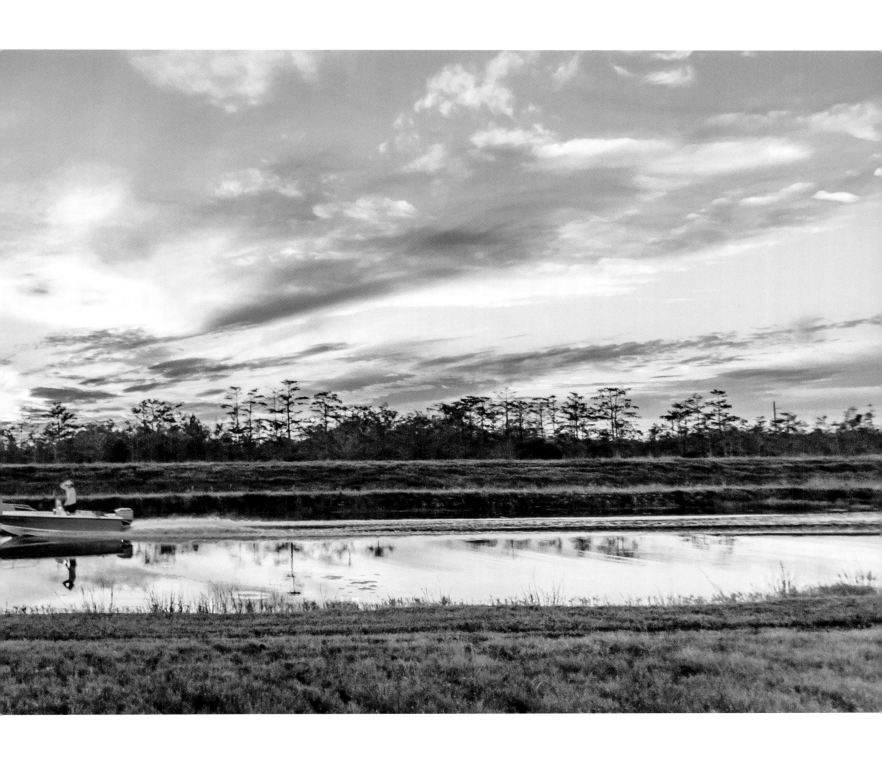

→→ In the Narodowy Ujście Warty National Park in Poland, the riverside landscape and the natural watercourse of the Warta are strictly protected. But fishing is allowed.

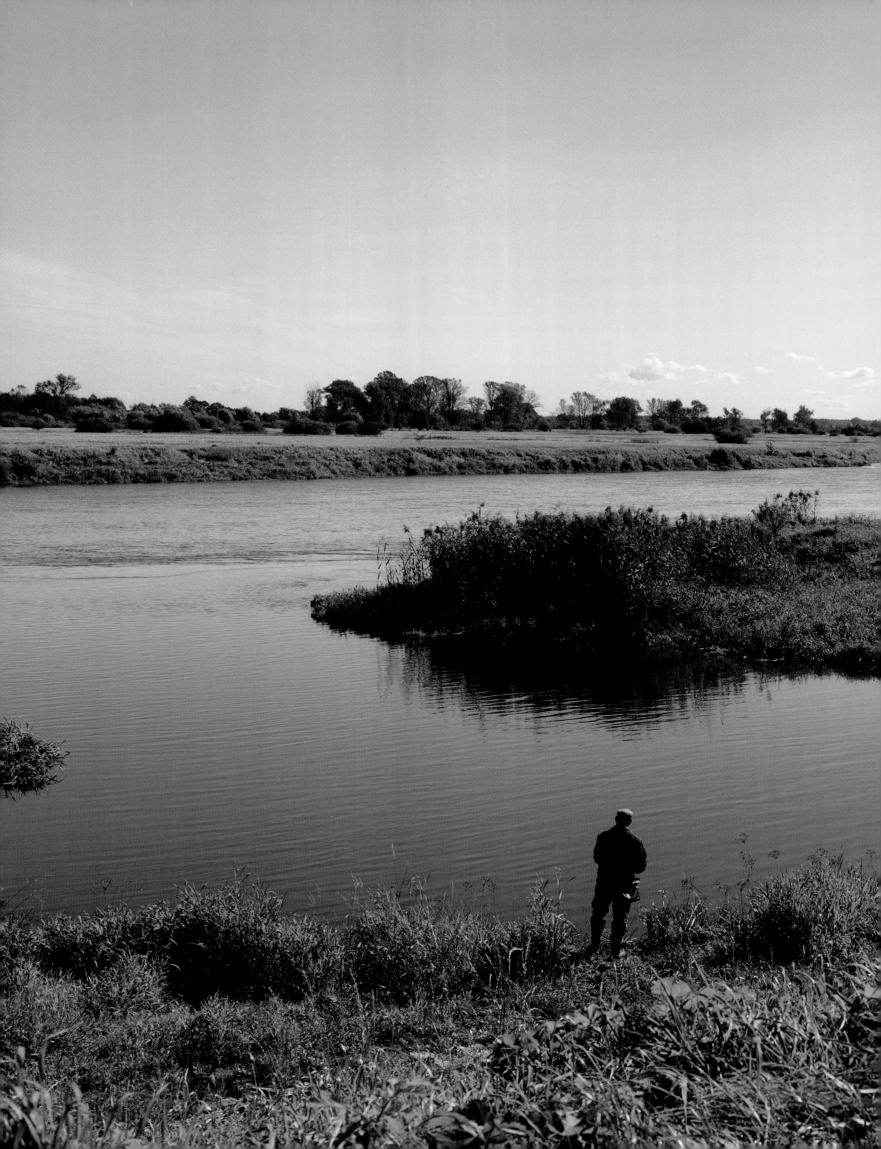

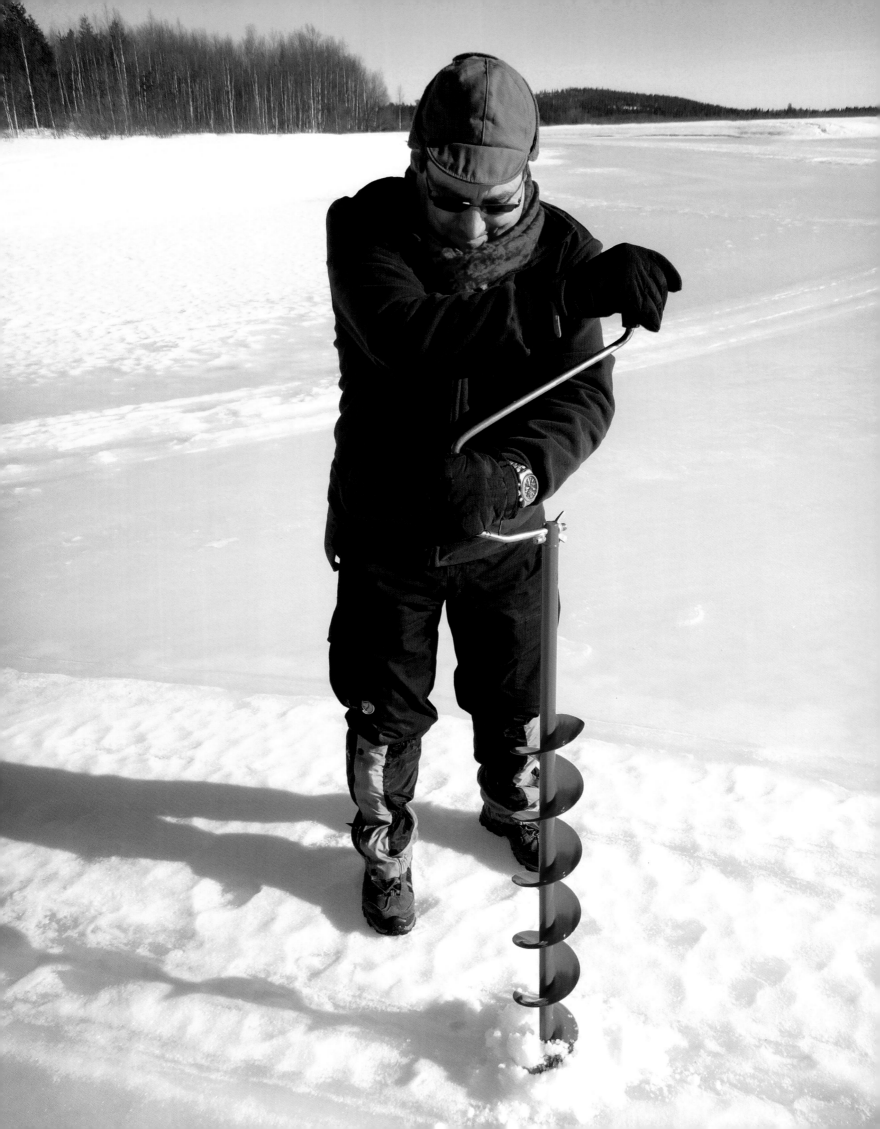

Ice Fishing

Strictly speaking, frozen lakes are not a special type of water, but they do offer a very special fishing environment.

Ice fishing naturally occurs in winter or in very cold regions when lakes, ponds, rivers, and other fishing waters are covered by a thick layer of ice. It is a popular activity in regions with cold winters, such as Scandinavia, Canada, Russia, and parts of the United States.

Before starting, an ice auger is used to drill a hole in the supporting ice. The hole should be large enough to insert the fishing rod and lift the hooked fish out.

Ice fishing requires specialized rods and reels optimized for winter use. These rods are often shorter and stiffer than conventional fishing rods. The rods are placed on ice fishing rod holders with visual bite indicators.

Popular fish species for ice fishing include pike, perch, and trout.

Sometimes, shelters like ice tents or huts are used to protect against the elements and create a more comfortable fishing environment.

← The angler uses the ice auger to gain access to the water.

↓ Now it's time to wait - but without water movement, the ice hole soon freezes over again.

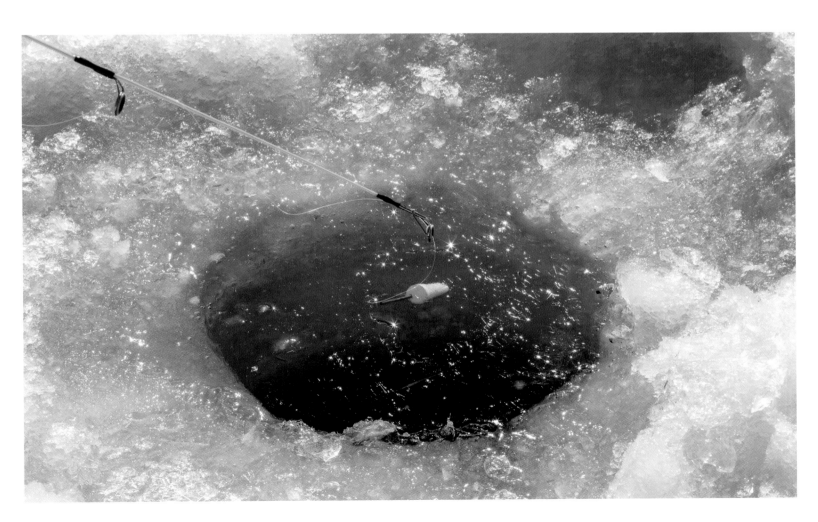

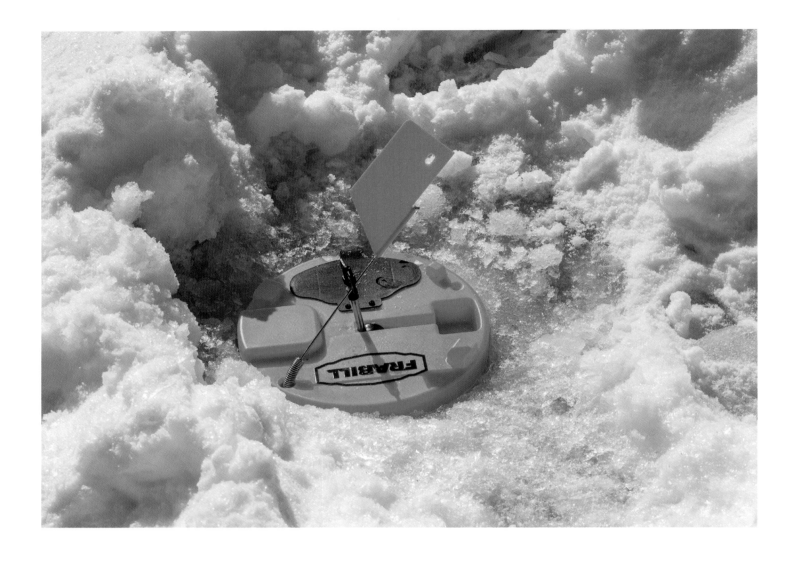

↑ The »tip-up« holds the bait in position and indicates a bite by means of a flag.

→ If a bite occurs, this flag points vertically upwards.

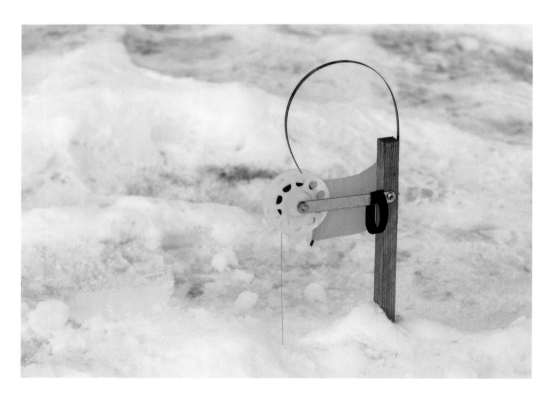

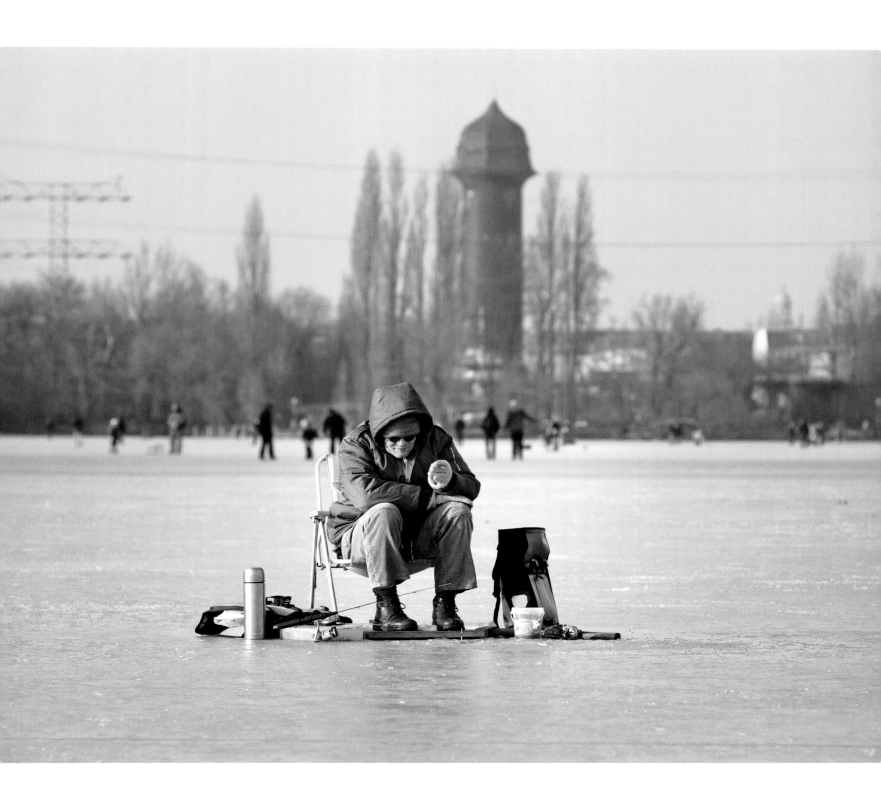

↑ The ice angler waits patiently for the next bite. Behind him, passers-by cavort on the thick layer of ice.

→→ Not only are the anglers crowded together on the ice, but also the fish underneath – typical of winter.

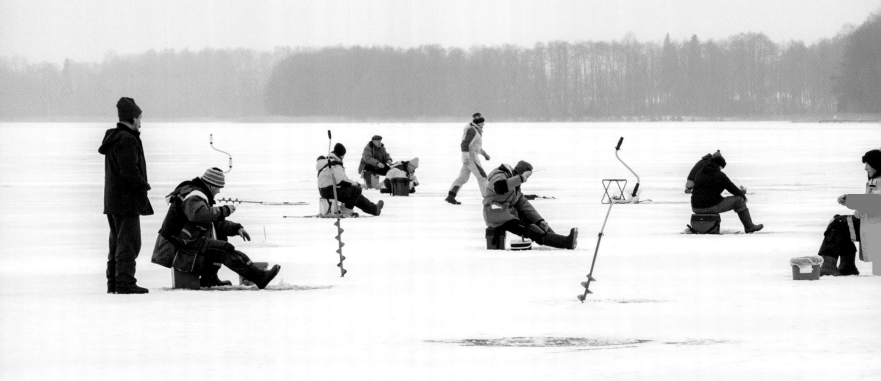

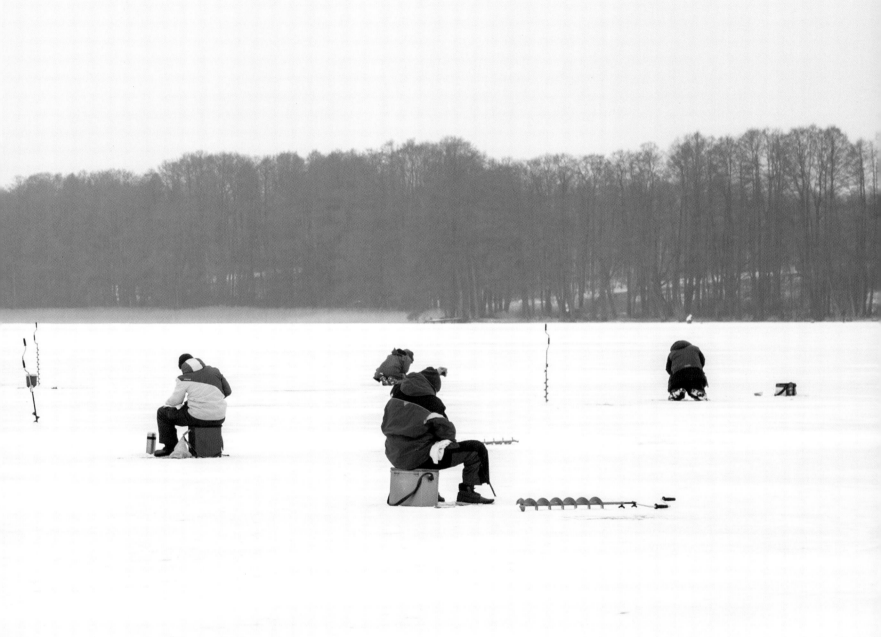

Fish Profiles

Atlantic Salmon

The Atlantic salmon primarily inhabits the Atlantic Ocean and is one of the most widespread species of salmon in Europe and North America. In late autumn, these salmon migrate up the rivers of Europe and North America to spawn in the upper reaches. An adult salmon can reach up to 5 feet (1.5 meters) in length and weigh up to 77.1 lbs (35 kilograms). Due to its size, grace, and spectacular leaps out of the water, it is considered the »King of Salmonids« by many anglers.

In their youth or during their freshwater residency, the diet of Atlantic salmon mainly consists of caddisflies, blackflies, mayflies, and stoneflies.

Adult salmon living in saltwater feed on larger prey, such as Arctic squid, sand eels, amphipods, northern krill, and sometimes herring.

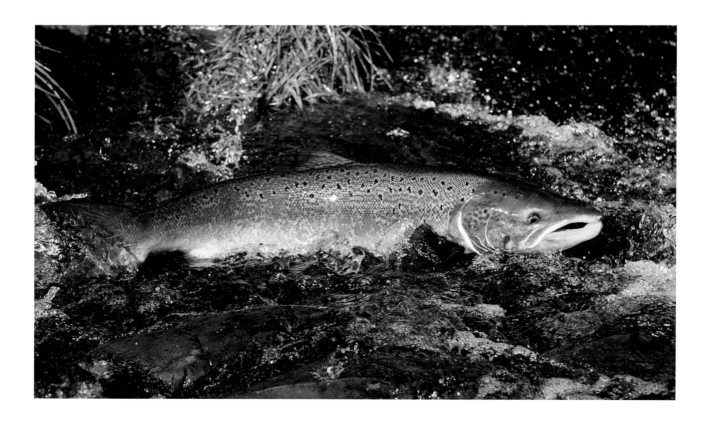

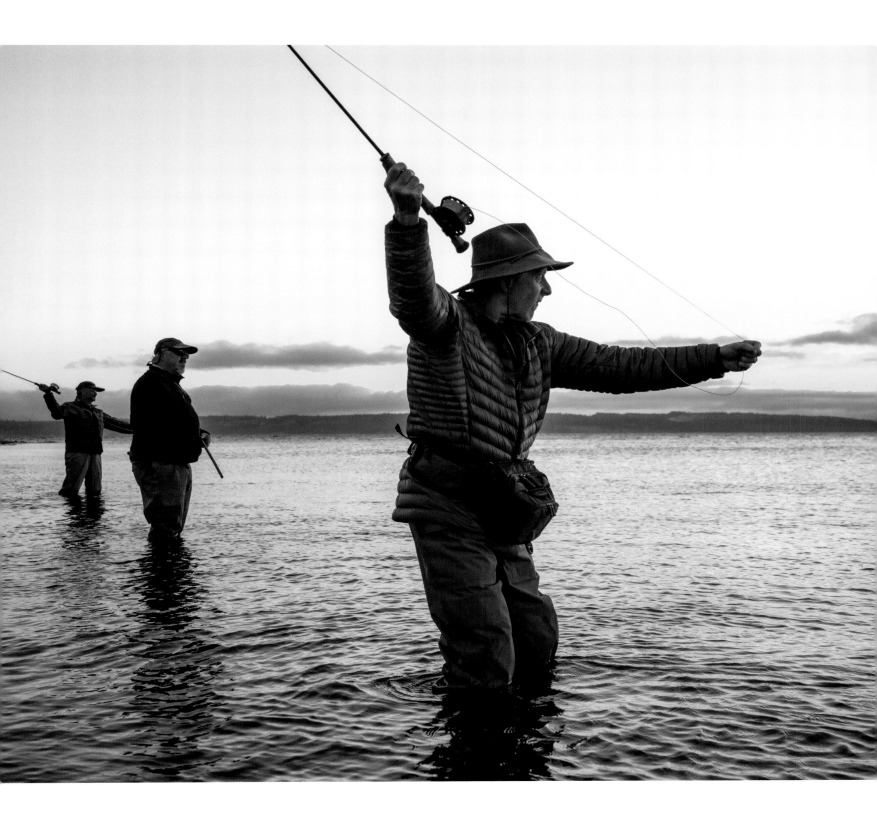

← Atlantic salmon in spawning dress. The male fish can be easily recognized by the spawning hook, a hook-like growth on the lower jaw.

↑ The anglers eagerly await together with their guide the arrival of the migrating salmon.

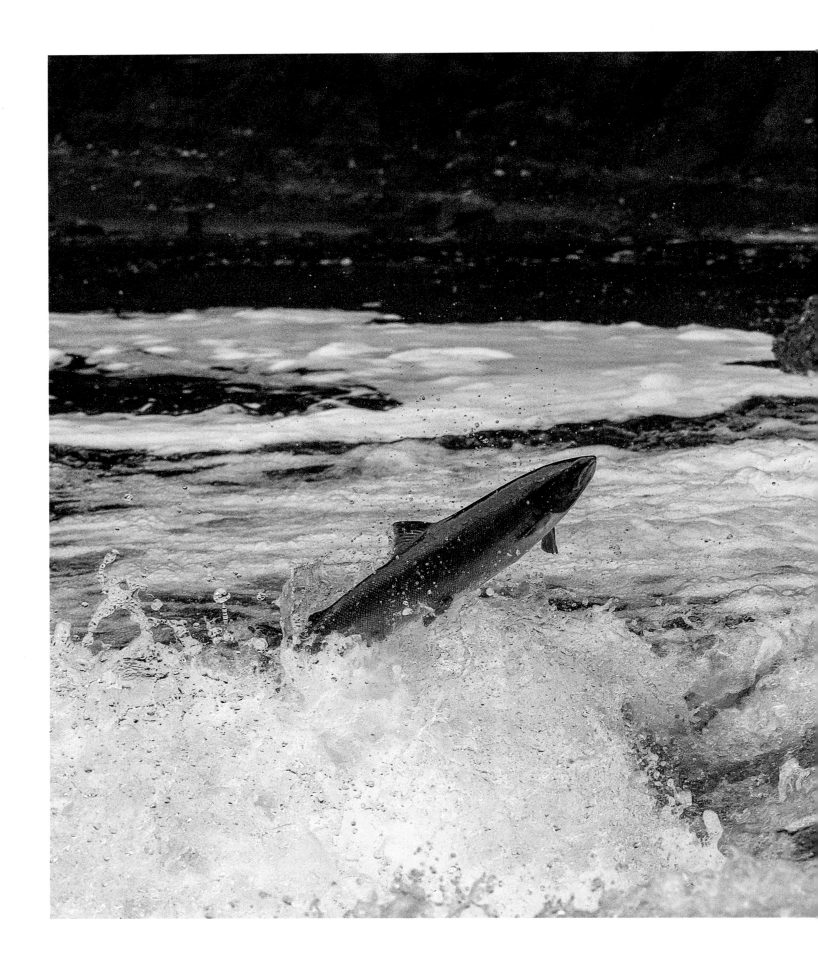

↑ On their migration upstream, the salmon not only cover long distances, but they also overcome several feet high obstacles such as waterfalls.

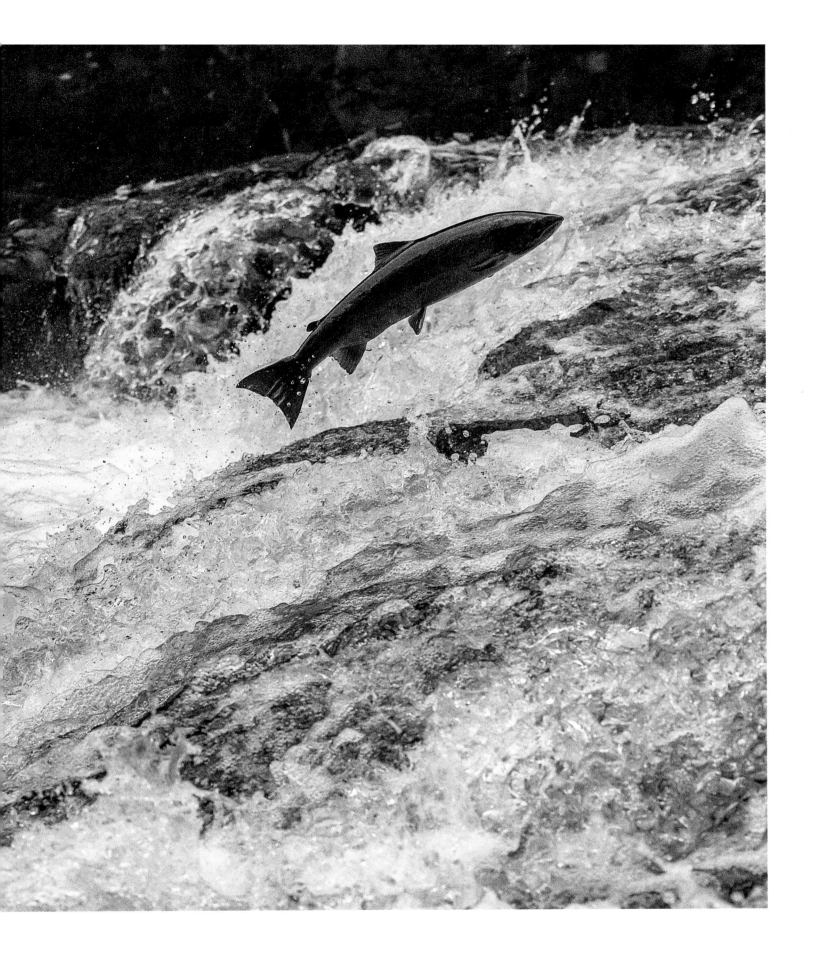

Brown Trout

The brown trout is a predatory fish belonging to the salmonid family. Depending on the food supply, brown trout grow to a length of 0.65 to 2.6 feet (20 to 80 centimetres); in exceptional cases, sizes of 3 feet (1 meter) and weights of over 33 lbs (15 kilograms) are possible. Their back is olive-blackish brown and silvery blue, with red spots with light borders appearing towards the belly, which is whitish-yellow.

Brown trout inhabit fast-flowing, oxygen-rich, cool, and clear waters with gravel or sandy bottoms throughout most of Europe.

Their diet varies based on their size and habitat but primarily consists of insects and aquatic insect larvae, small fish such as bullheads, smaller crustaceans, as well as snails and other aquatic creatures.

→ Sometimes it is no easy task to gently net a brown trout in the current.

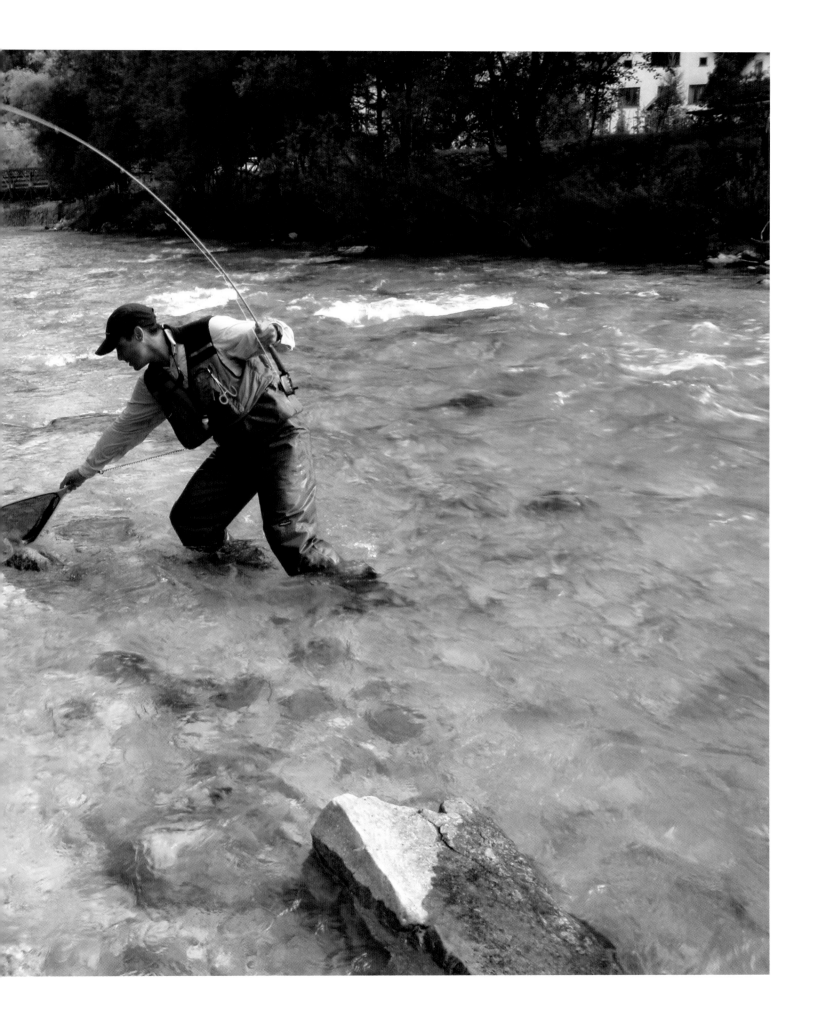

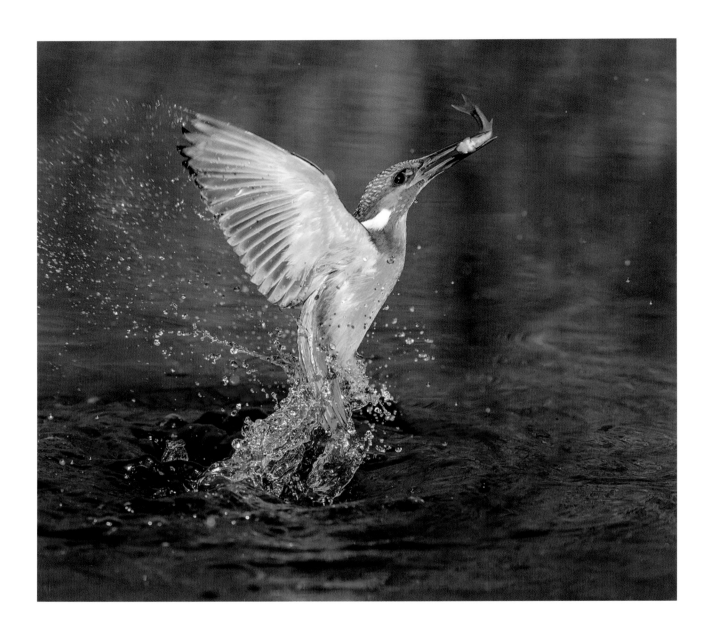

↑ The kingfisher is a shy but welcome guest at the
water's edge. It is considered an indicator of intact flora
and fauna and, unlike waterfowl such as the cormorant,
does not pose a threat to native fish stocks.

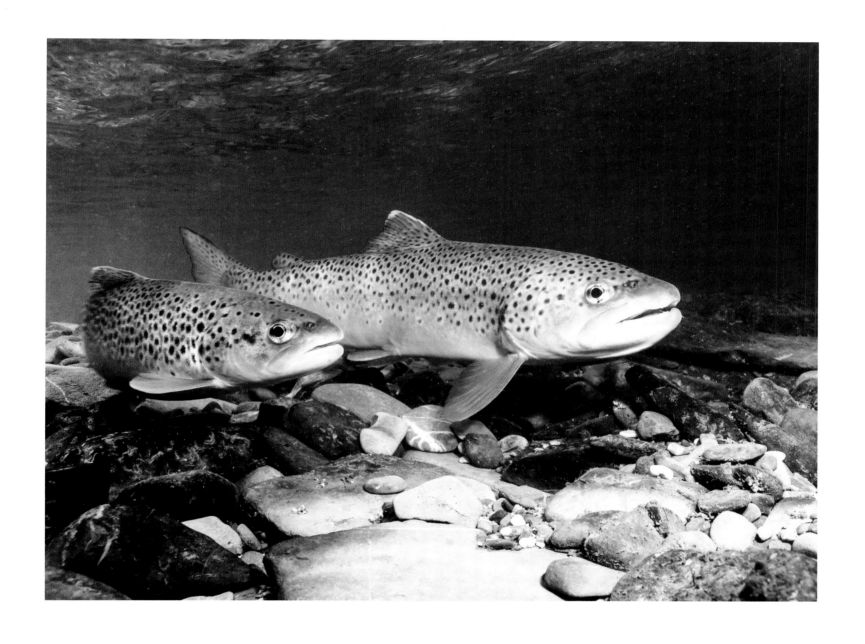

↑ Brown trout pair during spawning. After the females have laid their eggs (roe) in the water, fertilization takes place through the milky sperm of the male fish.

Char

Char belongs to the salmonid family. They can be found across the Northern Hemisphere and typically prefer cold, clear freshwater environments.

While the lake char is a European fish found in the deep pre-alpine and alpine lakes, the so-called brook trout is native to America. Despite their geographical differences, these fish are visually very similar and closely related.

→ At the diving station: After the char has caught an insect on the surface of the water, it immediately dives back into the depths.

↓ The otter may look cute, but among anglers, it is an unpopular guest on the water. Its hunger is great and the predator does not even stop at large fish.

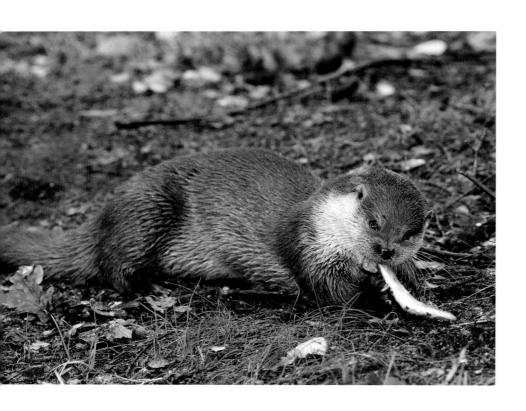

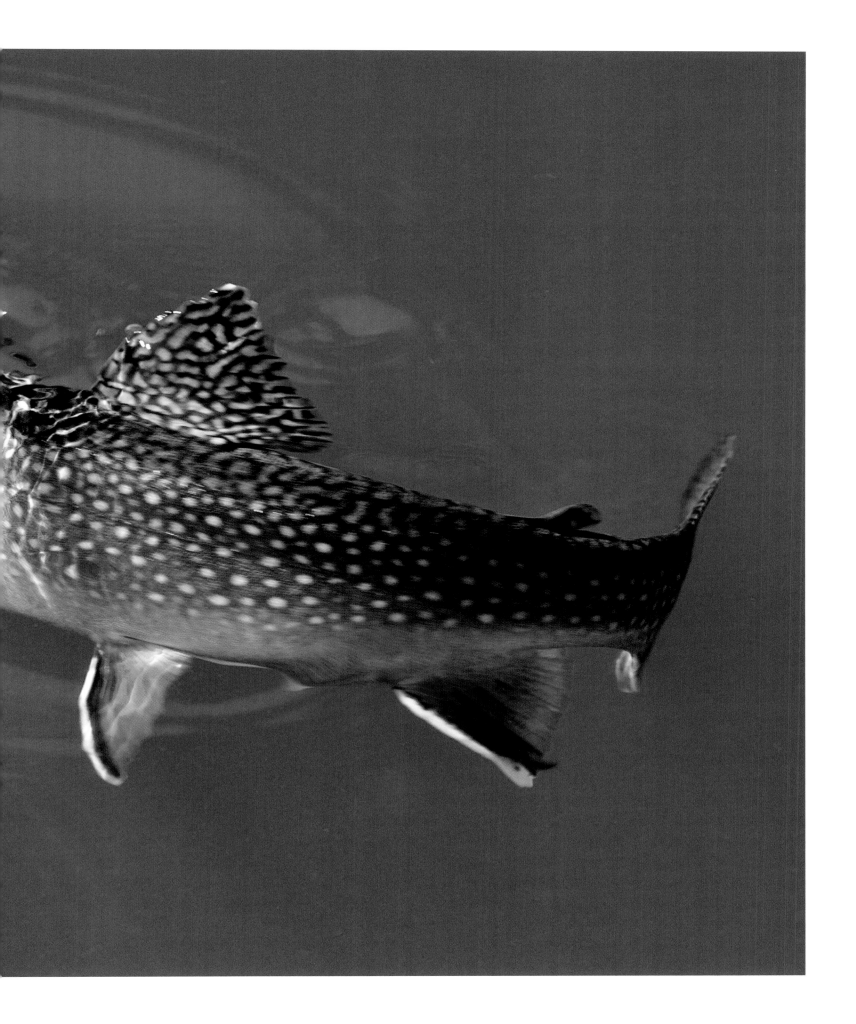

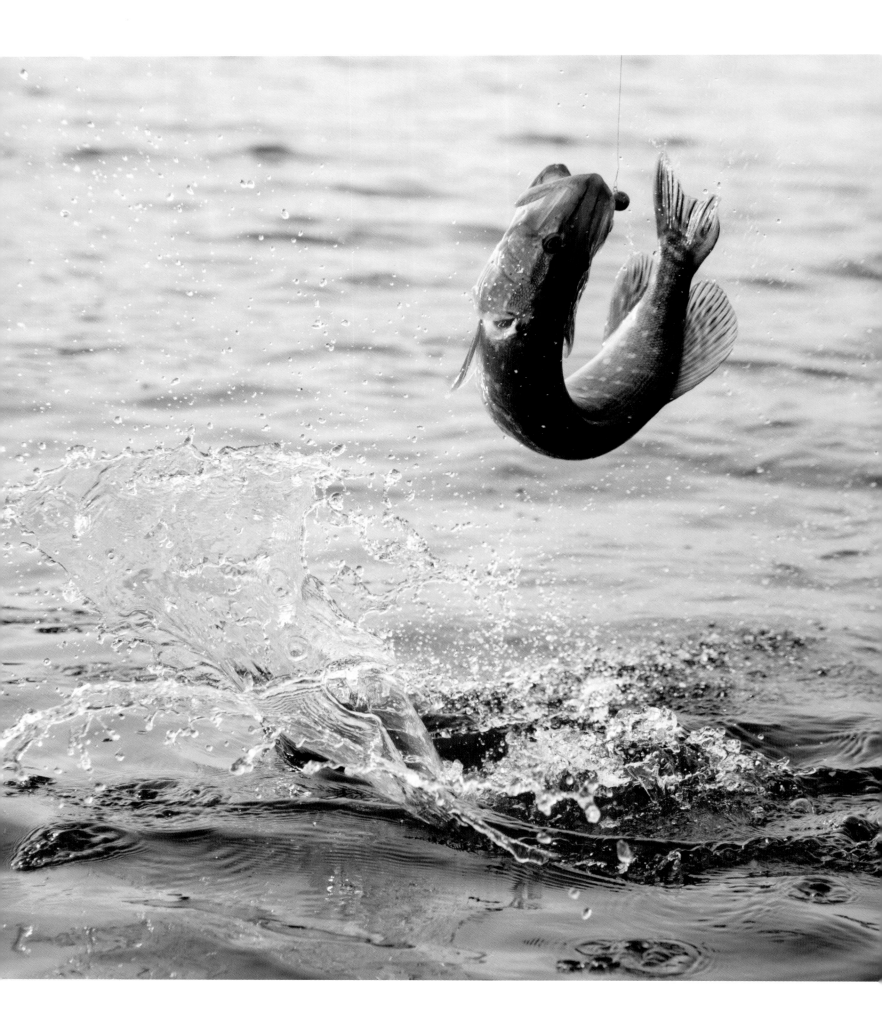

Pike

The European pike – distinct from the similar American pike, which is not native to Germany – is a fish species easily recognized by many. It features a long, rounded body and a large mouth reminiscent of a duck's bill, filled with numerous teeth.

The coloration of pike varies with their habitat. Young pike tend to be greenish and banded, while older individuals are more yellowish with spots or flecks. In dark moor waters, nearly brown-black pike can be found.

Pike can grow up to 5 feet (1.5 meters) in length and weigh up to 55 lbs (25 kilograms).

← Acrobatic leaps like this are not uncommon with pike during the fight.

↓ Problem bird: Cormorants can devour vast quantities of fish and do not even stop at large prey. They are therefore feared by fishing clubs and fish farmers.

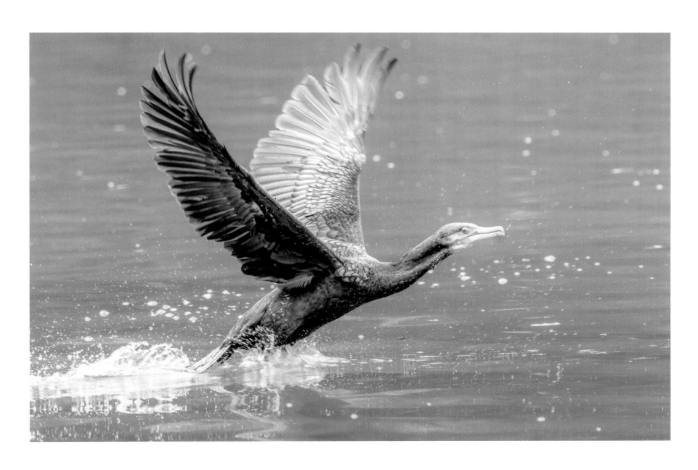

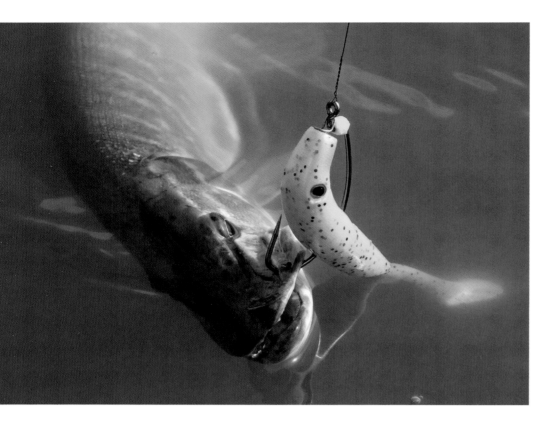

↑ This pike has fallen for a softbait. These artificial lures, also known as shads, imitate a fleeing prey fish and, thanks to their movable tail, generate pressure waves that appeal to the predator's lateral line organ.

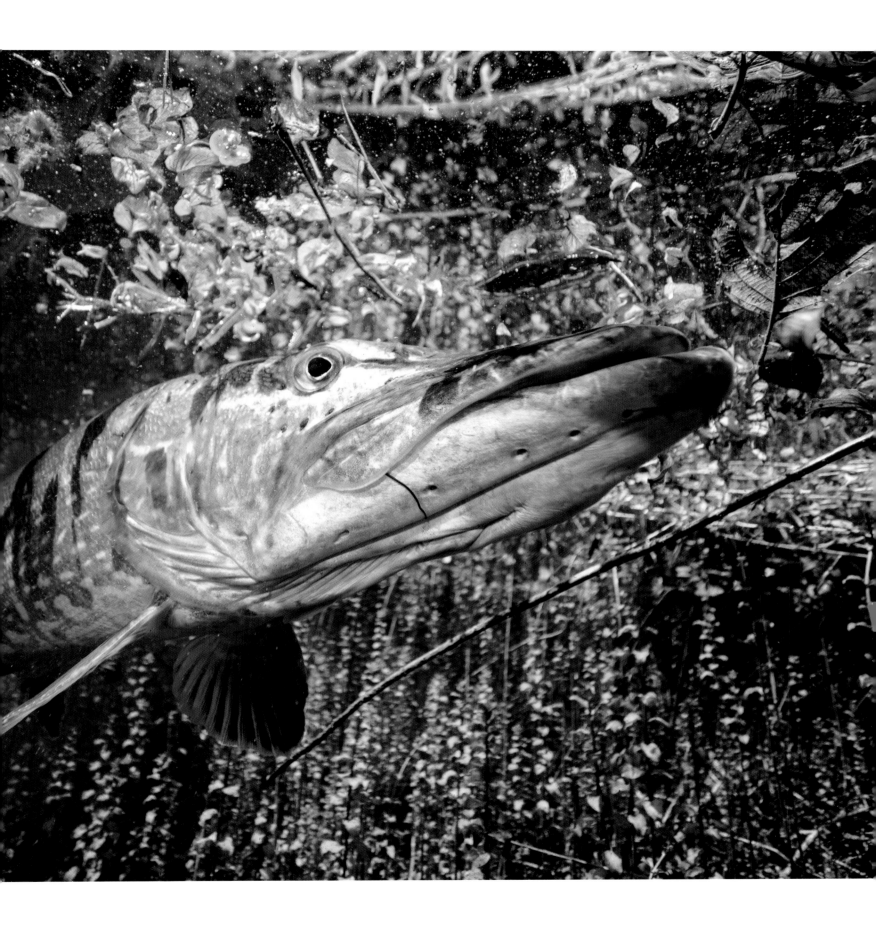

↑ Pike are territorial and often lie in wait for their prey from shelters in shallow water. They do not even stop at frogs and chicks. However, their main food is fish.

Musky

The muskellunge *(Esox masquinongy)* – often abbreviated as »musky« or »muskie« – is a predatory fish from the family *Esocidae*. Its natural habitat is in the eastern part of North America.

The name of the fish has nothing to do with muscles or lungs; it derives from its name in the Ojibwa language, *maashkinoozhe*, meaning »ugly pike« or »big fish«.

With maximum dimensions of 6 feet (1.83 meter) and 70 lbs (32 kilograms), the muskellunge is the largest species of pike.

Muskellunge are solitary and territorial. They typically lurk in hiding places to ambush potential prey. Adult muskies primarily feed on larger fish but occasionally prey on waterfowl and mammals up to the size of a muskrat.

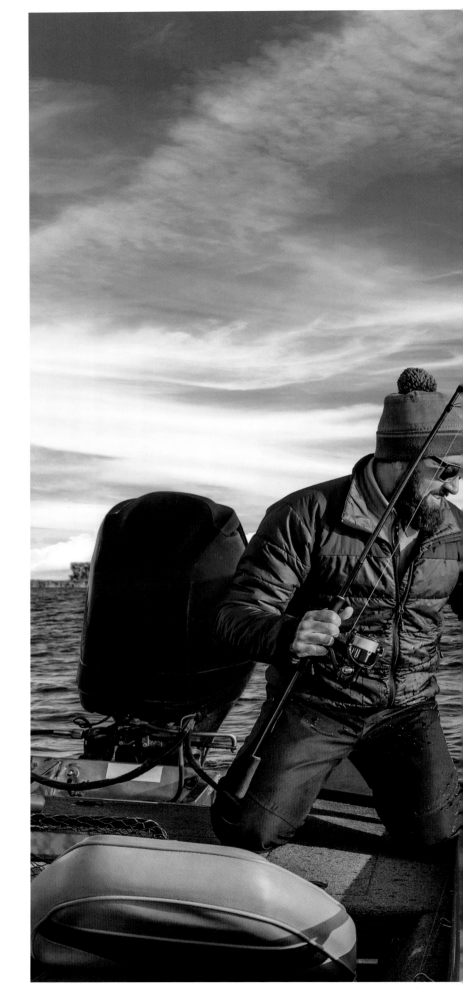

→ The musky is the big brother of the European pike and is difficult for the non-expert to distinguish from it.

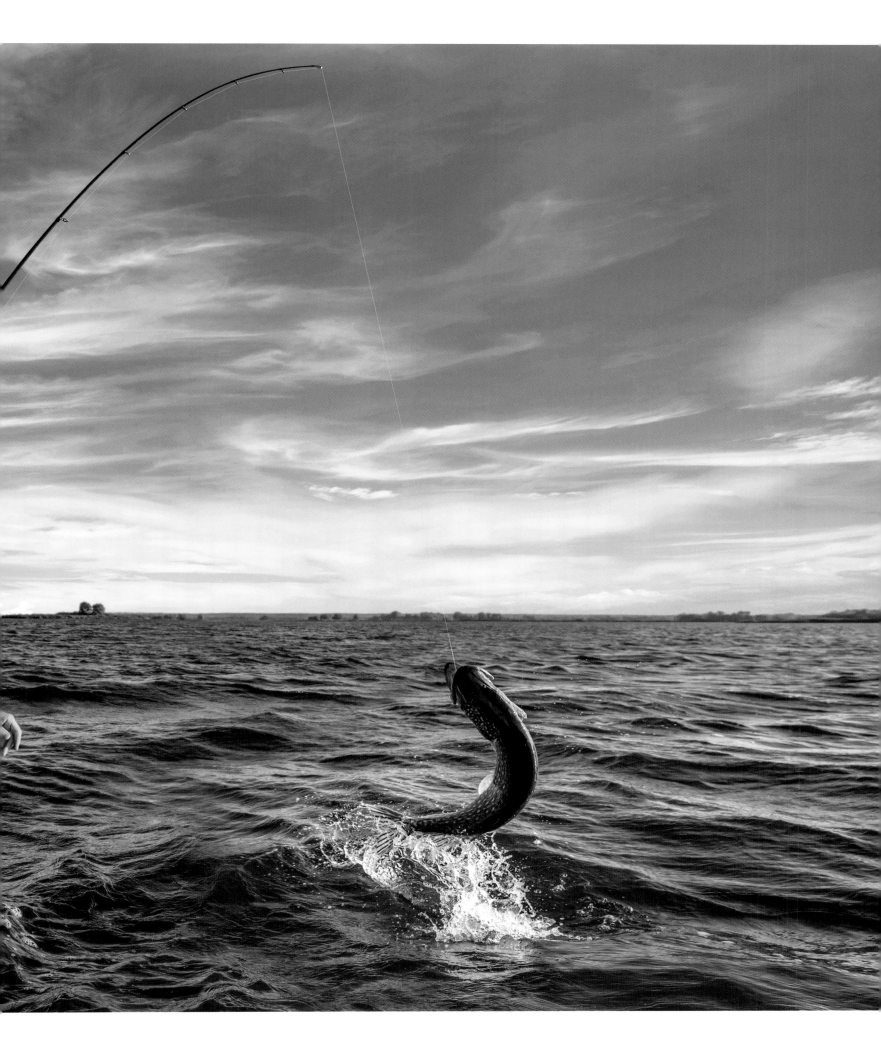

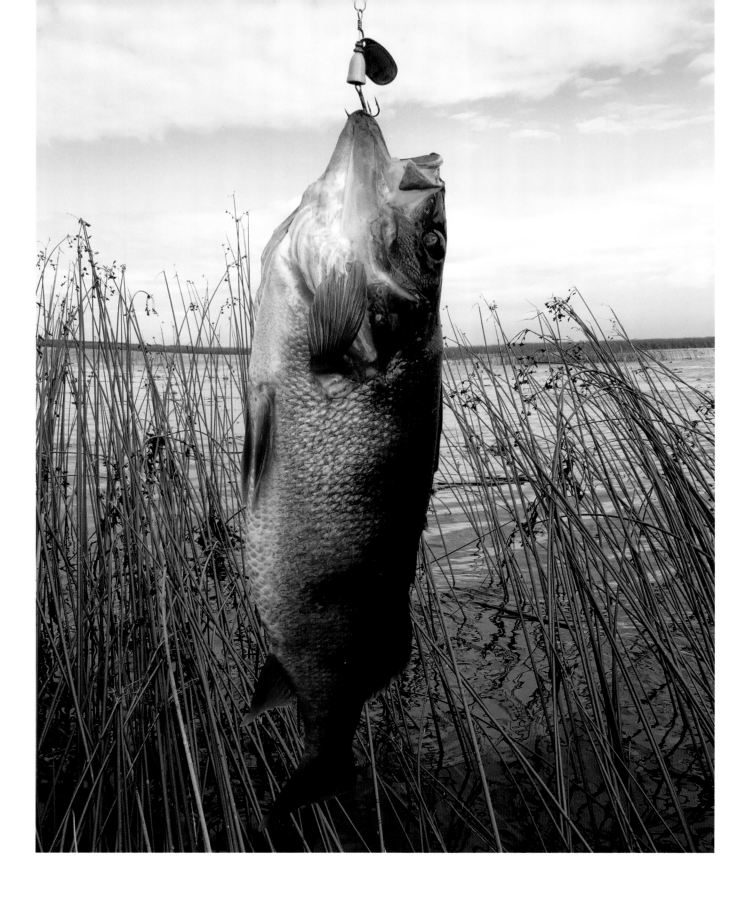

↑ This handsome perch has fallen for a spinner. Smaller predatory fish such as perch but also trout love these »tin lures«. Spinners are well suited to beginners in the sport of fishing, as the lure is not very complicated.

→ Baby perch: The perch fry live dangerously. It is not only larger rough fish that they like to eat. They are also on the menu of their own parents.

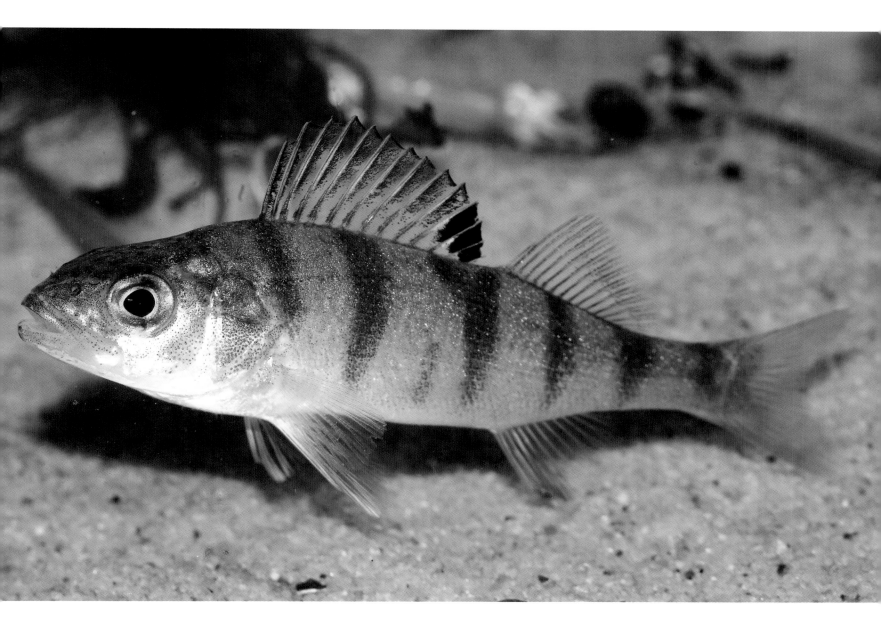

European perch

The European perch is a freshwater fish found throughout Europe, and among anglers, it is also known as the »spiny knight«.

Its distinctive features include its divided dorsal fin (characteristic of many perch-like species) as well as the reddish coloration of its pectoral and pelvic fins. The pelvic fins are located in the thoracic region. Both dorsal fins (especially the front one) and the anal fin are equipped with sharp spiny rays (hard rays).

Depending on the availability of food in their habitat, perches reach an average length of 0.65 to 1.3 feet (20 to 40 centimeters) and rarely weigh more than 2.2 lbs (1 kilogram). However, there are fishing waters with many large perches, such as the Rhine river delta, where fish over 1.6 feet (50 centimeters) are regularly caught. Specimens over 1.9 feet (60 centimeters) have also been reliably documented, though they are extremely rare. Depending on their habitat, some perches grow exceptionally slowly.

As distinct predatory fish, perches can be lured with various artificial baits such as spinners, twisters, or rubber fish of different (but mostly smaller) sizes. Additionally, fishing with (dead) baitfish is considered very successful. Small fish, such as small perches or gudgeons, are suitable baitfish for this purpose. Fishing with earthworms is also promising.

Black Bass

Due to its eagerness to bite and its great endurance during a fight, the black bass presents a particular challenge for spin anglers.

The black bass reaches a length of nearly 2 feet (70 centimeters) and a maximum weight of 11.9 lbs (5.4 kilograms). However, the largest officially recognized black bass in the United States reached a magical weight of 22.4 lbs (10.080 kilograms).

The native habitat of the black bass is in eastern North America. The black bass feeds on fish, crustaceans, and insects.

The massive head makes up more than a quarter of the total length. The mouth is large, with the lower jaw protruding. The dorsal fin is divided into two parts, with the front, spiny part being lower than the rear part.

The tail fin is slightly notched. Young black bass are olive green with light sides and a white belly. They have short vertical bars on their sides. Older fish become darker, solid grey-green or black.

↓ The black bass is originally native to North America, but has now also spread to the warmer regions of Europe.

→ The black bass has a very large head in relation to its body, and its mouth in particular is huge. It offers the angler a spectacular struggle during the fight.

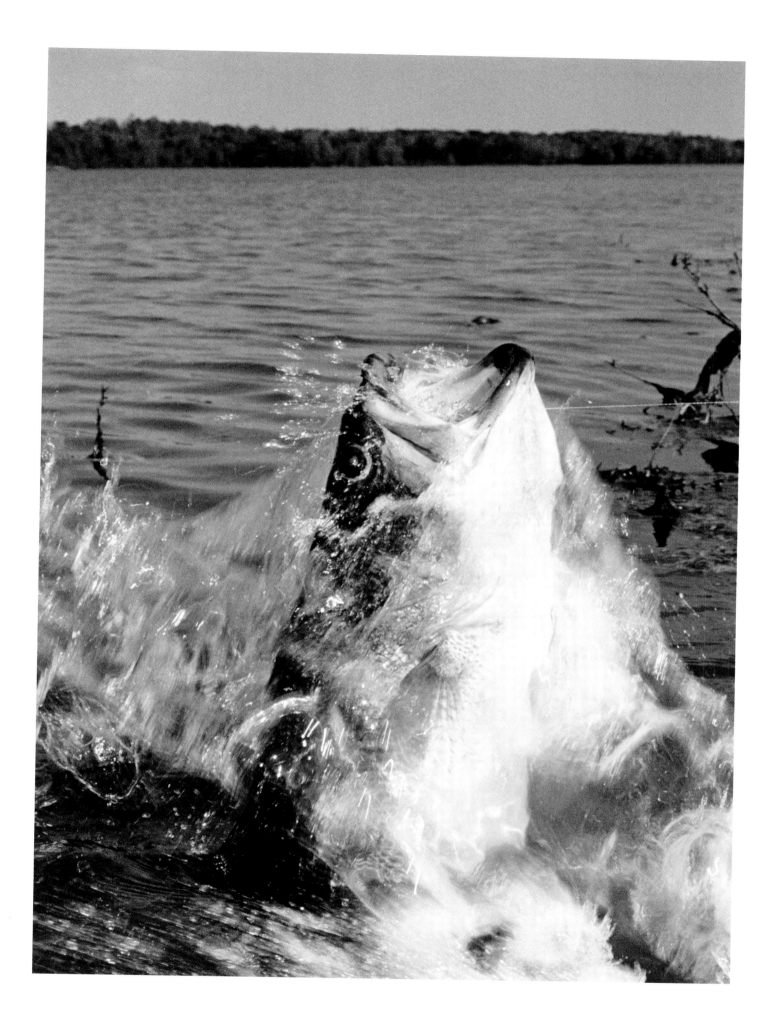

Carp

The different cultivated forms of carp are usually more compact and distinctly humpbacked. They also tend to grow faster than the wild form. The scales can vary in their reduction, distinguishing the following forms:

Common carp have a fully intact scale covering.

Linear carp have fewer scales, with a row of large scales along the lateral line.

Mirror carp have only a few scattered scales on the otherwise scale-less sides.

Carp are very popular among anglers due to their strong fighting ability, large size, and their selective response to boilies as bait. Carp fishing has evolved into a significant branch of angling, attracting many younger anglers in recent times. Fish weighing over 22 to 33 lbs (10 to 15 kilograms) are considered remarkable catches, depending on the fishing water. The world record for mirror carp, weighing 105.8 lbs (48 kilograms) and measuring 4 feet (125 centimeters), was set in 2015 at Euro Aqua Lake in Hungary. The new world record for common carp, weighing 100.3 lbs (45.5 kilograms), was caught in 2013 at Etang de Saussaie in France.

→ Carp usually feed at the bottom of the water. However, especially in the summer months, they slurp for insects on the surface of the water and can also be fed with bread in parks.

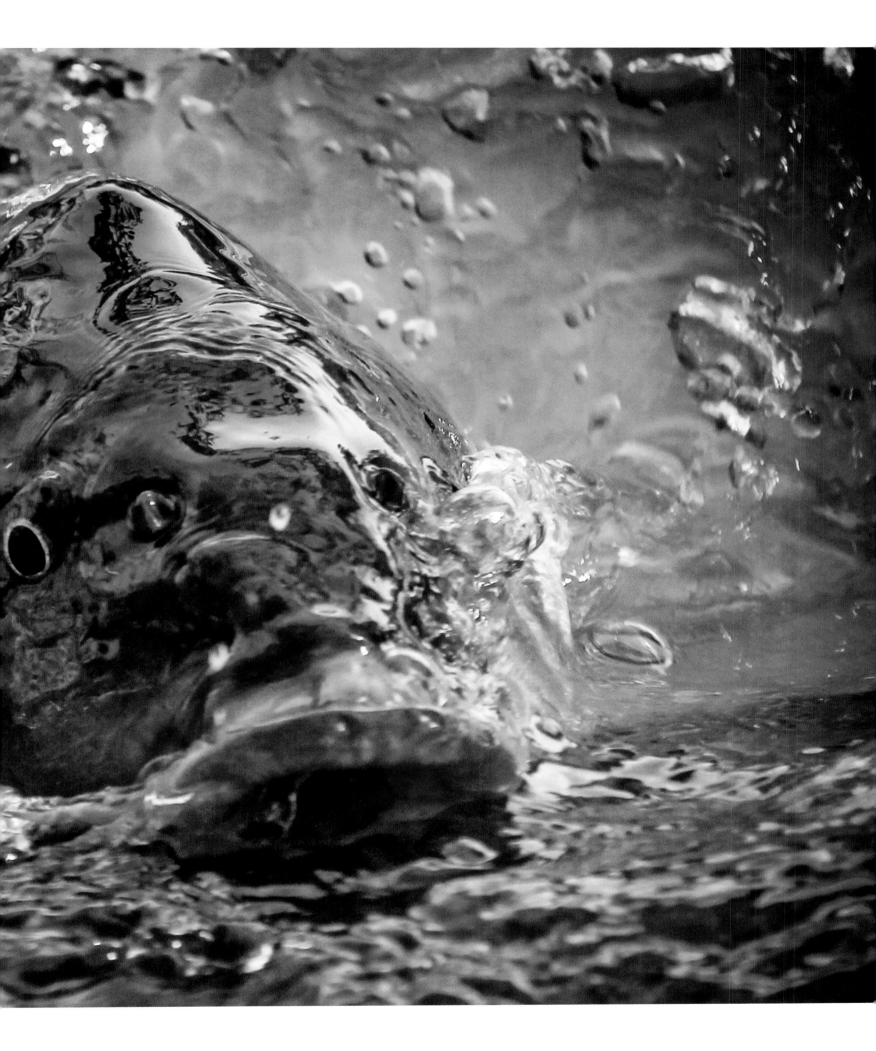

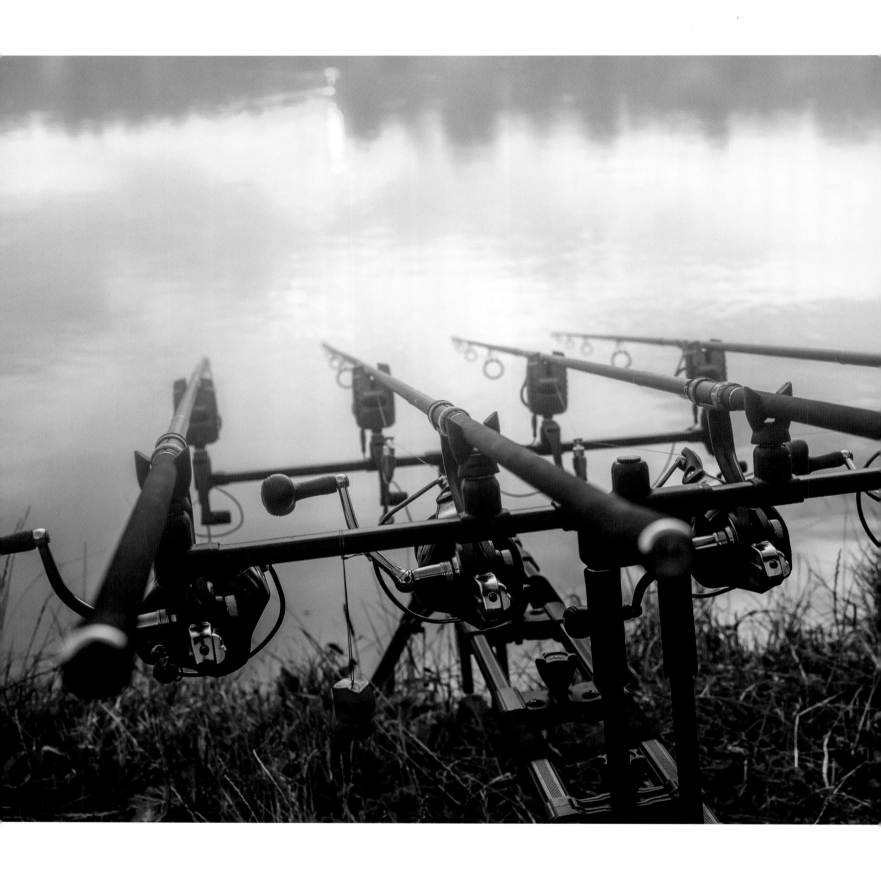

↑ Rodpod with four carp rods. While four rods can usually be used in France and three in England, German anglers have to make do with two.

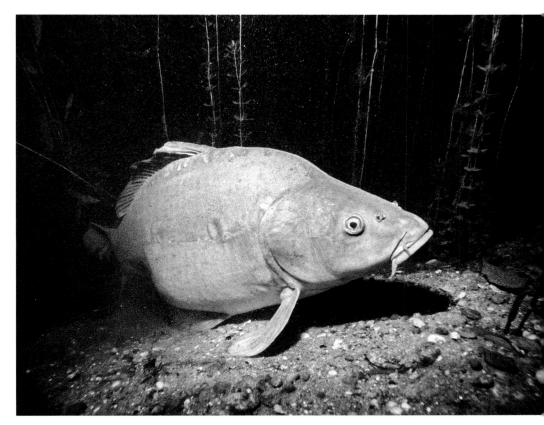

↑ A mirror carp in its element. The animals spend a lot of time feeding at the bottom of the water. The best way to catch them here is with boilies on a hair rig and self-hooking rig.

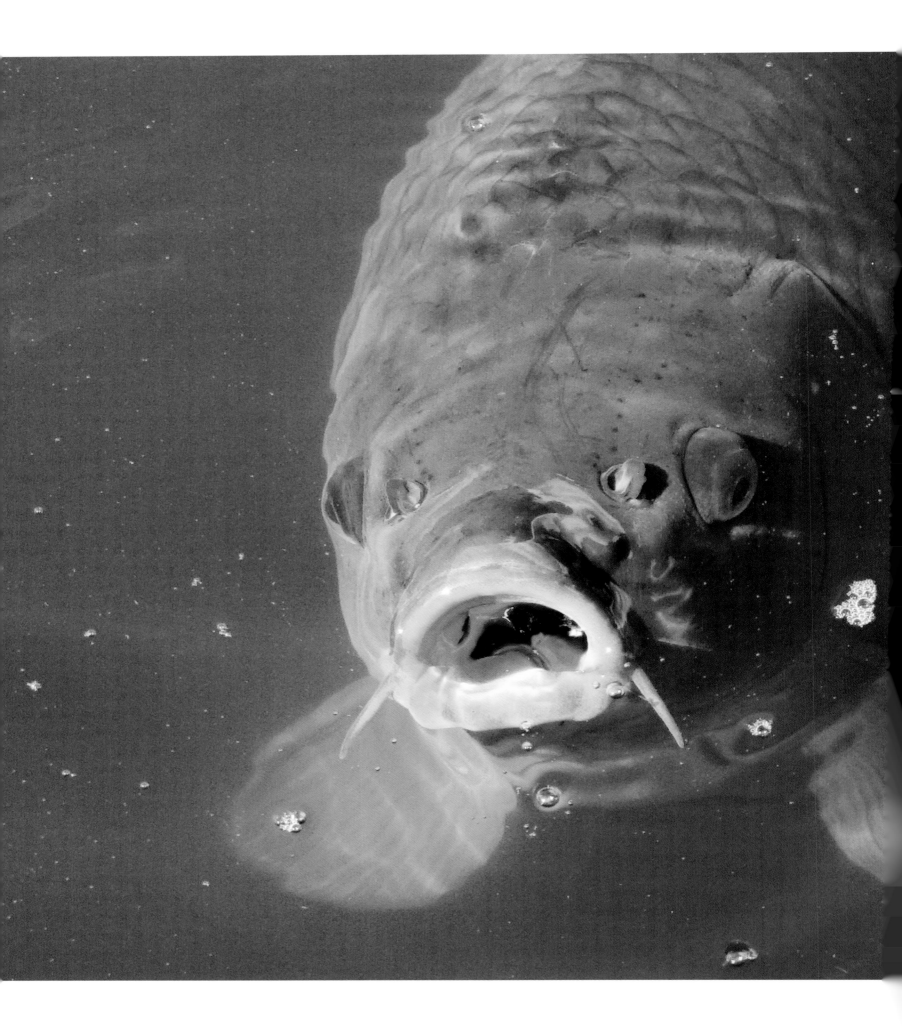

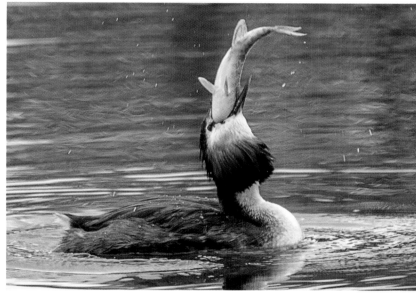

↑ Great crested grebes can dive deep for prey and also feed on larger fish. However, large carp are clearly outside the water-fowl's prey spectrum.

←← It seems that this Japanese koi carp has discovered something interesting on the surface of the water.

← With weighty elegance, this large common carp pushes itself along the surface of the water to slurp away the pellets introduced by the angler.

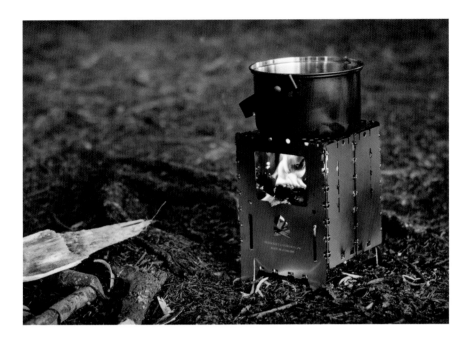

↑ Campfire atmosphere: A small campfire in the evening and a good cup of tea in the morning are a must for many die-hard carp anglers.

→ Other countries, other customs. Carp fishing is also practiced in Asia. However, fishing and camping equipment sometimes differ greatly.

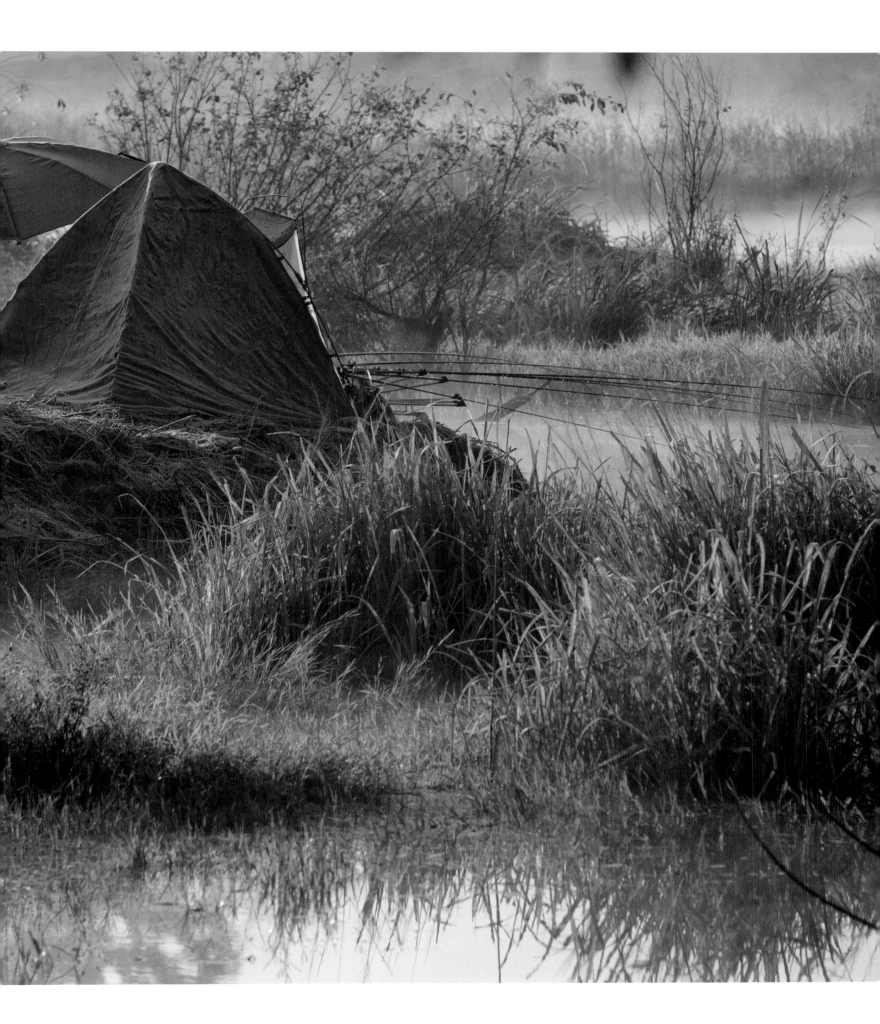

Other Target Fish

Not only salmon, trout, pike, perch, and carp are popular target fish. Among predatory fish, the zander is internationally popular among anglers. The tench is a favorite target among coarse anglers in England. And although bream are considered an undesirable bycatch by some anglers, there are enthusiasts for this species as well.

↓ Bream are very common in many waters and sometimes occur in large shoals. Anglers targeting other species such as carp often catch bream unintentionally, which can be frustrating. Bream are known to produce a large amount of mucus, which makes them unpleasant to handle. The slime can stain tackle and is often difficult to remove.

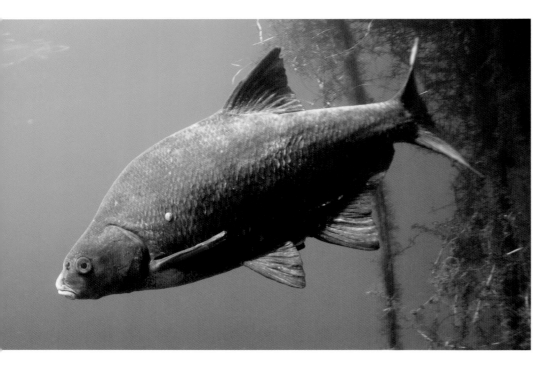

↑ Zander are known for their cautious and sometimes moody bite, which makes fishing for them a particular challenge. They require special techniques and a lot of patience.

→ Tench prefer calm, herb-rich waters such as ponds, lakes and slow-flowing rivers. Their preferred habitat is densely overgrown stretches of water. In many parts of Europe, fishing for tench has a long tradition.

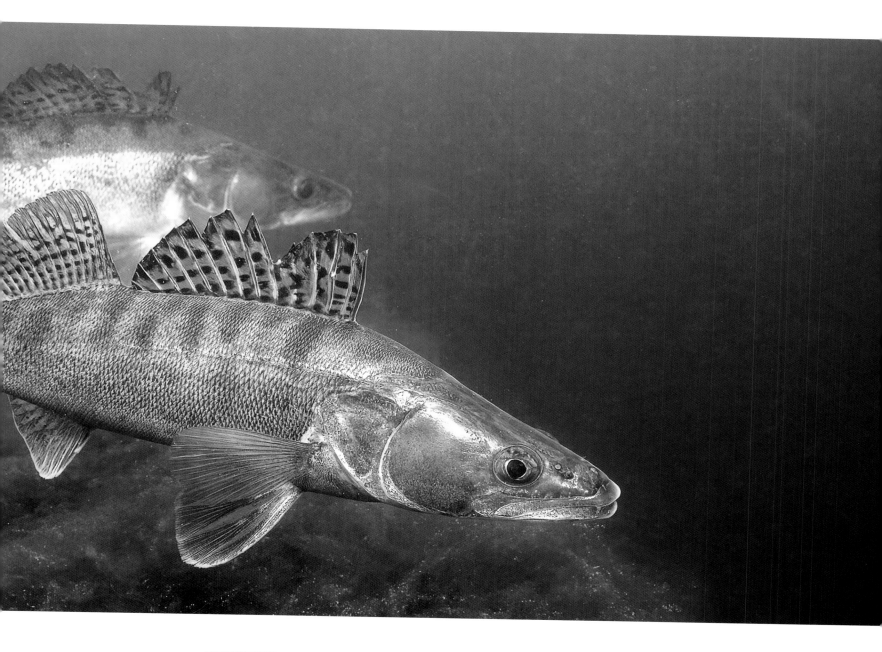

Exotic Target Fish

Arapaimas are among the largest freshwater fish. They can grow over 6 feet (2 meters) long and weigh over 286.6 lbs (130 kilograms). Arapaima means »Red Fish« in the Tupí-Guaraní languages. Their native habitat is the Amazon Basin.

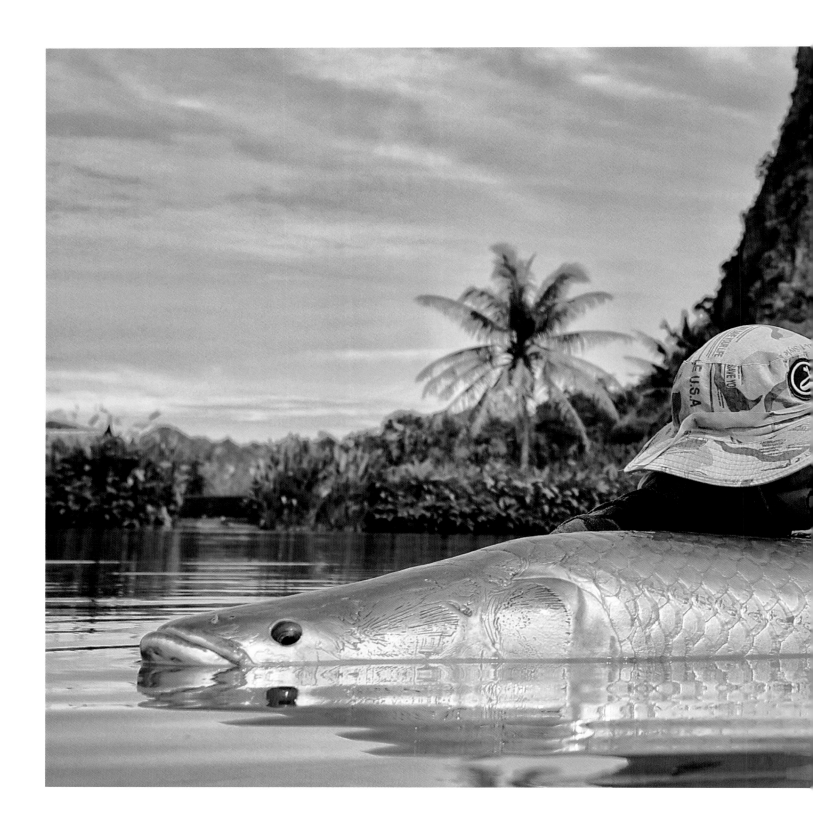

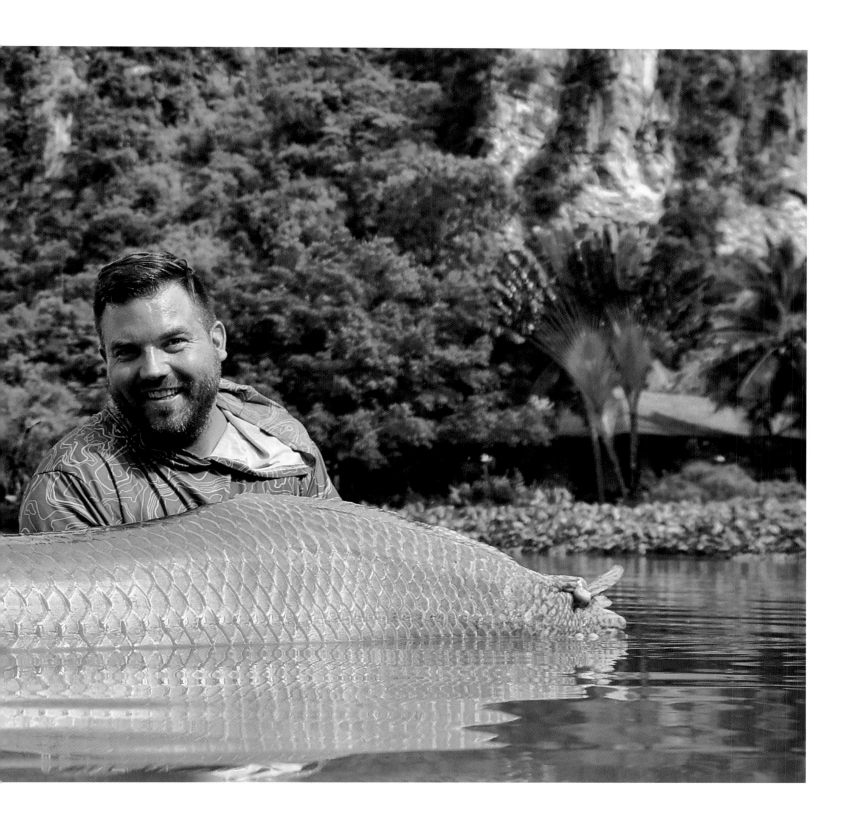

↓ Fishing pro and friend of the author Jan Ulak was able to fulfill a lifelong dream with the catch of this capital Arapaima.

Reproduction

Salmon Spawning Migration

The salmon spawning migration, also known as the »salmon migration«, is a remarkable natural phenomenon where salmon return from the sea to the rivers and streams where they were born to lay their eggs. The salmon spawning migration is a complex process influenced by various factors such as the salmon's biological clock, tidal influences, water quality, and other environmental conditions.

Salmon possess a remarkable ability to navigate, being able to detect the direction and distance to their spawning grounds by orienting themselves using certain magnetic or olfactory cues.

The salmon spawning migration is fraught with numerous challenges, including overcoming rapids, waterfalls, and other obstacles on their way to the spawning grounds. During this journey, salmon often cover great distances and must defend themselves against strong currents and natural enemies.

Once they arrive at their spawning grounds, salmon look for suitable spawning sites to lay their eggs. These sites are found in shallow, gravelly areas of rivers and streams where the eggs are protected from predators and have a good supply of oxygen.

The spawning act begins with females laying their eggs in shallow pits or gravel beds, while males release sperm over the eggs to fertilize them. This process can take several days and is often carried out by a group of salmon gathered together in the spawning grounds.

After laying their eggs, salmon often die within a few weeks due to energy loss during spawning and natural aging processes. Their bodies are often consumed by other animals, contributing nutrients to the ecosystem.

The fertilized salmon eggs remain in the spawning grounds and slowly develop into young salmon, which later migrate downstream and out to sea.

→ Against the current: The spawning migration is exhausting for salmon; some fish pay for the effort with their lives.

→→ To make it easier for salmon to reach their spawning grounds, so-called »fish ladders« are installed in many countries – here on the Faroe Islands.

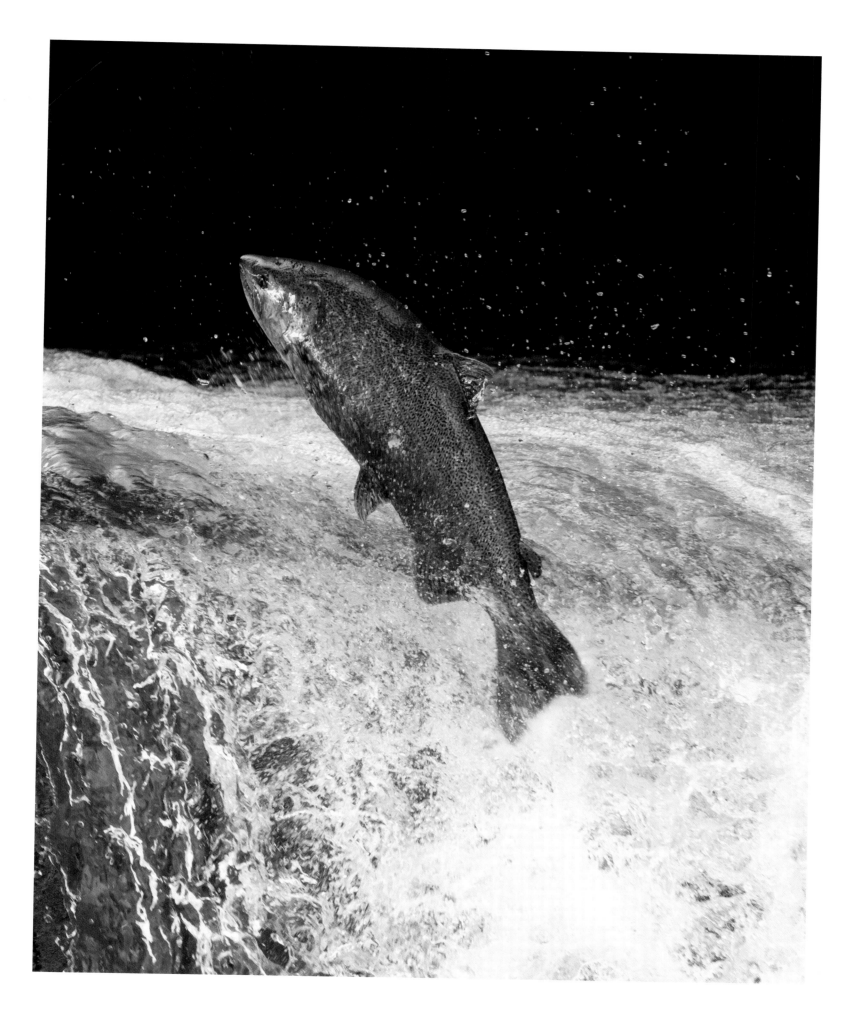

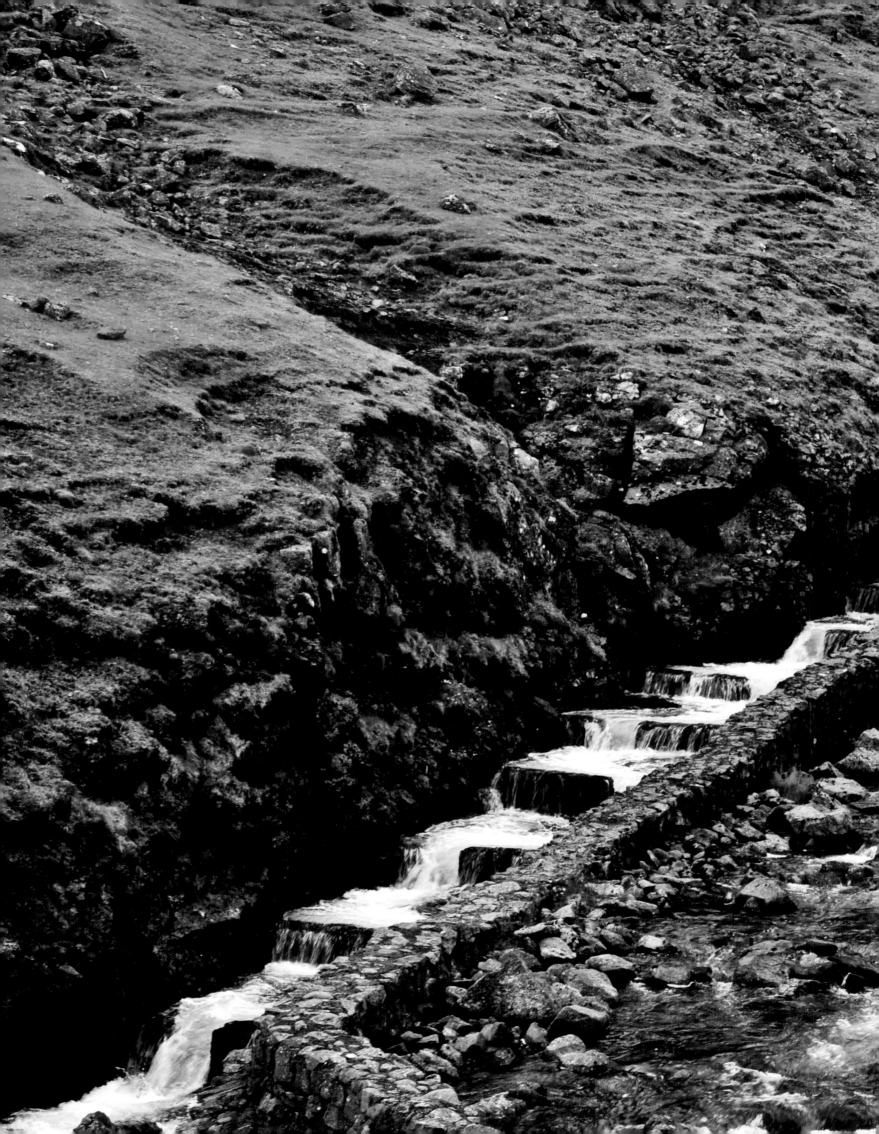

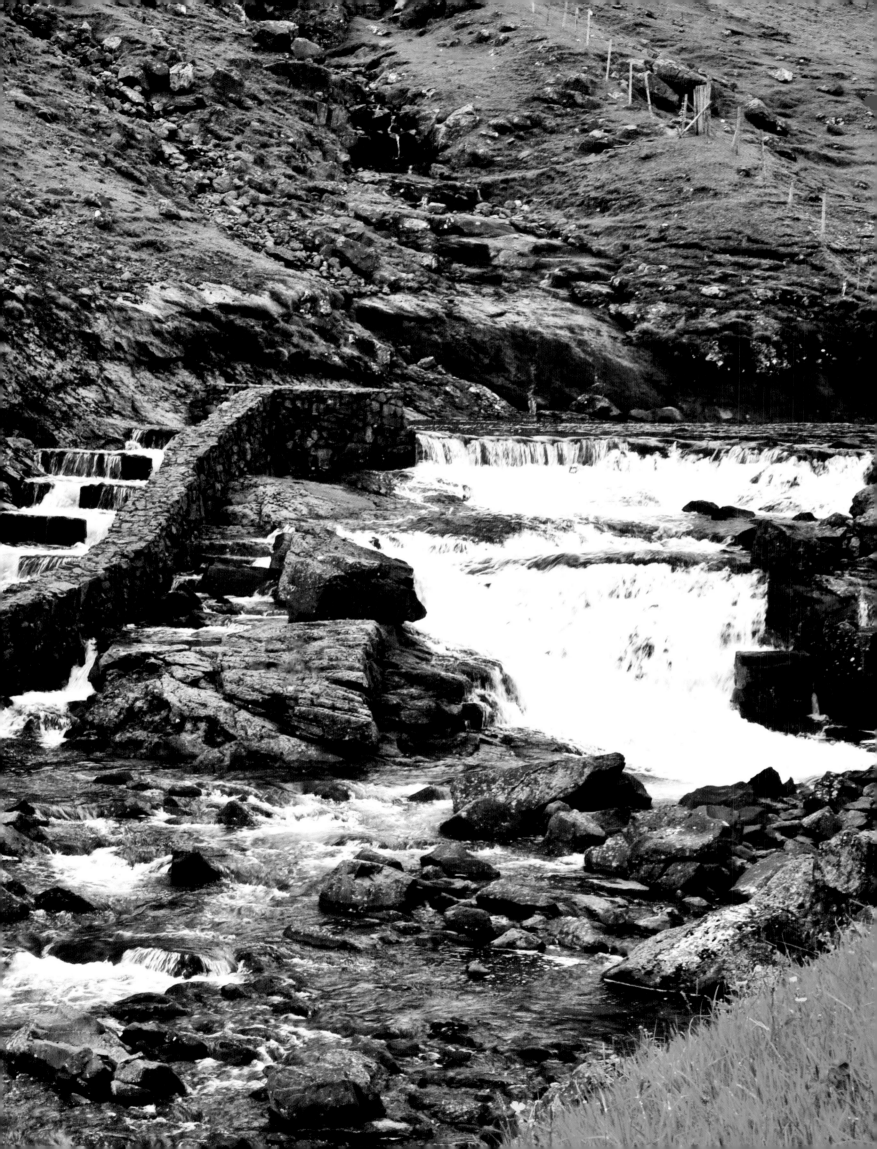

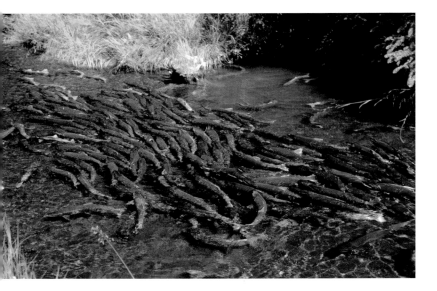

↑ The red salmon (sockeye) are crowded together to spawn.

→ Pole position: Shortly before the finish there is a real crowd of fish ready to spawn.

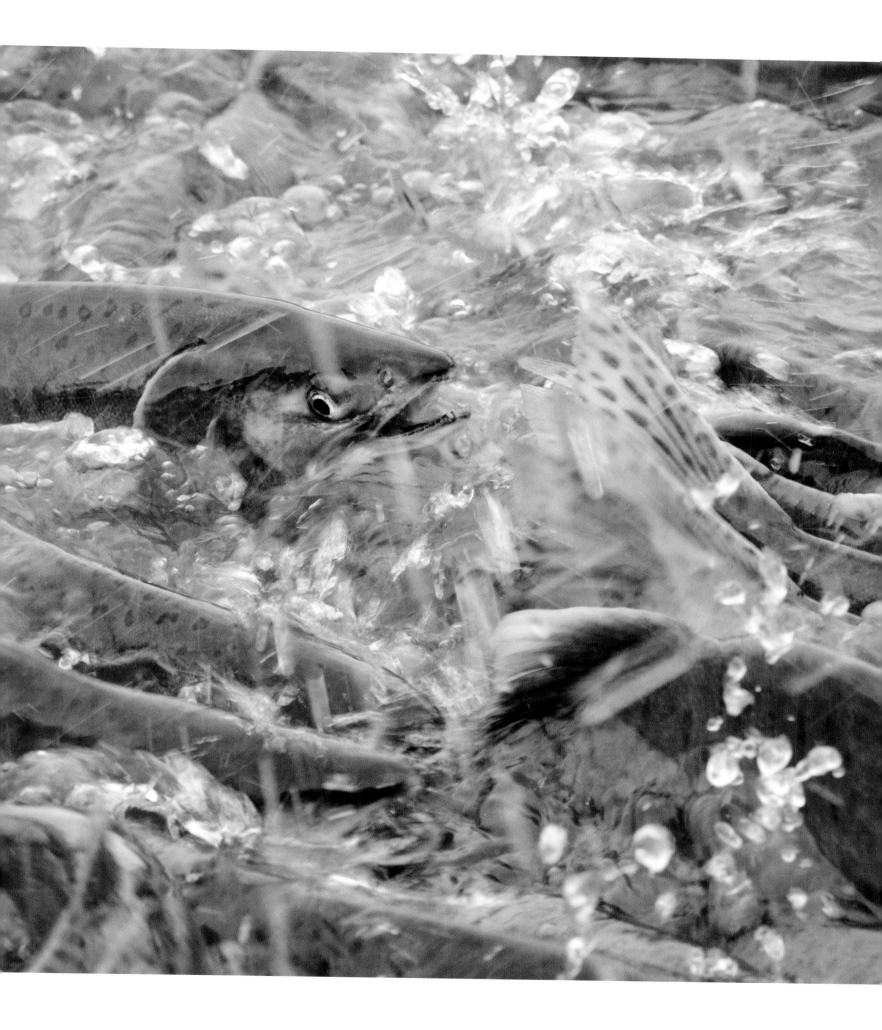

↑ The life journey begins: Salmon that hatch in spring, known as alevins, remain in the gravel bed for a few weeks, where they feed on their yolk sac.

→ This sockeye salmon has not survived the rigors of reproduction. What remains of it serves as valuable biomass for the environment.

→→ The salmon migration is a real feast for brown and grizzly bears.

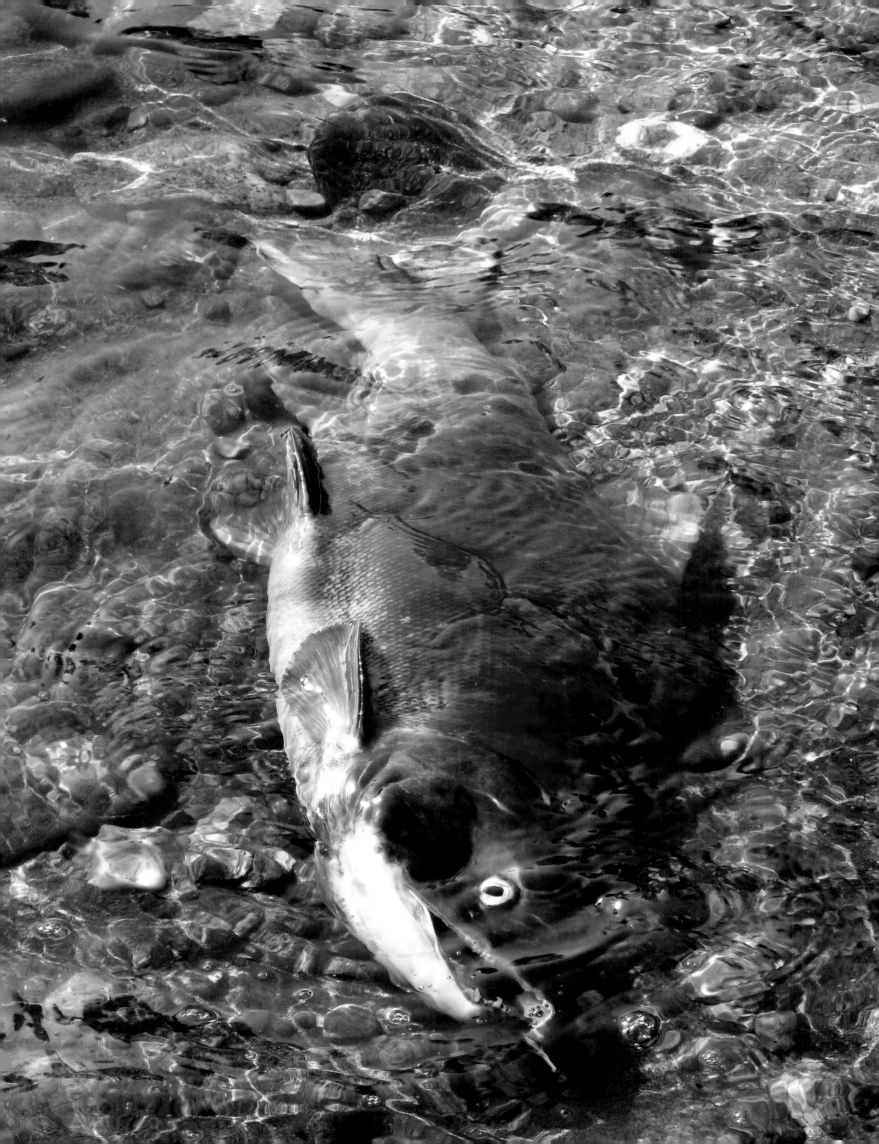

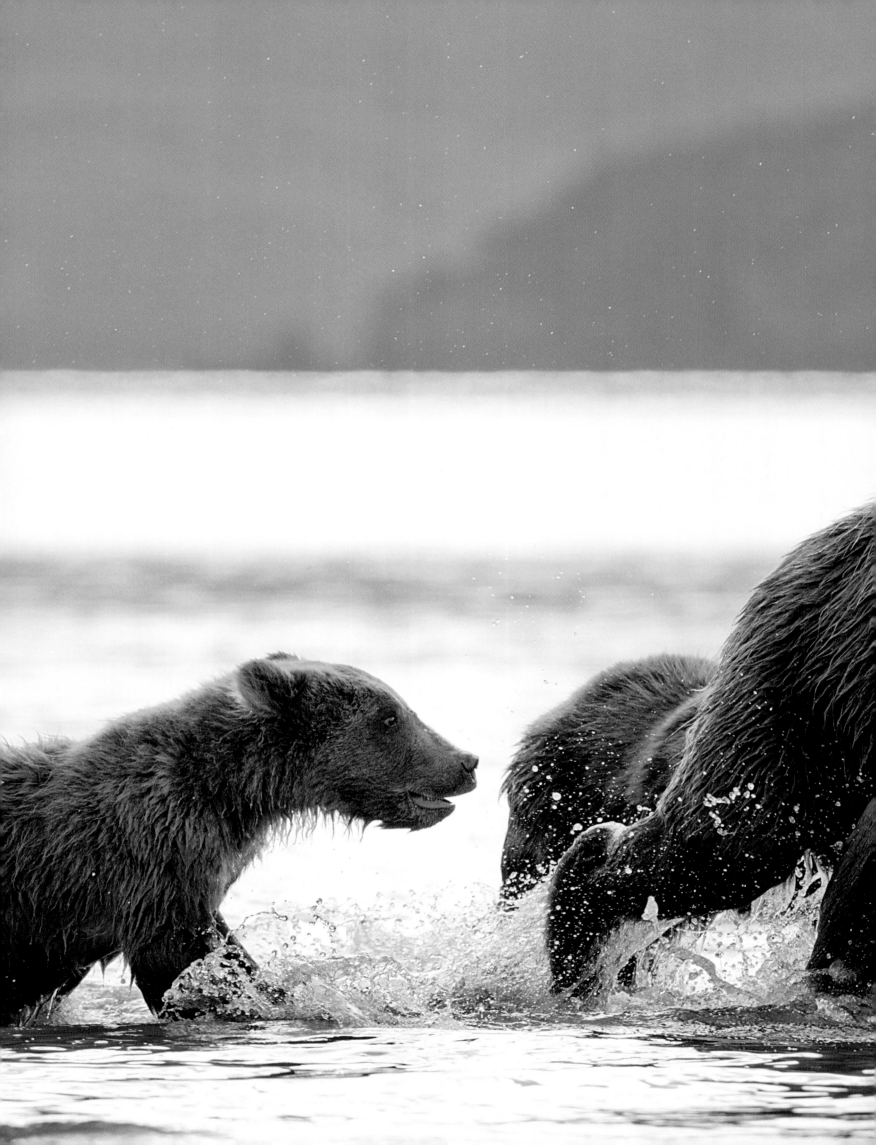

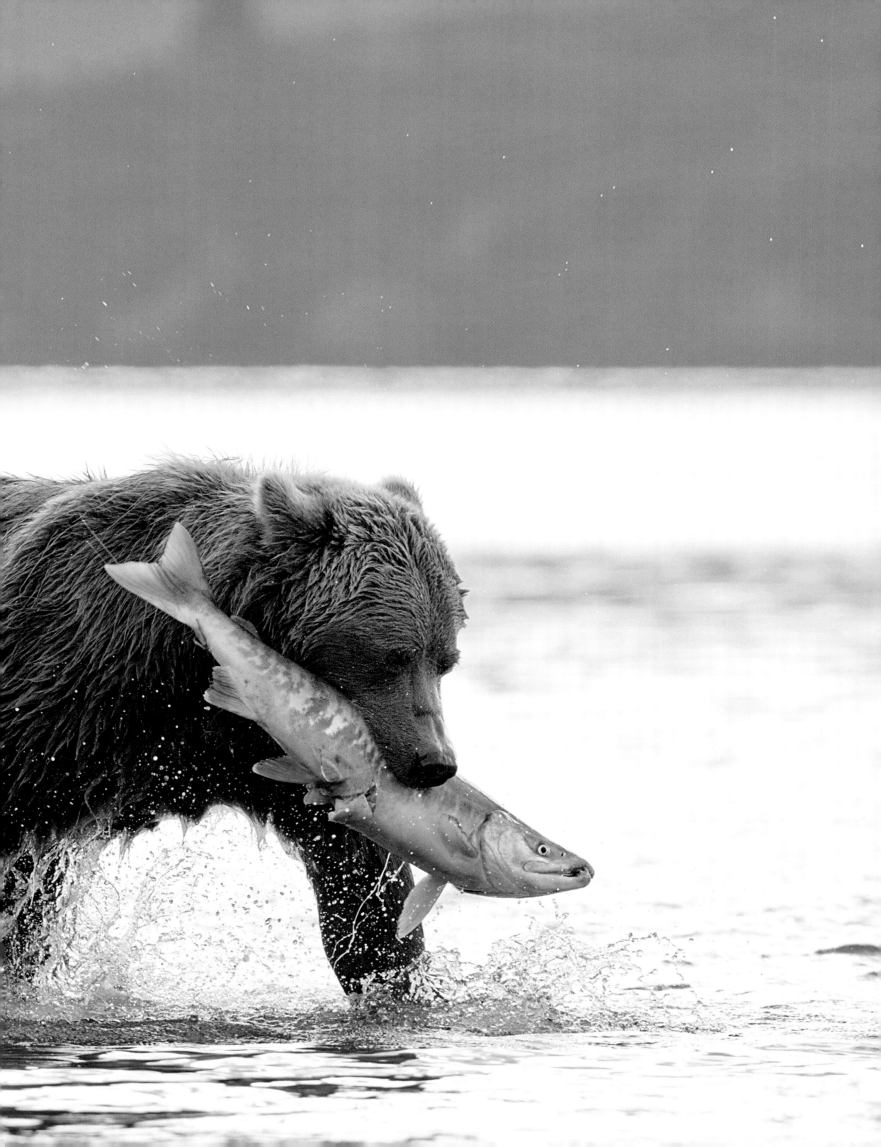

Carp Breeding

Anglers are often involved in the establishment and maintenance of fish populations. Streams, rivers, ponds, and lakes are frequently managed by fishing clubs. This management includes initial stocking and restocking with fish. This is necessary not only because anglers remove fish, but also because many fishing waters are so significantly impacted by human activities that they require support.

For example, the spawning migrations of salmonids can be interrupted by locks or hydroelectric power plants. Artificial lakes, such as those created by gravel mining, often require renaturation measures and supportive stocking, as their banks are often too steep and deep to provide fish with adequate opportunities for productive spawning.

While freshwater fish farming for the food fish market is becoming less significant, it is experiencing a renaissance in the stocking fish market. Angling is booming, and fish have become a valuable and long-term investment due to the increasingly practiced catch and release.

This trend is particularly evident in carp breeding. Fish farms like VS Fisheries specialize in raising high-quality and large stocking carp. Their methods and handling are more reminiscent of Japanese koi breeding than conventional food fish farming. Carp produced in this way can cost several hundred euros, live for several decades, and weigh dozens of kilos.

→ At feeding time, the carp crowd into the rearing tank to get as many of the popular pellets as possible for themselves.

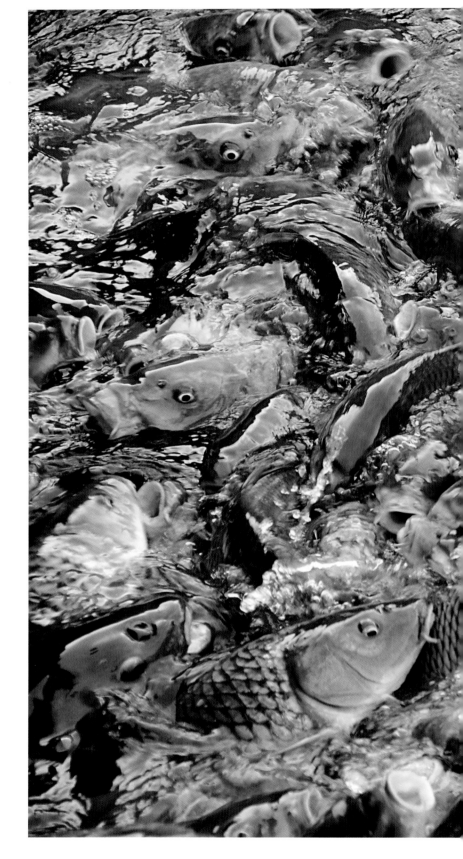

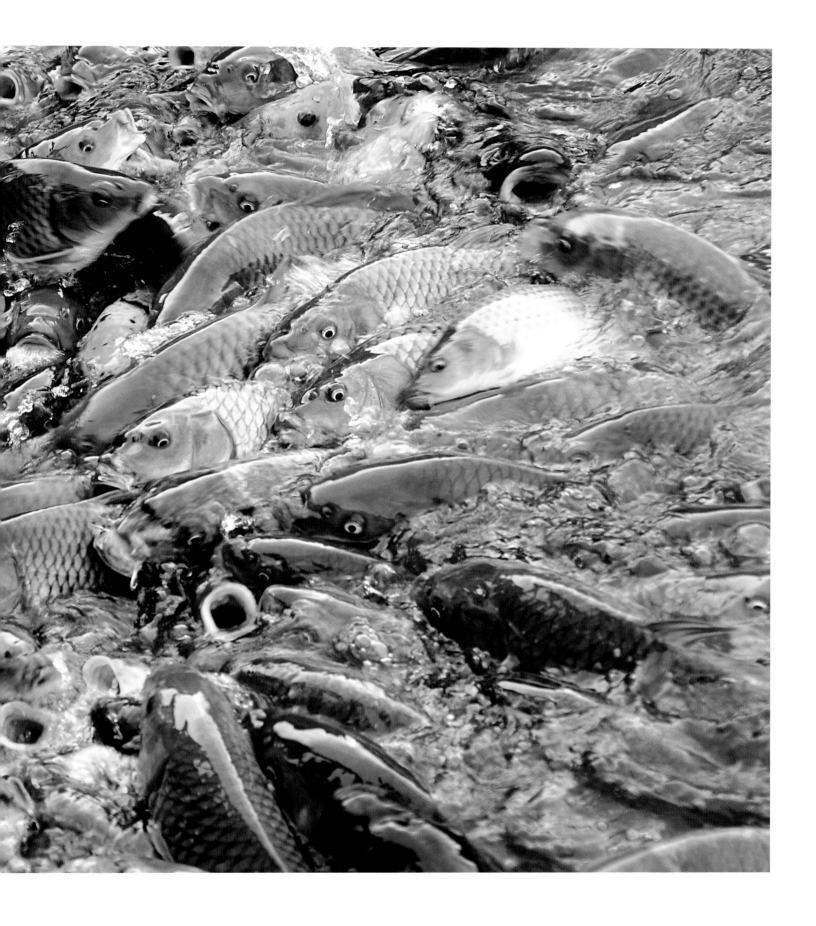

→ Koi farming serves as a model for many modern carp breeders, who produce stock fish for angling and generally no longer produce food fish.

The British Big Carp Scene

It is difficult to pinpoint exactly when it all began, but for many, Richard »Dick« Walker's capture of the carp »Clarissa« marks the birth of the English big fish scene.

Richard »Dick« Walker (29th May 1918–2nd August 1985) is an English angling icon, known not only for his record carp.

Walker was the first angler to apply scientific thinking to fishing and wrote many books on the sport. He also contributed numerous articles to angling publications.

Among his inventions are the electronic bite alarm and the Arlesey bomb weight, and he played a significant role in the development of the carbon fiber fishing rod. Many consider him one of the best anglers of the 20th century, and his books are now precious collector's items. One of his hand-crafted split cane Mark IV carp rods is worth several thousand pounds.

He held the record for a carp in the United Kingdom for 28 years with a massive fish caught in Redmire Pool in Herefordshire. On 13th September 1952, Walker landed the then-record carp weighing 44 lb (about 20 kg). After catching the fish, he decided to contact the London Zoo to verify its weight. After the catch, the fish was transported to the zoo's aquarium and publicly displayed there. Walker had named the carp »Ravioli«, but the fish was renamed to »Clarissa«. Walker's record stood until 1980 when it was surpassed by Chris Yates, whose carp weighed 51 lb 8 oz (about 23.6 kg).

The catch of Clarissa was a milestone in big carp fishing. Until then, catches of carp over 10 kilos were considered the exception, and those over 20 kilos almost impossible.

→ Richard Walker, the man who made fishing history.

→→ Near Redmire Pool, in the rural Herefordshire countryside, the River Wye meanders peacefully.

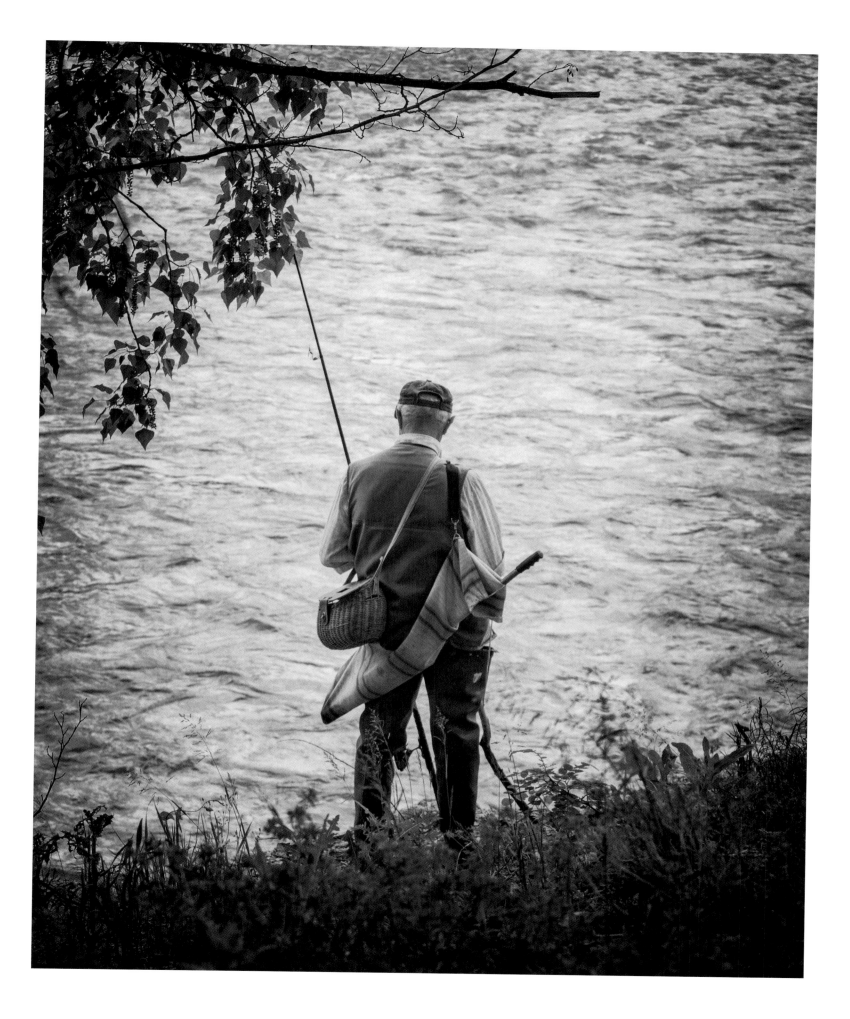

→ Richard Walker's influence on fly fishing and fishing in general was enormous, and he is considered by many to be one of the most important anglers of the 20th century. Walker developed various fishing tackle, including fly rods.

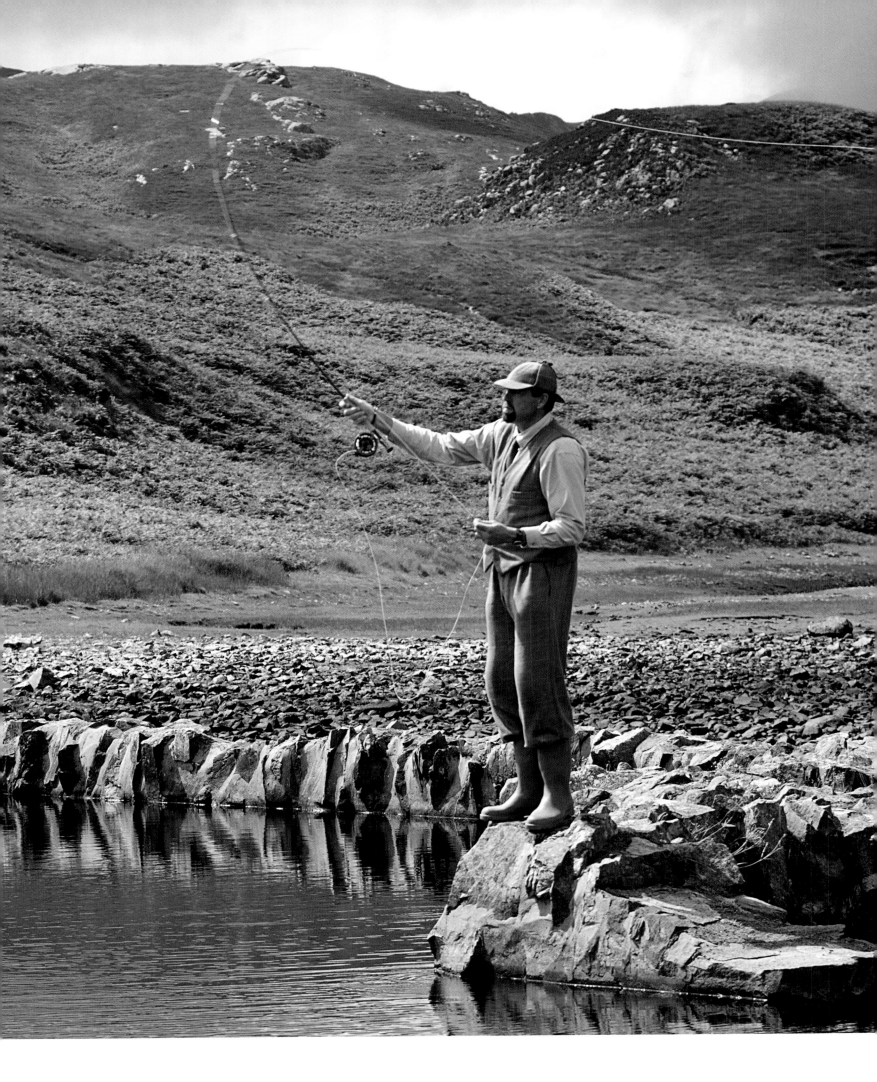

Urban Fishing

*»To fish is to hope. Each cast a new beginning,
each retrieve a new promise.«* — M.K. Soni

Urban or street fishing describes a relatively new trend in the fishing scene, particularly practiced by the younger generation.

The appeal lies in experiencing the nature of fishing in the contrasting environment of large cities and industrial areas. Instead of pure nature, graffiti, promenades, and neon lights at night serve as the backdrop.

The fishing spot is reached not by car, but by subway, and instead of birdsong, pumping bass from clubs echoes over the water. Besides the extraordinary scenery urban fishing also boasts considerable catch opportunities. The fishing pressure in large cities is sometimes lower than in well-known natural waters, and some fish species have adapted excellently to the artificial water structures.

But fishing in urban areas is by no means new. In big cities like New York or Istanbul, fishing in harbors and promenades has a long tradition.

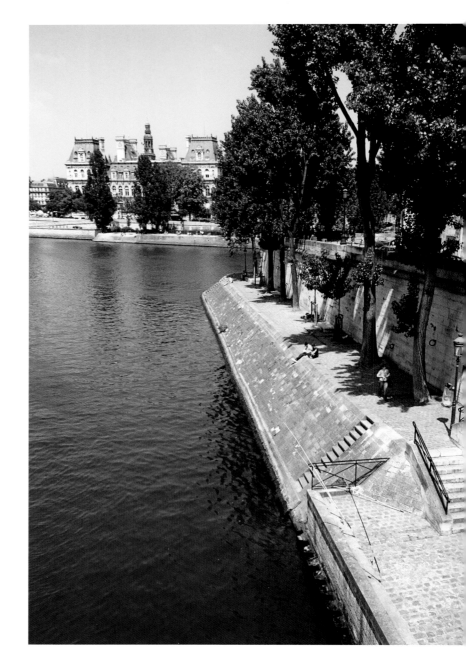

→ On the banks of the Seine – here on the Quai d'Orleans on the l'Ile Saint-Louis – in Paris, there are anglers hoping for a good catch at almost any time of day.

↑ An evening of fishing by the river – review the day and reflect on your thoughts.

→→ On the banks of the East River with a view of the Manhattan Bridge, you can also enjoy some quiet moments in New York.

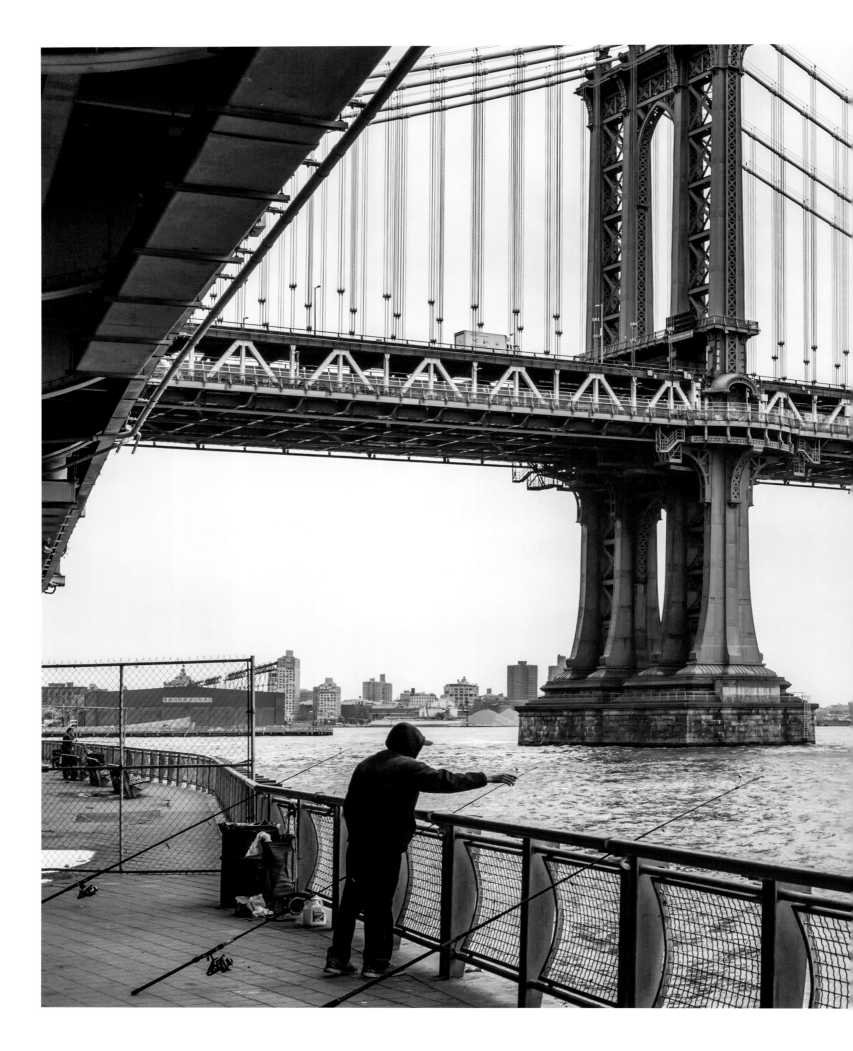

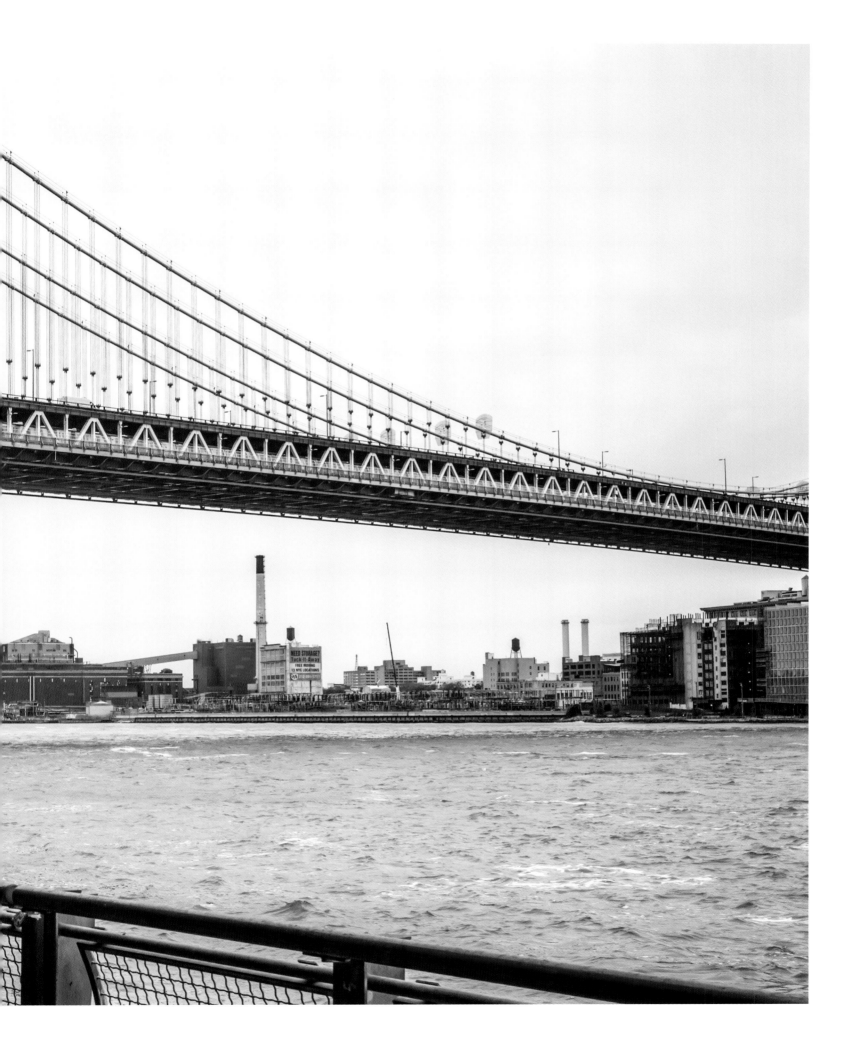

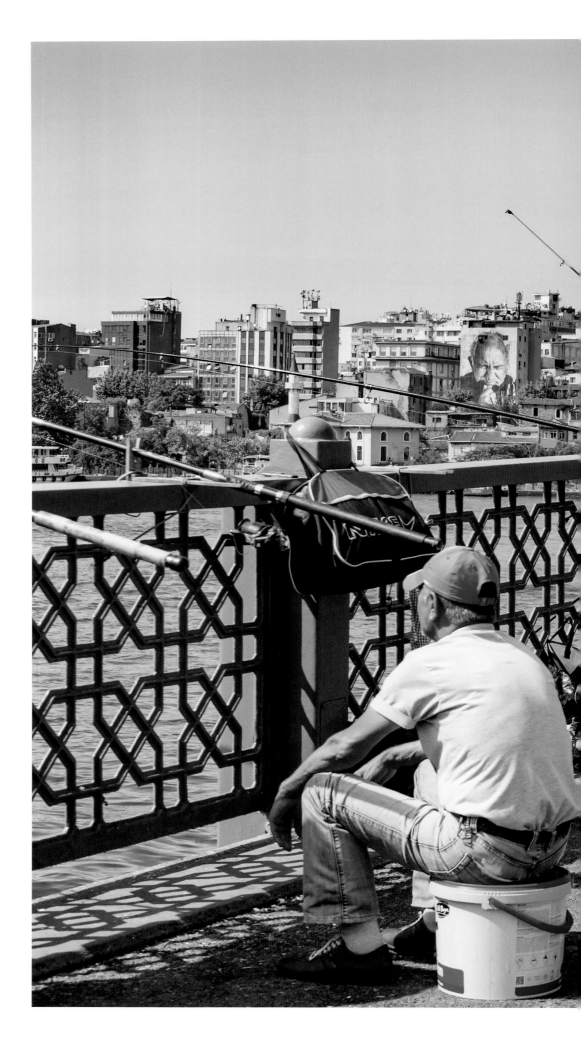

←← Thien Quang Lake in the middle of Hanoi is not really a fishing spot, but many people try their luck there after work.

→ In Istanbul, anglers on the Galata Bridge – which crosses the Golden Horn – are an integral part of the cityscape.

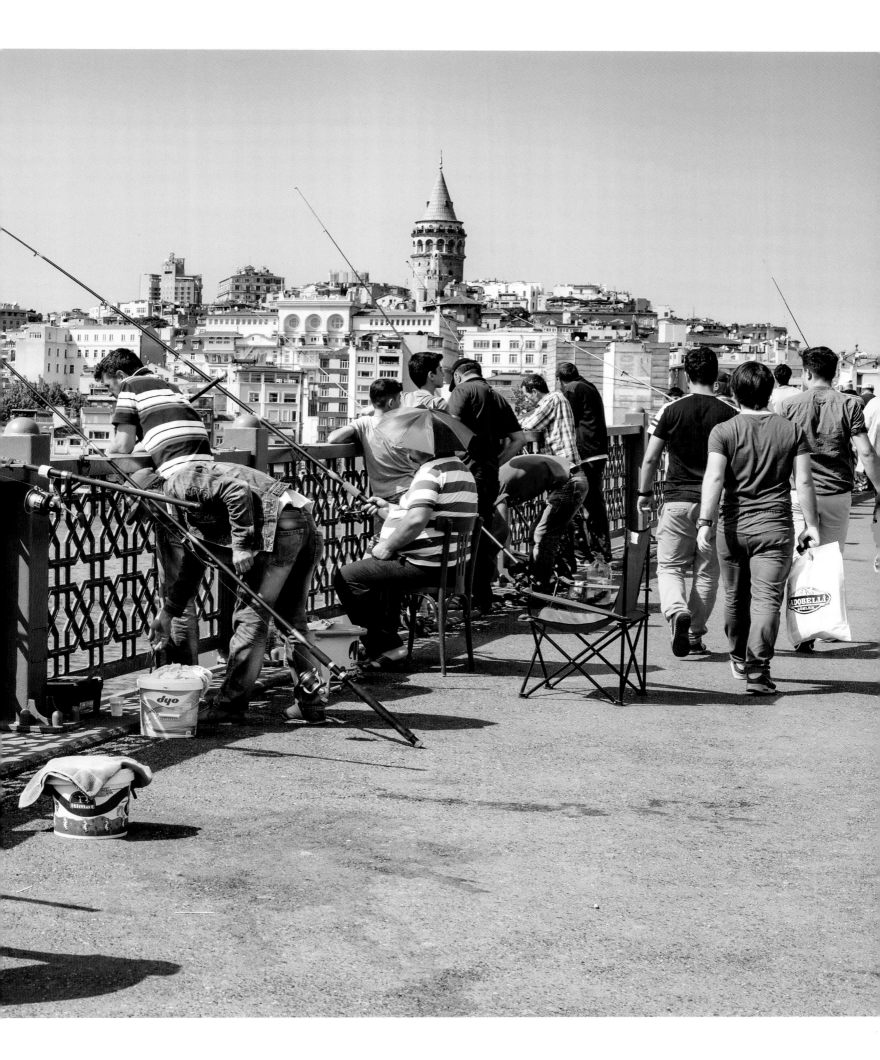

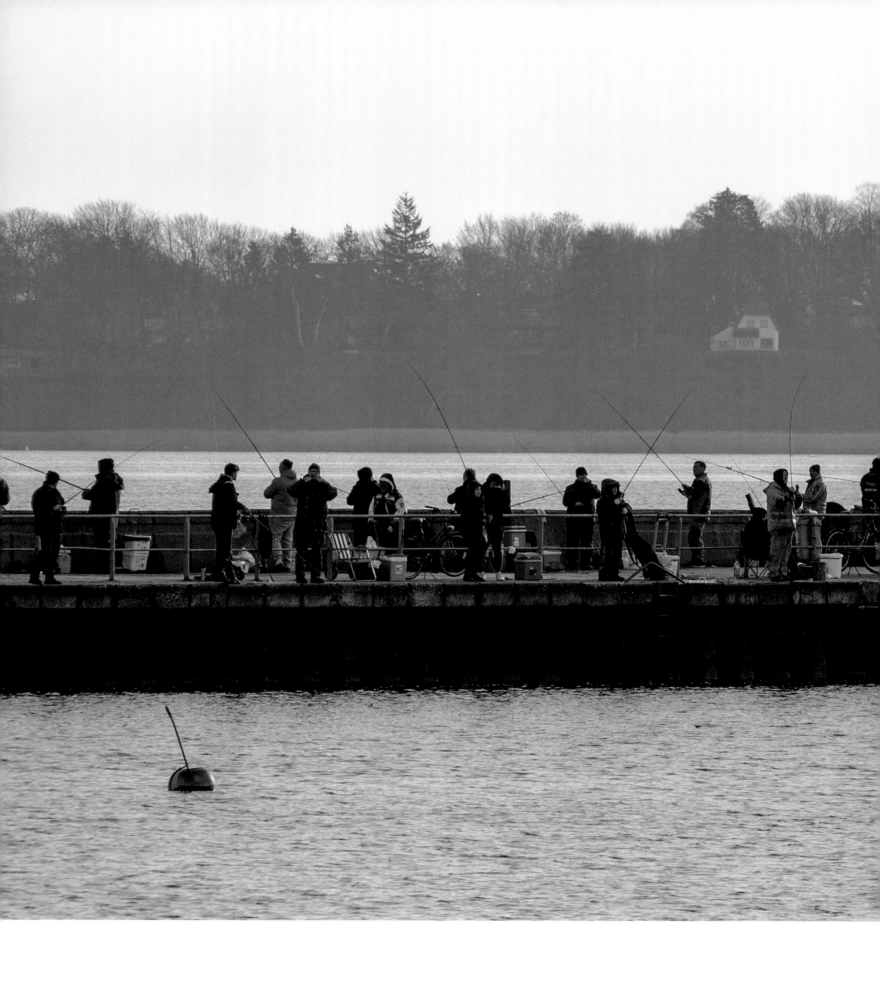

↑ Every city angler will find a spot along the shipping lanes
with their numerous sea marks.

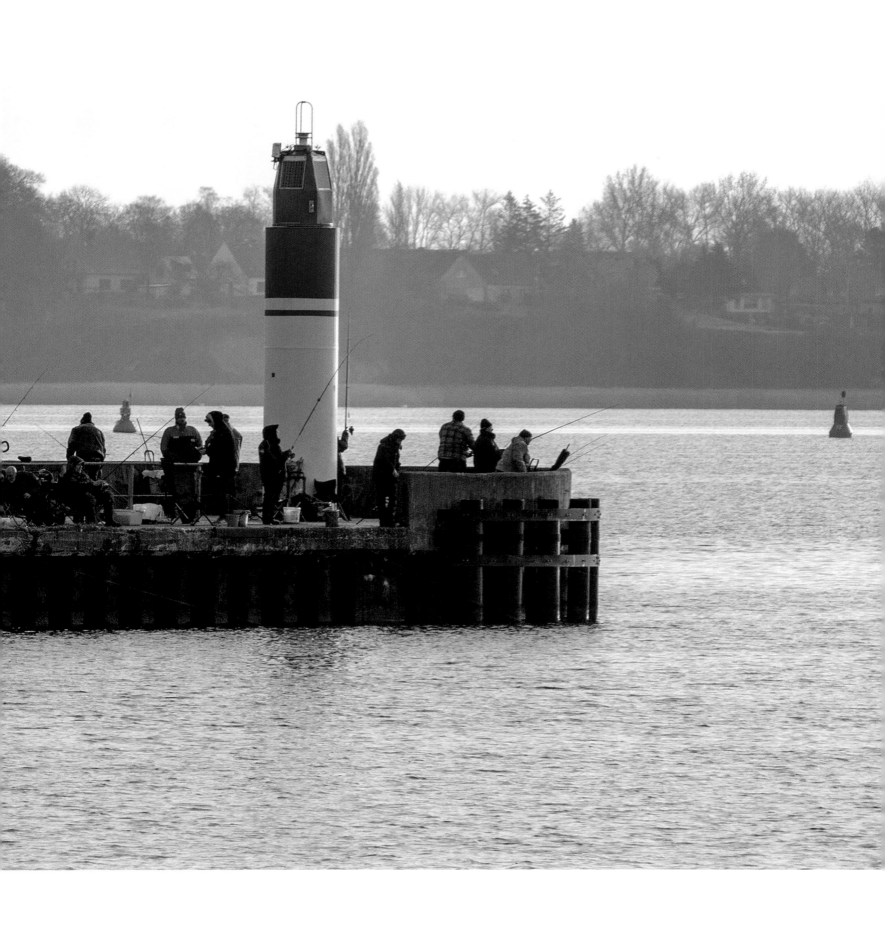

Rod Building

Each Piece a Unique Item

Mass production and globalization of the fishing industry have made good fishing rods affordable for everyone. Almost all major fishing manufacturers now produce their rods entirely or partially in Asia. Producing fishing rods in Europe or the United States has simply become uneconomical.

However, there are still rod builders in the United States and Europe who craft fishing rods to customer specifications. In rod building, the individual components of the rod are selected and assembled by the rod builder.

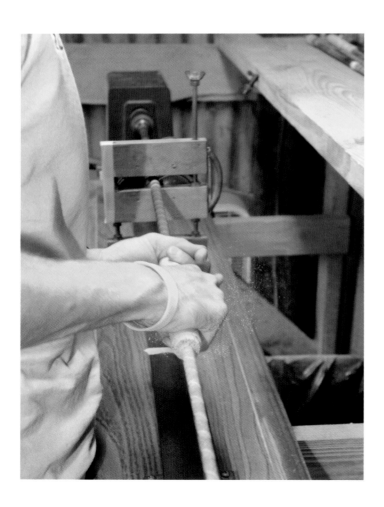

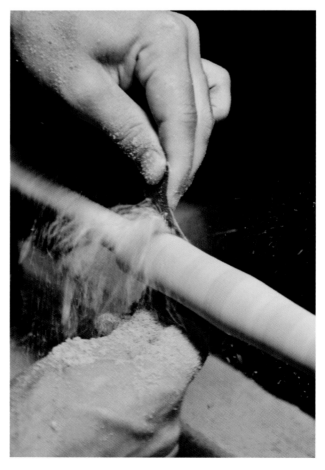

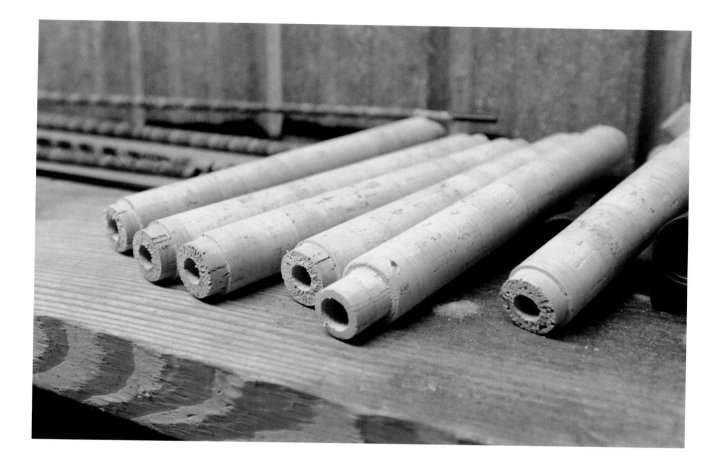

Steps of Rod Building

Selection of Components

The first step in rod building is to choose the components to be used for the rod. These include the blank (the main part of the rod), the guides (guide rings), the reel seat, the grip, and other accessories such as adhesives, varnishes, and thread.

Preparation of the Rod Blank

The rod blank is the main component of the rod and forms its structure. It is usually made of carbon fiber. First, the blank must be cut to the desired length. Then, the positions for the guides and the reel seat are marked on the blank.

Assembly of Components

The guides are placed along the rod blank. The reel seat is attached to the handle section of the rod. The grip, which can be made of various materials such as cork, foam, or Duplon, is also attached to the blank.

←← Cork rod handles are first glued together from many small cork discs placed next to each other.

← The cork is then shaped using sandpaper.

↑ In addition to the classic material cork, modern rod handles are mainly made of Duplon.

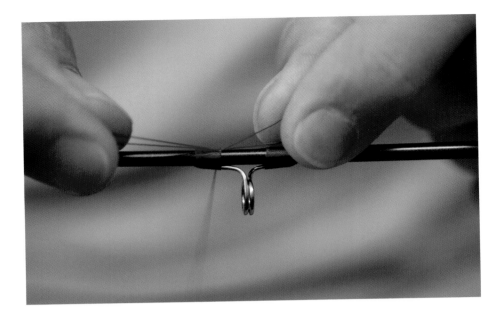

← Yarn is used to create a tight winding that holds the rings in position.

↑ The ring winding is then fixed with lacquer.

Wrapping the Guides and Finishing Touches

After assembling the components, the guides are wrapped with thread onto the rod blank to secure them. This process is called »wrapping« and requires precision and skill. Once the guides are wrapped, they are sealed with varnish to protect them and complete the rod.

There are also rod builders who specialize in traditional bamboo rods. These rod builders typically craft their blanks from split bamboo.

Steps of Splitting Bamboo

First, high-quality bamboo poles are selected, cleaned, and cut to the desired length. They are then split into carefully chosen pieces to obtain the individual strips or »splines« that will later form the basis of the rod.

The split bamboo strips are sorted and prepared according to their position in the rod. This includes straightening the splines using heat and planing them into tapered triangles (60°).

The prepared bamboo strips are then glued together with a special adhesive that ensures a strong bond. Usually, six triangular strips are glued together to form a rod blank. This process requires precision and accuracy to ensure that the splines are properly aligned and bonded.

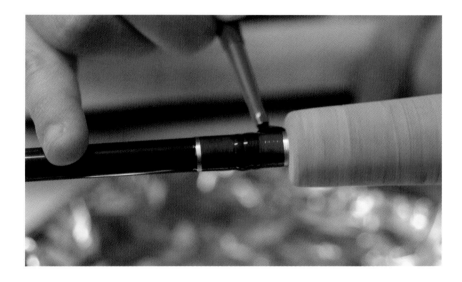

← The lacquer is applied with a fine brush while constantly rotating the blank. It is important that an even layer of lacquer is applied and that no bubbles form.

→ The rod builder aligns the guides exactly in line with each other. This is not only for visual reasons but is also important for a clean line and the action of the rod.

Fishing Destinations
Around the World

»Fishing is a discipline in patience. It's about the journey,
not just the destination.« — Chris Campanioni

Fishing is a versatile hobby. Along with dozens of methods and different types of waters, there are a variety of outstanding target fish to choose from. Some dream fish can be caught right at your doorstep, while for others, ambitious anglers embark on world travels. Sometimes, the allure lies precisely in distant destinations. For many anglers, the fishing experience is not limited to the act of fishing itself but also encompasses adventure and exploring new worlds.

For many anglers, the ultimate adventure and often a long-cherished dream is catching a blue marlin while deep-sea fishing. Fishing for marlin requires the heaviest gear and demands immense physical effort from the angler who is fortunate enough to hook a marlin. The most commonly used technique is trolling, where baits are dragged behind a slowly moving boat. This can be done with live or artificial baits.

The blue marlin has a formidable sword-like bill and a sail-like fin on its back. The Atlantic blue marlin can grow up to a length of 12 feet (3.75 meters) and a weight of up to 1,278 lbs (580 kilograms). The highest weight of a caught blue marlin, confirmed by the International Game Fish Association, was 1,282 lbs (581.51 kilograms).

→ Big-game fishing is a costly endeavor, as this photo no doubt suggests.

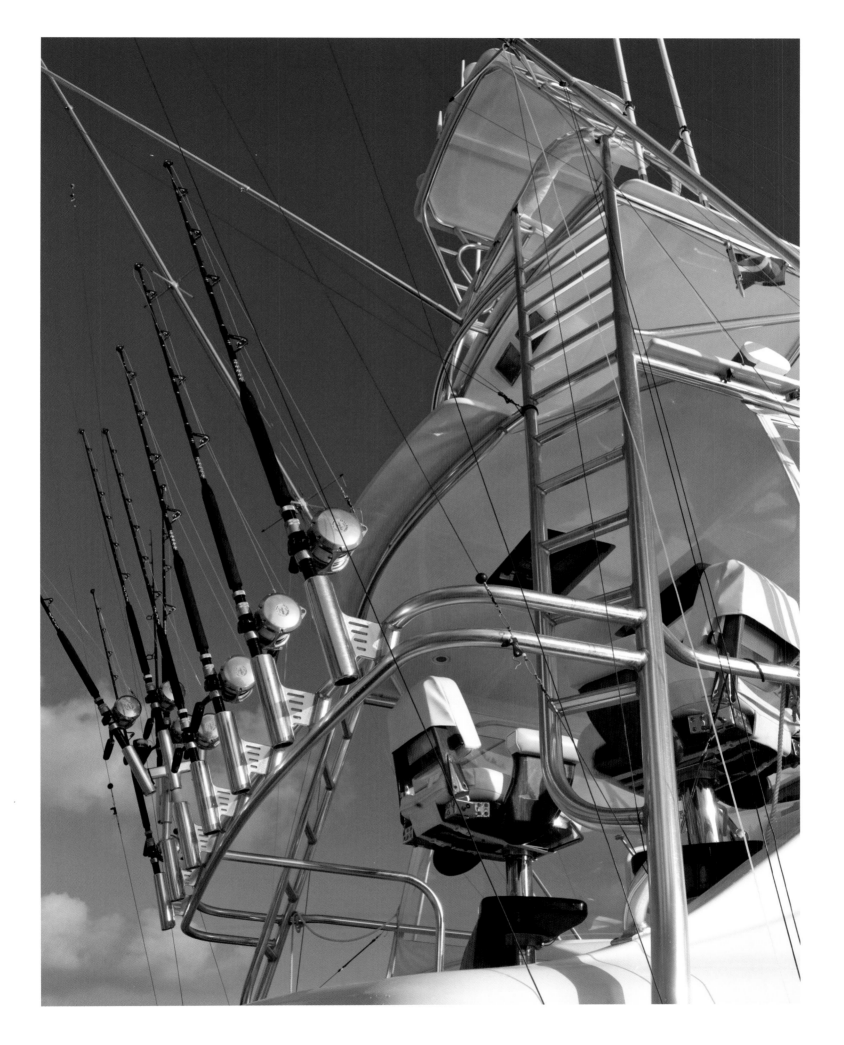

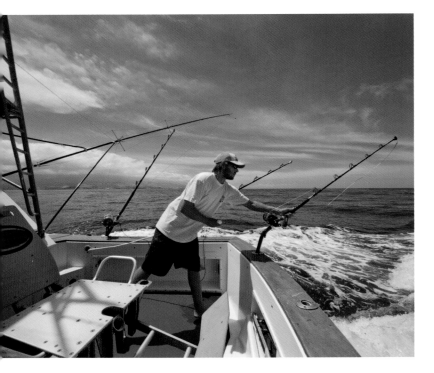

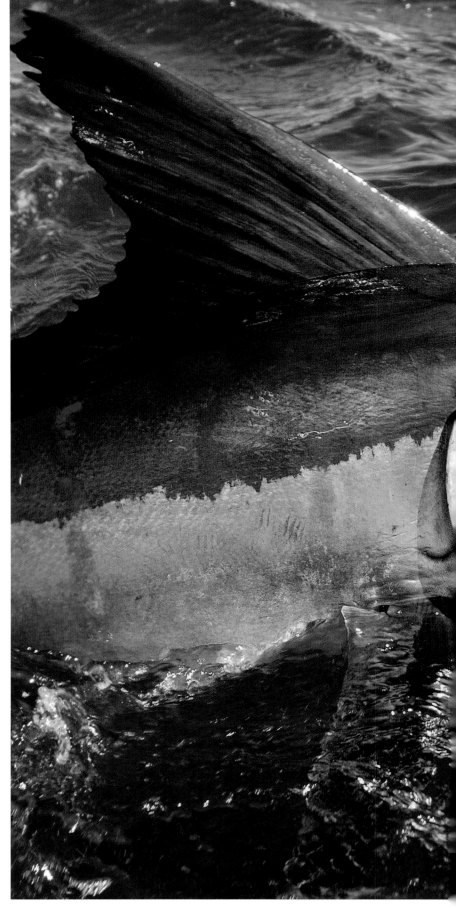

↑ The motor yacht tows several lures
behind it.

→ Reward for the effort: A handsome
marlin appears in front of the boat,
ready to land.

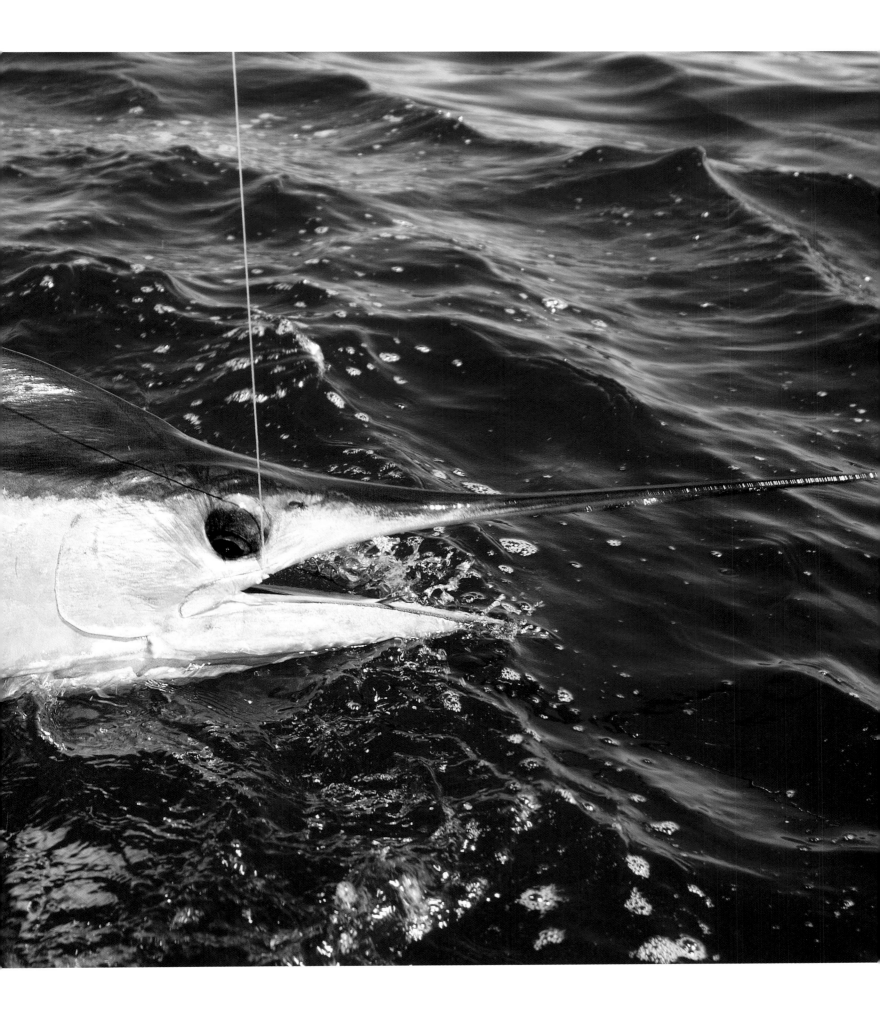

The Netherlands

The Netherlands is considered a particularly fishing-friendly country. This neighboring country is a popular destination, especially among German anglers. In the 1980s and 1990s, the country and its canals were particularly known for competitive and carp fishing. Additionally, rivers like the Meuse (Maas) are popular predatory fish areas. Thanks to its numerous coastal sections, surf fishing in the North Sea is also possible.

→ Considerable casting distances can be achieved with a surf rod. Under optimal conditions and with special equipment, professionals can achieve casting distances of 220 yards (200 meters) or more.

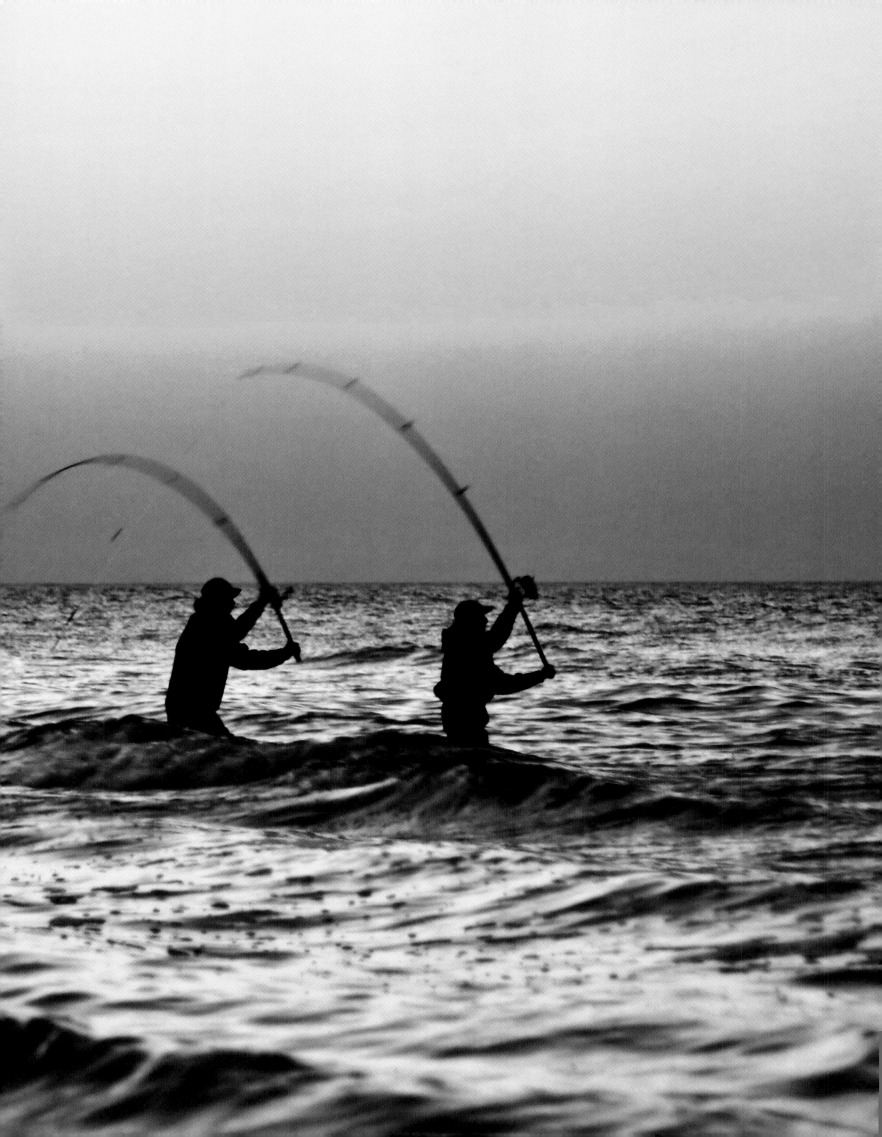

Norway

Thanks to its fjords and large freshwater lakes, Norway is a fishing paradise. In the sea, anglers can expect to catch gigantic cod and halibut, while in freshwater there are good chances of landing a »big pike«.

→→ Many waterfront vacation homes in Norway have a rowing boat. It is worth having a pike rod on board when you go boating.

→ The smell of freshly smoked salmon hangs in the air.

↓ House at the water front: What angler wouldn't be tempted by the sight of this fjord for a fishing trip?

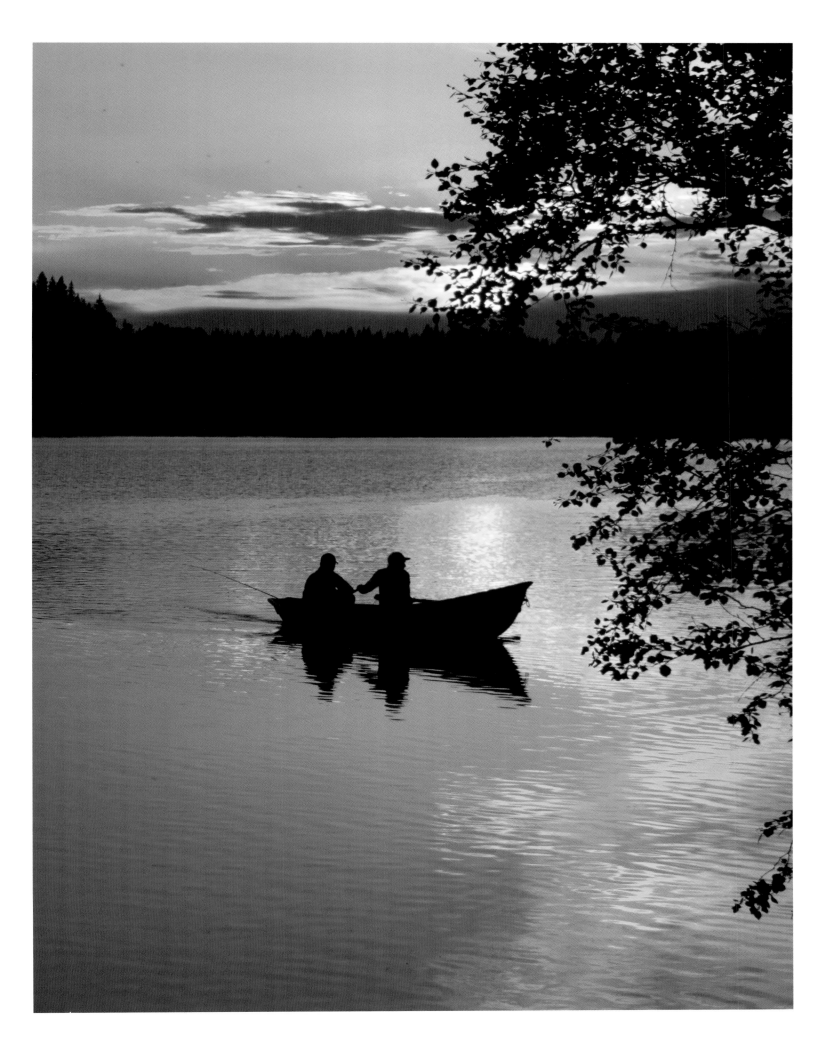

Rocky Mountain National Park

The Rocky Mountain National Park features many rivers and high mountain lakes teeming with wild rainbow, brook, and cutthroat trout.

In most of the high mountain lakes, you can fly fish for brilliantly colored cutthroat trout. The experience of catching one of these beautiful specimens against the spectacular mountain backdrop is unforgettable.

The many rivers of RMNP are home to several trout species. In some of them, like the Big Thompson, Glacier Creek, Colorado, and Fall River, you can even achieve the so-called »Colorado Grand Slam« (brook trout, cutthroat trout, rainbow trout, brown trout).

In the summer, there are many days in the park when you can enjoy excellent dry fly fishing.

→ In the fall, many of the region's rivers are covered in golden yellow leaves.

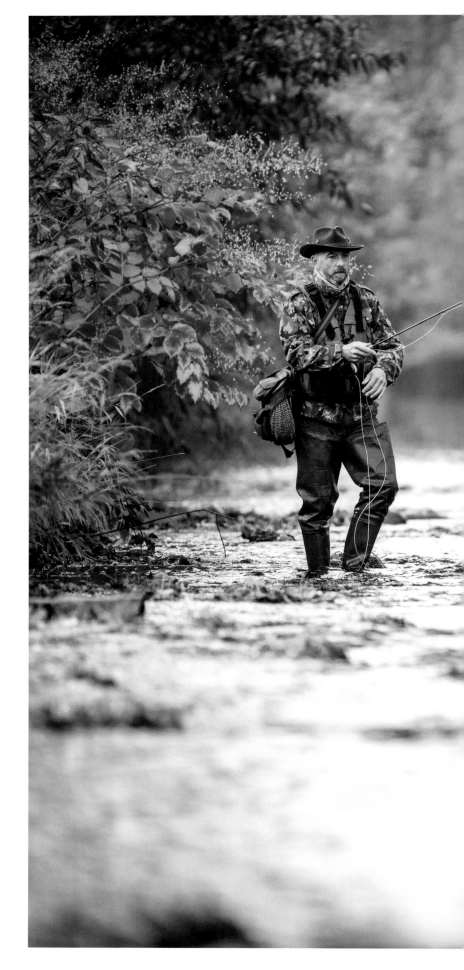

Canada

There are a total of nine different species of salmon. In Canada alone, five of these species migrate up rivers at different times to spawn.

The Chinook (also known as King salmon) is the largest species of Pacific salmon, reaching lengths of up to 5 feet (1.5 meters) and weights over 110 lbs (50 kilograms). Also from the Pacific, but slightly smaller, is the Chum or Dog salmon, sought after especially for its large-grained keta caviar.

The Sockeye or Red salmon gets its name from the red color it develops on its back in freshwater. The Coho or Silver salmon, on the other hand, shimmers with a silver back.

The smallest salmon species in Canadian waters is the Pink salmon, also known less flatteringly as Humpback salmon due to its distinctive humpback shape. Preferring colder waters, it can also be found in Arctic coastal waters, including the Mackenzie River in the Northwest Territories.

When Chum, Coho, and Chinook make their way upstream every year from late October to late December, for example through the Goldstream River, the spectacle does not go unnoticed. Up to 200,000 visitors flock to witness the salmon migration at Goldstream Provincial Park on Vancouver Island.

King salmon have swum up to 745 miles (1200 kilometers) to reach their spawning grounds in Swift Creek, Valemount. The spectacle can be observed from August to September in George Hicks Park.

The largest Sockeye salmon migration on Canada's west coast is best observed in early October at the Fraser River, where the fish color the waters red at the Hell's Gate rapids.

Those lucky enough might witness moments where life and death hang by a thread. This happens when grizzly bears and black bears position themselves at the rapids, mouths open, waiting for their lunch. For every tasty treat they catch, hundreds make it to the spawning grounds. There, females lay up to 30,000 eggs during the entire spawning season, and the cycle begins anew.

← The lighthouse belongs to the small fishing village of Peggy's Cove in the province of Nova Scotia on the east coast.

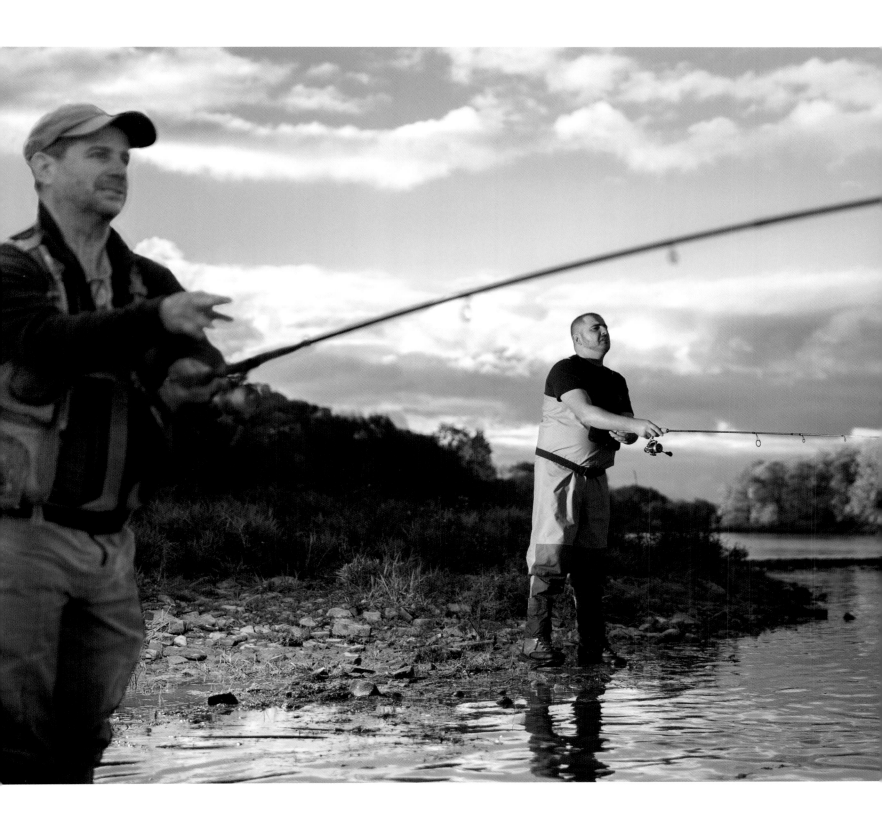

↑ Salmon fishing is not the only popular activity in Canada. The country's lakes and rivers are also excellent pike and zander waters.

→→ This grizzly is waiting for its prey, which literally jumps into its mouth.

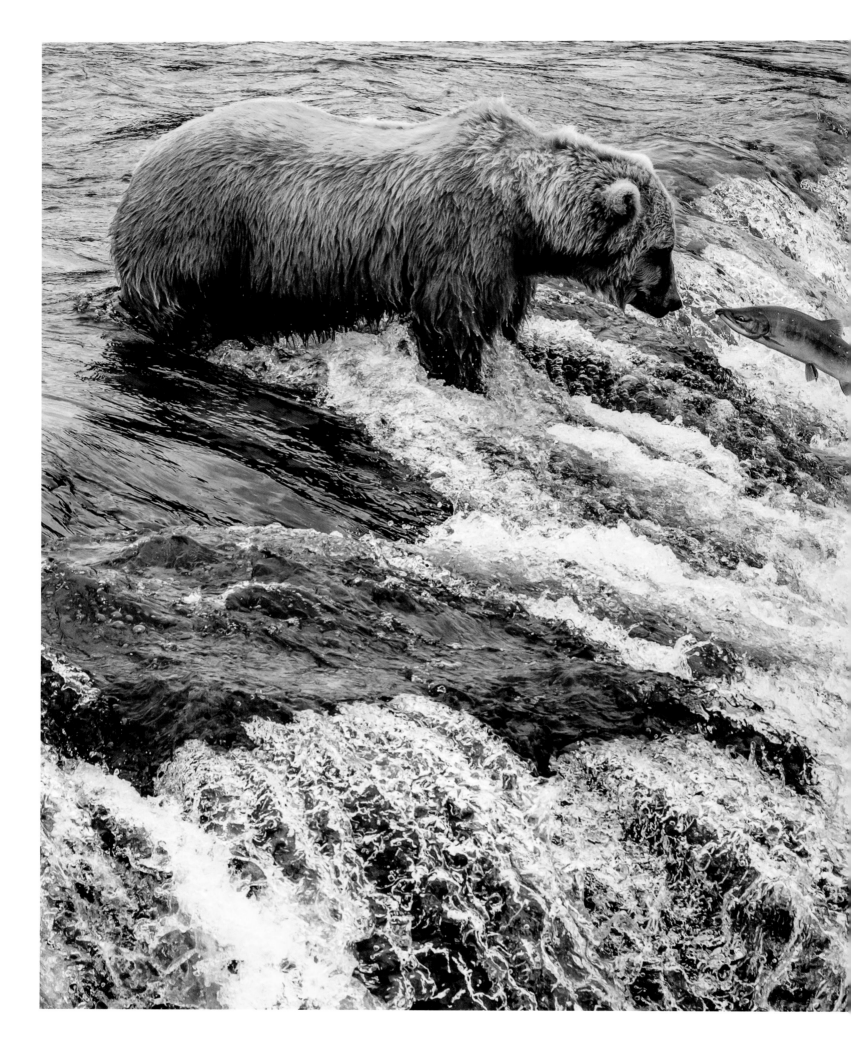

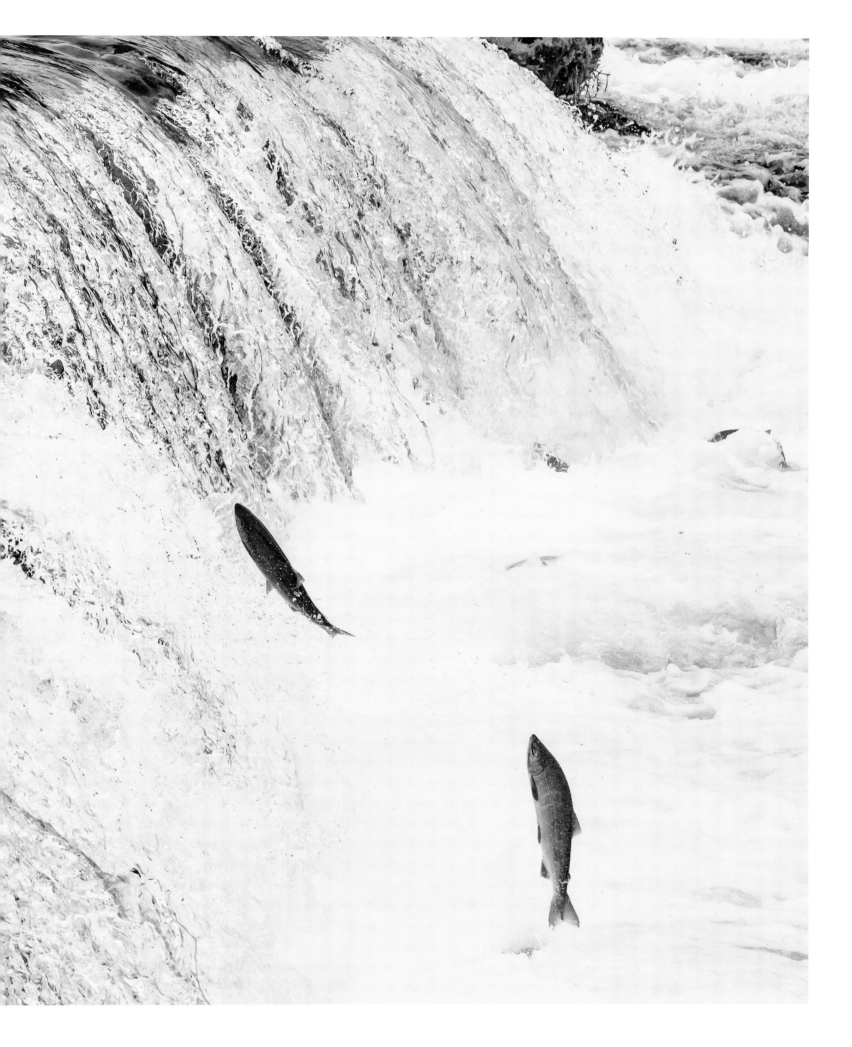

Alaska

Like British Columbia in the eastern part of Canada, Alaska – the northernmost state of the United States – is known for its excellent salmon population and above all for its pure wildlife.

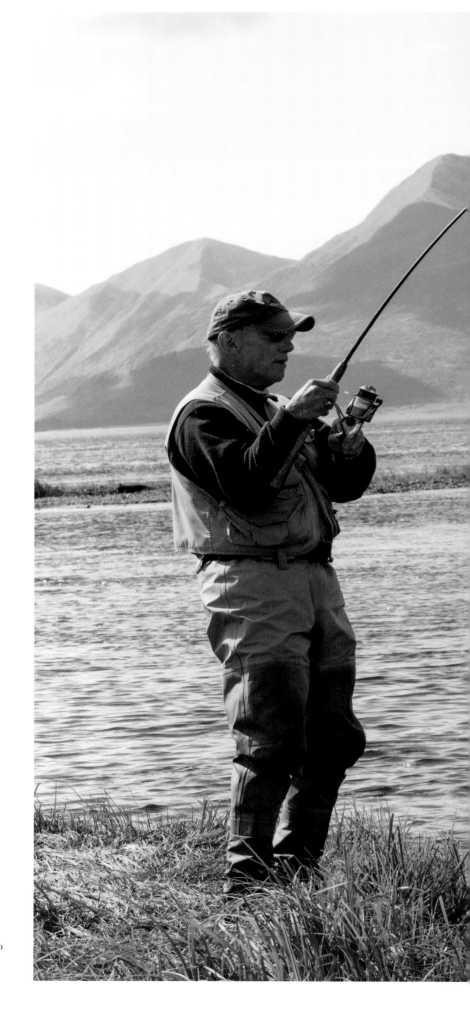

→ Alaska's rivers are not only excellent fishing grounds, but also bear territory. Keep a safe distance, especially as the bears are also after the tasty salmon.

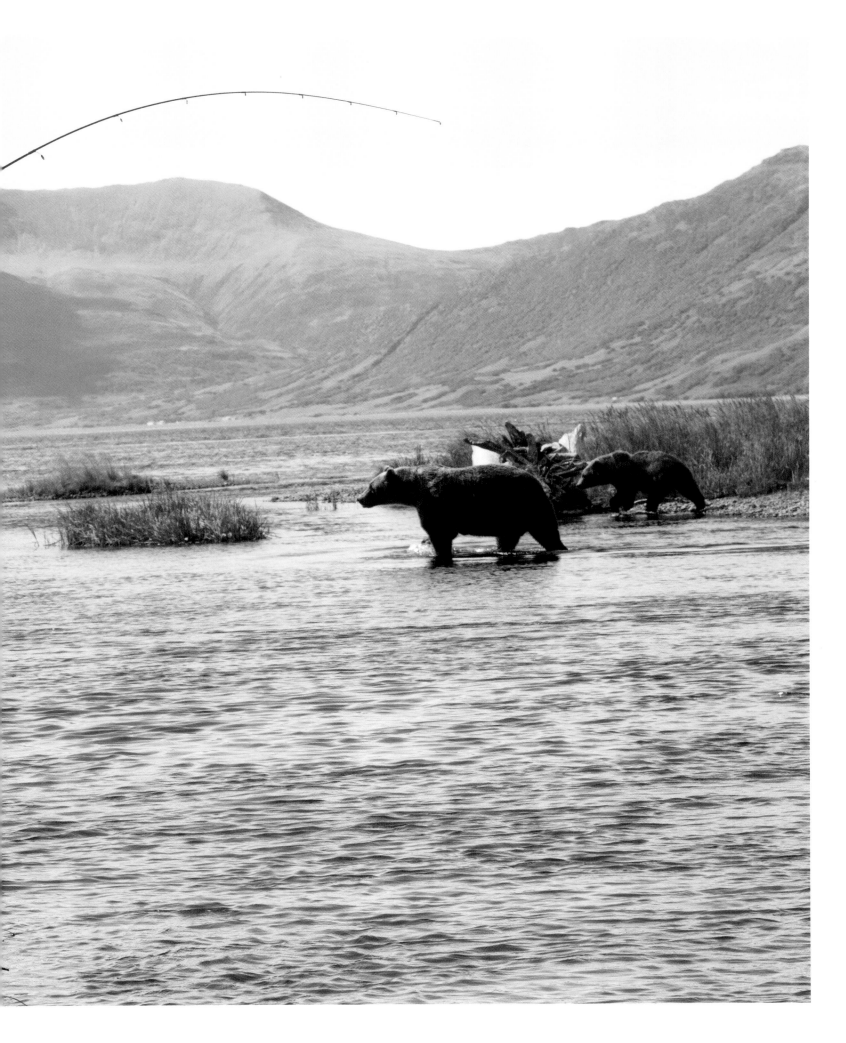

Spain

Rivers, lakes and 4970 miles (8000 kilometers) of coastline make Spain an excellent fishing destination.

→ In the touristy coastal region of Alicante, the waterfront is still pleasantly calm in the morning.

↓ Spain offers not only beaches and the sea, but also a multitude of rivers that are suitable for fly fishing, especially in the northern regions and in the Pyrenees.

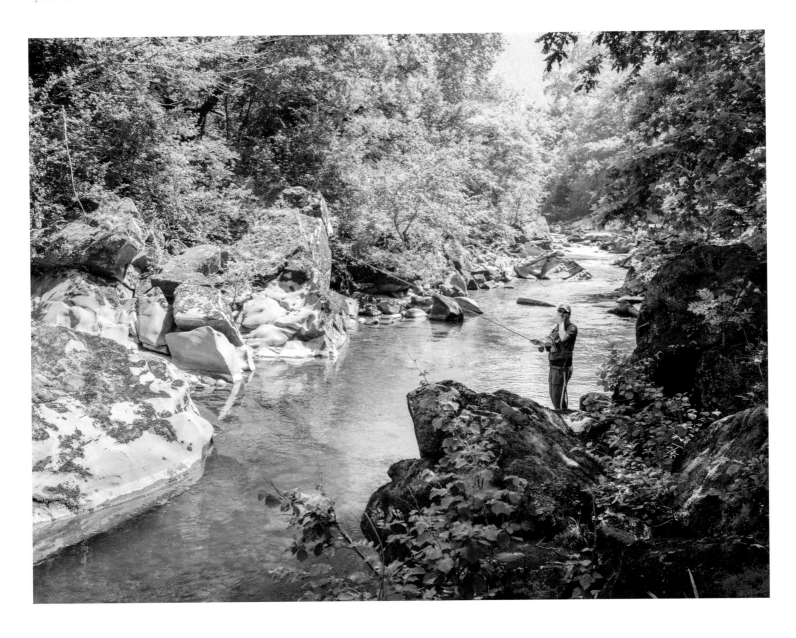

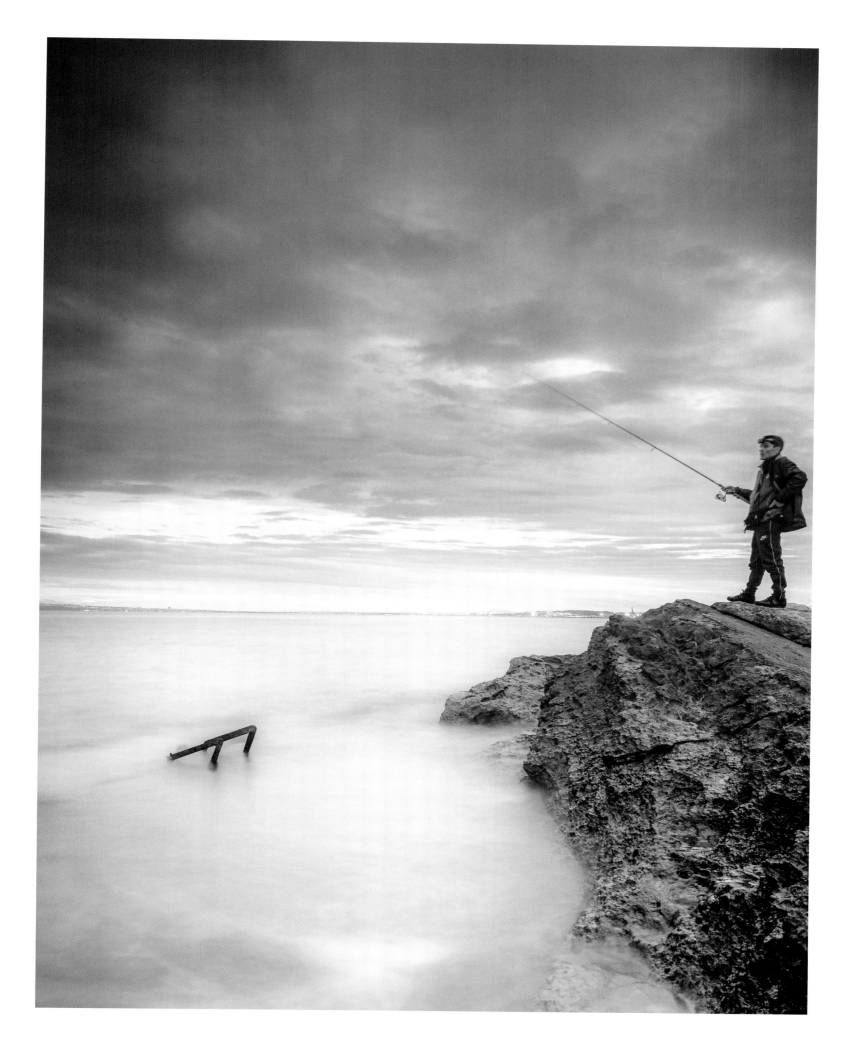

Ireland

For many pike anglers, Ireland is considered the ultimate destination. Decades ago, the country was primarily known for its salmon and trout. However, Ireland has now also gained an excellent reputation among pike anglers.

Pike can be found in all types of waters in Ireland, from ponds and large lakes to rivers and canals. Irish pike grow quickly and can reach weights of up to 44 lbs (20 kilograms) in some waters. Fish weighing 22 lbs (10 kilograms) are widespread.

← Lough Sheelin is famous for its pike stocks and attracts anglers from all over the world.

↓ Ireland has a variety of sea fish that are easy to fish for, both from the coast and on offshore trips.

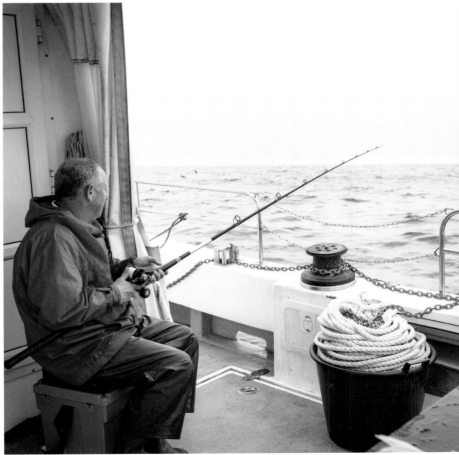

Slovenia

The small EU state is a gem in the heart of Europe, not only underestimated by anglers. Slovenia's diverse landscape and rich biodiversity are impressive: Every fiftieth globally known species of continental animals and plants can be found here.

One of the country's most significant rivers is the Soča. The Soča Valley is highly popular among fly fishermen due to its breathtaking landscape and bright blue waters.

Here, the Marble Trout, also known as Soča Trout, has its home. The Marble Trout's distribution is limited to the Adriatic region, making it relatively rare compared to other trout species. Its marbled scales distinguish it clearly from relatives like the Rainbow Trout and Brown Trout.

The Marble Trout can reach an impressive length of 4 feet (120 centimeters) and weigh up to 110.2 lbs (50 kilograms). Due to displacement by invasive species and increasing river channelization, the Soča Trout is considered endangered.

→ In the middle of Lake Bled, on the island of Blejski Otok, stands the Church of St. Mary – a striking landmark and an important pilgrimage site in the region. The church is known for its baroque architecture and characteristic bell tower.

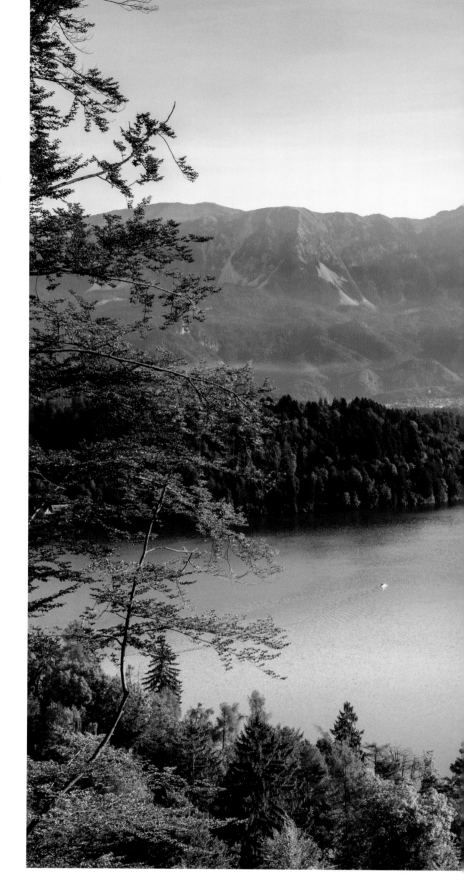

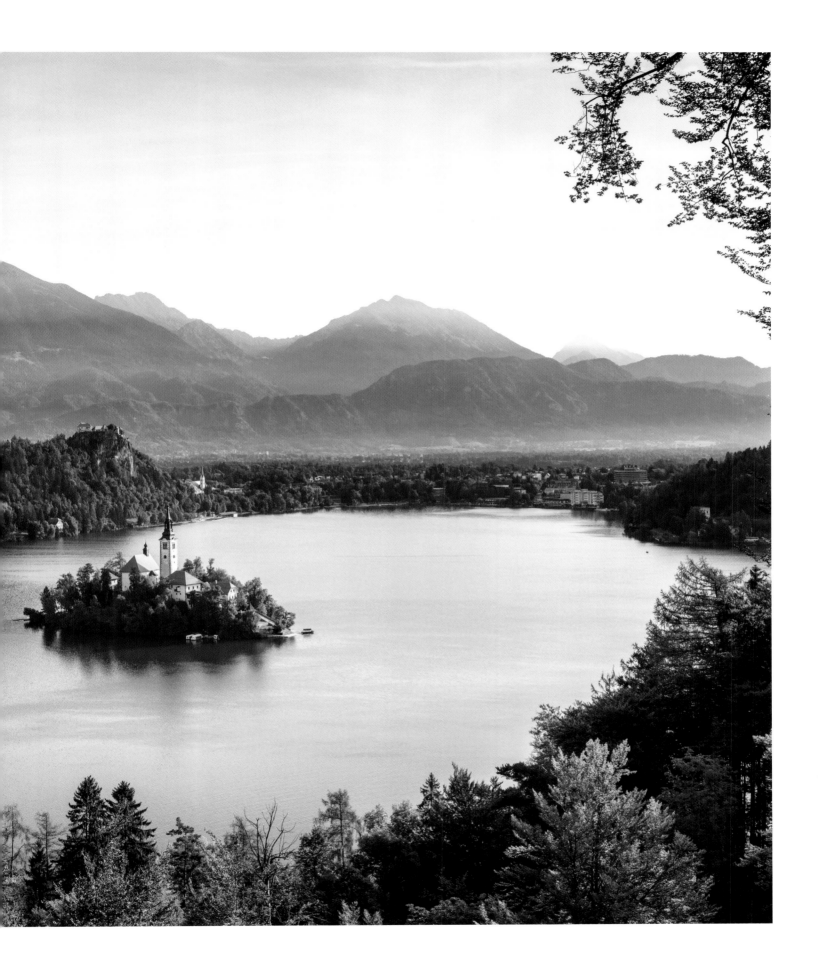

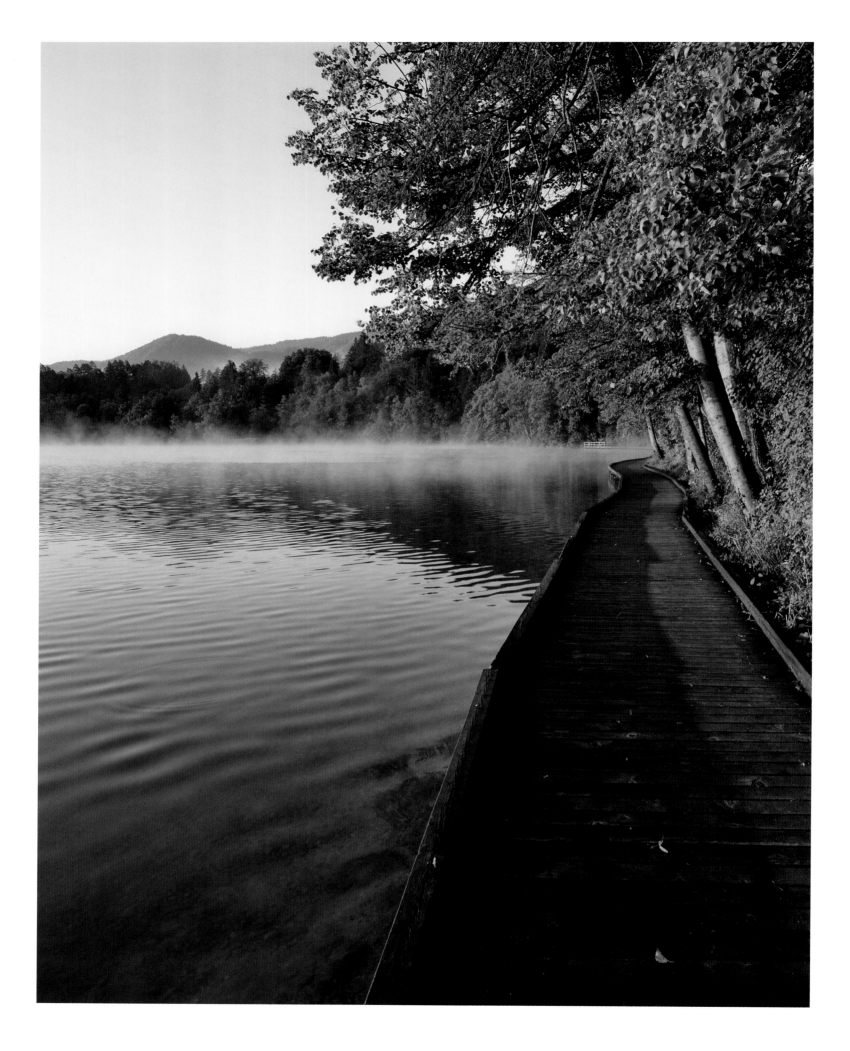

Lake Bled in the Slovenian region of Upper Carniola (Gorenjska) near the spa town of Bled at the foot of the Pokljuka plateau is a popular destination for tourists and carp anglers. The lake, which is around 1.3 miles (2.1 kilometers) long and up to 0.86 mile (1.4 kilometer) wide, has a total area of 358.3 acres (1.45 square kilometers) and a maximum depth of 98 feet (30 meters).

The small island of Blejski Otok, in the middle of the lake, is known for its prominent Mary's Church and significant excavations dating back to the Early and High Middle Ages. It is the only island in Slovenia.

Anglers visiting the lake not only enjoy the spectacular scenery but also have the opportunity to catch enormous carp. The current record weight is 81.13 lbs (36.8 kilograms).

→→ The Soča Valley is an excellent area for fly fishing. The Soča River and its tributaries, such as the Tolminka, are known for their clear waters and rich population of trout, including the Marble trout.

↓ The name Marble trout is derived from the characteristic marbling of its body. The pattern can vary greatly and ranges from fine dots to larger spots or bands.

← The wooden path along the bank of Lake Bled is shared by walkers and anglers.

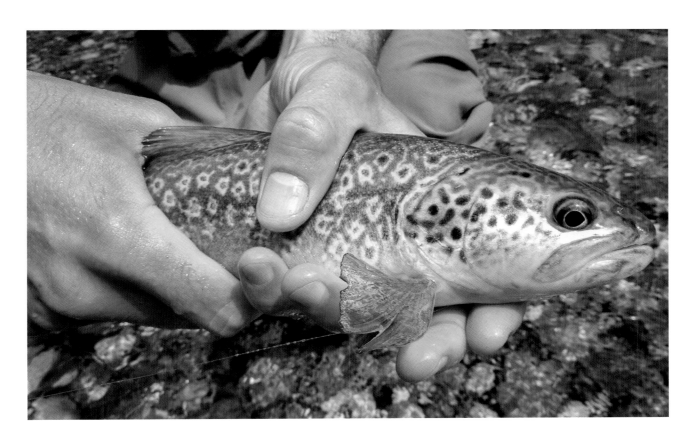

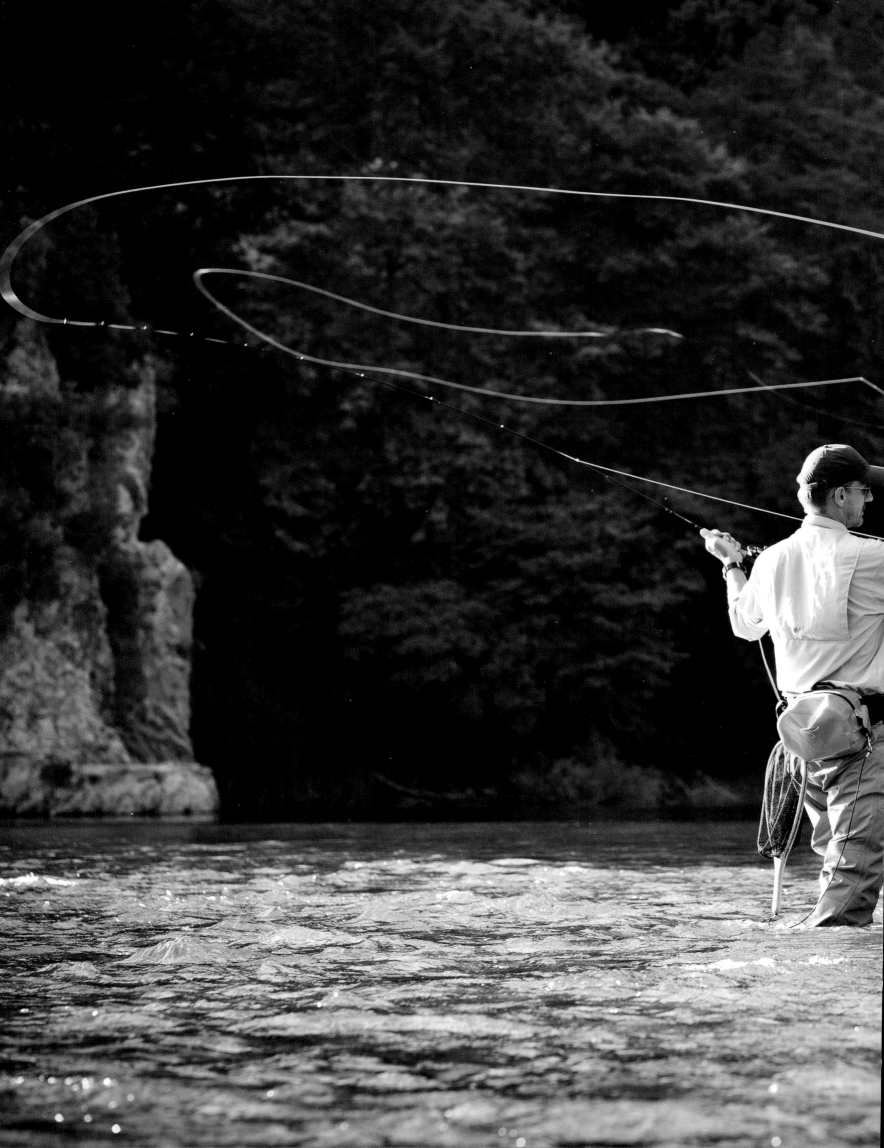

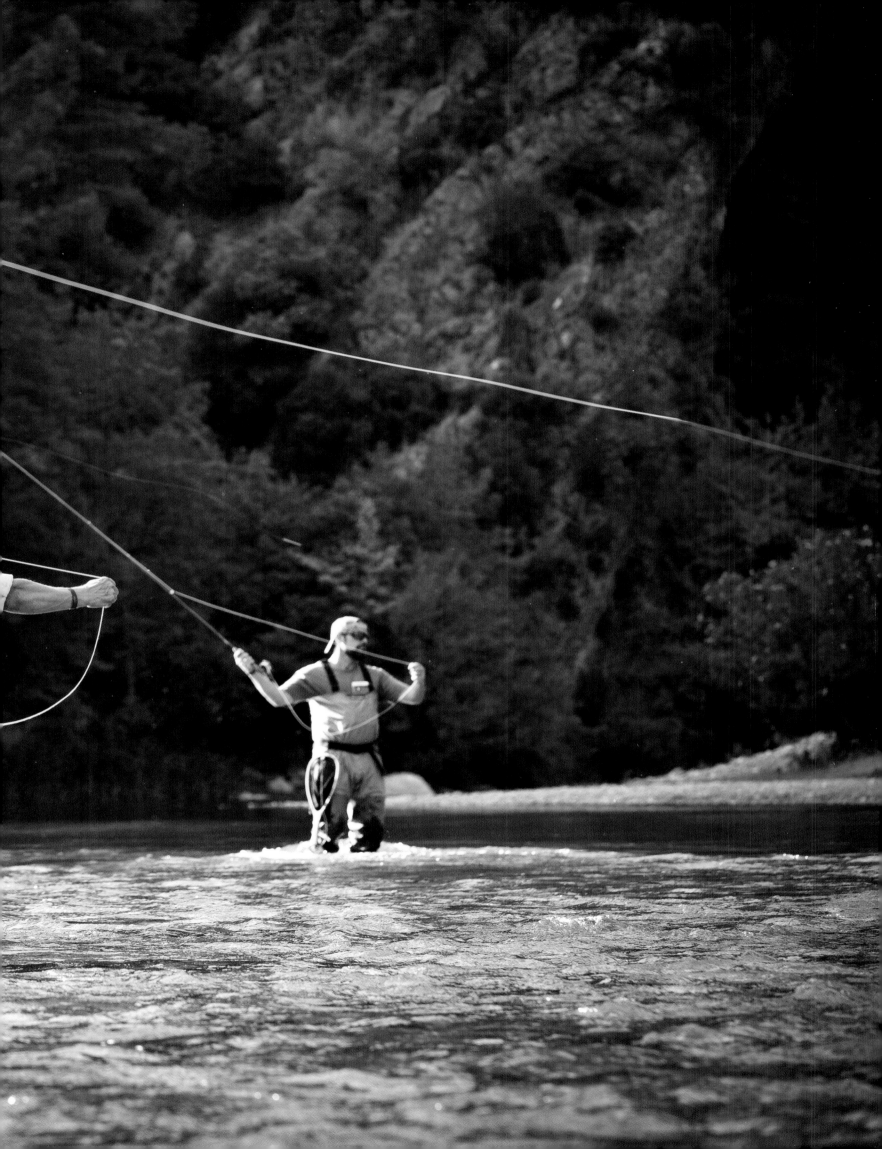

Imprint

© 2025 teNeues Verlag GmbH

Texts: © Moritz Rott. All rights reserved.

Editorial Coordination by Dr. Johannes Abdullahi, teNeues Verlag
Project Management and Art Direction by Susanne Maute, mcp concept GmbH
Copyediting by Susanne Maute, mcp concept GmbH
Layout and typesetting by mcp concept GmbH
English Translation by Stephanie Keil
English Proofreading by Susen Truffel-Reiff
Production by Sandra Jansen-Dorn, teNeues Verlag
Photo Editing, Color Separation by Jens Grundei, teNeues Verlag

Library of Congress Number: 2024937763
ISBN: 978-3-96171-626-5
Printed in Bosnia and Herzegovina by GPS

FSC MIX
Paper | Supporting responsible forestry
FSC® C118234

Bibliographic information published by the Deutsche Nationalbibliothek:
The Deutsche Nationalbibliothek lists this publication in the Deutsche Nationalbibliografie; detailed bibliographic data are available on the Internet at dnb.dnb.de.

Published by teNeues Publishing Group

teNeues Verlag GmbH
Ohmstraße 8a
86199 Augsburg, Germany

Düsseldorf Office
Waldenburger Straße 13
41564 Kaarst, Germany
e-mail: books@teneues.com

Augsburg/München Office
Ohmstraße 8a
86199 Augsburg, Germany
e-mail: books@teneues.com

Press Department
e-mail: presse@teneues.com

teNeues Publishing Company
350 Seventh Avenue, Suite 1702
New York, NY 10001, USA
Phone: +1-212-627-9090
Fax: +1-212-627-9511

www.teneues.com